# Mother
# Camp:
# Female
# Impersonators
# in
# America

ESTHER NEWTON

# MOTHER CAMP: FEMALE IMPERSONATORS IN AMERICA

The University of Chicago Press
*Chicago and London*

The University of Chicago Press, Chicago 60637
The University of Chicago Press, Ltd., London

© 1972, 1979 by Esther Newton
All rights reserved. Published 1972
Phoenix Edition 1979
Printed in the United States of America

83  82  81  80  79      987654321

ISBN:  0-226-57760-0
LCN:  76-37634

To Jean F. White and Nancy R. Smith,
who helped me grow up.

*The mass march that ended Gay Power Week was the first such demonstration in U.S. (perhaps world) history: almost 20,000 sisters and brothers marched from Sheridan Square all the way to Sheep Meadow in Central Park, chanting and singing as they went, "Out of the Closets and Into the Streets!" "Ho, Ho, Homosexual/The Ruling Class is Ineffectual!" and "Two, Four, Six, Eight/Organize and Smash the Straight!" among other rallying cries. . .*

*In New York and Bay Area especially, Women's Liberation contingents marched under banners declaring solidarity in the fight against our mutual oppression: the sexism that has degraded and destroyed millions of lives, the sexism we are now setting out to destroy with our weapons of courage, anger and love.*

From *The Rat*, New York Radical Newspaper, 15 July 1970.

# Contents

**Preface to the Phoenix Edition**   xi

**Preface**   xv

**Acknowledgments**   xix

**Note to the Reader**   xx

CHAPTER ONE

**On the Job**   1

CHAPTER TWO

**The "Queens"**   20

CHAPTER THREE

**Types of Acts**   41

CHAPTER FOUR

**Two Shows**  59

CHAPTER FIVE

**Role Models**  97

CHAPTER SIX

**"The Fast Fuck and the Quick Buck"**  112

APPENDIX

**Field Methods**  132

# Preface to the Phoenix Edition

Scrutinizing one's past work is like meeting a former lover: evocative, disconcerting, perhaps saddening. This book was written in the late sixties, and our affair is over. I had no desire to revise it for this second edition, not only because it belongs to my past, but also because it strikes me still as an accurate analysis of its subject: drag queens as gay male culture "heroes" in the mid-sixties. Nor do I think that the contradictions that gave rise to female impersonation have changed in essentials, so that the analysis in *Mother Camp* is still valid. New fieldwork on the current state of the drag world would certainly be desirable, but I am not the one to do it, having been severed from that world by my own evolution and the brute passage of time. Those who would bring things up to date will find in *Mother Camp* a solid baseline for their own explorations.

Still, I follow female impersonators and the gay male world from afar, and seize the opportunity to offer some thoughts about the changes of the last ten years. These fall into two categories: various cracks appearing in the straight world's relentless wall of hostility, and the transformations wrought in the gay community by the gay-pride movement.[1]

The gay-pride movement has challenged the traditional stance of the dominant culture; that homosexuals are a shameful group of pariahs to be erased, if possible, or passed over in silence, if not. In the mid-sixties, and as new historical research indicates, probably long before that, drag queens both defied and upheld societal attitudes toward "queers." The dominant culture, which has its own internal divisions—the constituency represented by Anita Bryant is not the same as that represented by the *New York Times*, for example—has not been able to prevent gays from becoming visible and clamoring for rights and toleration. But the structural underpinnings of heterosexual domination are still very much intact. What few legal gains have been made in the areas of decriminalization and discrimination are being vigorously attacked by the organized sexual

xi

The gay-pride struggle revolves around the issue of coming out, which the conservatives have correctly seen would lead to the toleration of gays as a minority. Why this is the key issue will be clear to any reader of *Mother Camp*. The overwhelming concern of the pre-movement gay community was disclosure, and the resulting overt/covert distinction referred to throughout this book. In chapter 1 I refer to "baroque systems of personal and territorial avoidance" which had resulted from the fact that the stigma of homosexuality, unlike blackness or femaleness, could be hidden. If more and more gays come out, and get away with it, the most dramatic forms of shame and suffering imposed on drag queens, who previously were among the very few visible, aggressive homosexuals, would fade.

However, gay men are kidding themselves if they think the deeper stigma of homosexuality can be eliminated while the antagonistic and asymmetrical relations between men and women persist. It is true that legitimized male homosexuality and male domination have coexisted in some cultures (for instance, ancient Greece and tribal New Guinea), but never exclusive homosexuality, and besides, those men were not Judeo-Christians. So long as women are degraded, yet powerful enough to constitute a threat, gay men will always be traitors in the "battle of the sexes." So long as current models of sexuality persist and predominate, gay men will always be "like" women.

In the last ten years there has been an enormous struggle within the gay male community to come to terms with the stigma of effeminacy.[3] The most striking result has been a shift from effeminate to masculine styles. Underline the word *styles*. Where ten years ago the streets of Greenwich Village abounded with limp wrists and eye makeup, now you see an interchangeable parade of young men with cropped hair, leather jackets, and well-trimmed mustaches. "Sissies" are out. Inevitably, and sadly, the desire to be manly, pursued uncritically—only a few souls in the wilderness cried out for a feminist analysis—has led to a proliferation of ersatz cowboys, phony lumberjacks, and (most sinister) imitation Hell's Angels, police, and even storm troopers. The S & M crowd, once a small and marginal subgroup, are now trend setters; their style and, to a lesser degree, their sexuality have captured the gay male imagination.[4] This is playing with shadows, not substance. John Rechy, himself a "butch" gay, exposes "those who put down 'queens' and 'sissies' (and most leather gays do so, loudly) for hurting our image. (Ironically, it is a notorious truth that mass arrests of transvestites almost inevitably result in rough, heavy punching out of the cops, whereas a mass raid in a leather bar will result in meek surrender, by both 'M's and 'S's.)"[5]

Rechy, whose admirably honest and thought-provoking book *The Sexual*

---

[3] I see the transsexual phenomenon as a variant of this struggle. If you don't like being a man, get out. America: Love it or leave it.

[4] That is, among urban, white males. There is a possibility that Black and Hispanic gays (and poor whites?) have retained the effeminate drag style.

[5] *The Sexual Outlaw* (New York: Dell Publishing Co., 1977), p. 258.

reactionaries. Yet gay books and films appear at a rate undreamt of in the sixties; the business world, having discovered that gay people spend money, is taking advantage of the new openness to direct products toward the "gay market."

Not only that, but recent movies point to a cooptation of drag symbols and camp sensibility by the mass media. In *Outrageous* a female impersonator of the type described in this book is portrayed sympathetically: indeed, he is seen as a kind of counterculture Everyman, who invites the admiration of both gay and straight. The surrealistic figures in *The Rocky Horror Show* are not female impersonators per se, but the symbolic elements in this latter-day Frankenstein cum Dracula story will be familiar to readers of this book. Though Dr. Frank N. Furter's drag is drawn more from pornography (black garter belt, tight corset) than from gay drag, and though he is represented as an androgynous bisexual, his creation of a witless muscle man as an ideal lover puts us back on familiar ground. The muscle man and the drag queen are true Gemini: the make-believe man and the make-believe woman. But if the symbolism of the film is familiar, the fact that it was made, and that apparently thousands of American adolescents flocked to see it at midnight showings is not.

At a further remove, the immensely popular film *Star Wars* is saturated with drag ("powers-of-darkness" drag, "princess" drag, "terrestrial alien" drag, "robot" drag, etc.) and camp sensibility. I'm sure the queens loved it, but then so did millions of other people. The gay sensibility, like that of other minorities before it, is finding, in watered down form, a larger audience.[2] I would guess that masses of people are finding themselves torn, as drag queens are, between traditional values and an acquired but profound cynicism. The campy way of expressing and playing with this tension, as described in chapter 5, is becoming presentable.

Yet just as gay sensibility and even real live drag queens are making their way into mass culture, the conditions that nourished them are changing. While camp humor was an assertion of gay existence, much of its content was self-hating, denigrating, and incompatible with the assertions of gay pride, whose aim is perhaps not the end of drag, but at least the transformation of the ethos described in chapters 5 and 6.

[1] I denote here the whole spectrum of political activities whose minimum goal is the toleration of the gay community as a minority group. Within the gay-pride movement, a few groups have what would properly be called gay liberation as a goal: the end of state-enforced heterosexual hegemony, male domination, and a consequent disappearance of the gay/straight opposition as we know it. Besides, the word "liberation" implies a socialist coloration which at present is rather pale. If the distinction seems invidious, perhaps I must plead guilty. But if even the more limited goals of the gay-pride movement could be realized in my lifetime, it would make me proud of my native land.

[2] Passing by my local (working-class) French movie theater, I find they are featuring *Outrageous,* with the subtitle *Un amour "différent"* beside pictures of the starring impersonator and the female lead gazing tenderly at each other. Not all forms of cooptation are so blatant.

*Outlaw* confronts (and approves) promiscuity and male worship among gays, condemns the S & M trend as self-hating and destructive (his own model is Charles Atlas, which is surely more benign). But he stops short of saying that, without new models of manhood, its glorification can lead only to dead-end dramas of domination and submission.

I much preferred drag queens. What will happen to them amid the conflicting pressures of the gay-pride movement, the S & M trend, feminism, continued homophobia, and a limited mass acceptance of gay sensibility is difficult to predict. But even if female impersonation and all it stands for were to disappear tomorrow (which seems most unlikely), *Mother Camp* now has the virtue of being an invaluable historical document, at once photograph and X-ray of the male gay world on the edge of historic changes.

I would never do this work again, though having done it immeasurably enriched my twenties. The men whom I knew in Kansas City and Chicago were tough; they knew how to fight and suffer with comic grace. They had the simple dignity of those who have nothing else but their refusal to be crushed. I bid them farewell with a bittersweet regret, and leave it to others to carry on the work of illuminating their past and chronicling their future.

September 1978
Paris

# Preface

I thought I might write a short article about drag queens. Instead, my interest deepened; the research grew from a thesis proposal to a doctoral dissertation, and finally to this book. The dissertation was completed in the spring of 1968. Its conclusions dealt with the necessity for anthropologists to study American culture, and with problems in sociological deviance theory. Two years later, I began to reorganize and rewrite the thesis. During those two years, the existence of American culture had been recognized by the American Anthropological Association and deviance theory had lost some of its usefulness.

In 1968 I wrote: ". . . this ethnography is a map of *terra incognita* as far as most middle class social scientists are concerned. The need for more descriptions of deviant groups is clear if any general theory of deviance is to be developed." That statement has generated the questions: "*Who* needs a theory of deviance? Why? What about a theory of 'normalcy'?" Today these seem like obvious questions, but having the courage to ask them is another thing. If we really examine "normalcy" we may choke on what we bring up. Our own culture is hard to think about; we can't get far enough away to look at it. I had wrestled with this problem for a long time before I studied it formally as anthropology.

So as I considered the problem of drawing new conclusions from my experience with drag queens it slowly dawned on me that in order to write about them I would have to alter the book so profoundly that it would become a whole new project. I decided instead to let the book stand substantially as I had written it, and delete the old conclusions. In the absence of new conclusions, I want to indicate the elements that would have shaped them. The relevant framework includes the Viet Nam war, the rise of Black, Feminist and Gay consciousness, and the collapse of legitimacy in American institutions (including universities). My own consciousness has responded to these events in a number of ways, one of which has been to question whether anthropologists are really outsiders to their own culture as has often been claimed.

Two years ago, I believed, without full awareness of my belief, that academics were objective truth-seekers and that the university was basically a free and independent haven of enlightenment — at any rate, a good alternative to business. I thought politics was a matter of opinion, that one made choices between unsatisfactory candidates. It never occurred to me that politics and anthropology had any connection.

Now I think that anthropology (and the other social sciences) are the ideological arms of sociopolitical arrangements. I use *ideology* here not in the narrow sense of propaganda, but in the sense of pervasive idea system making up a world view that both reflects and molds particular social arrangements. In general, scholarship reflects and molds the sociopolitical system called a university, and universities are not independent from our social order, but are paid and organized to perpetuate and legitimize it. Not all the ways in which we are implicated are obvious, though. Some are so subtly structural that trying to change them is like to crawl out of your own bones.

In graduate school I was trained to conceptualize culture as a static functional system. (How to account for change was a persistent but peripheral problem). We never asked whether a system might not be more "functional" for some people than for others. I did not see or look for connections between culture and power; now it seems obvious that elites attempt to manipulate knowledge and symbols to their own purposes. So-called minorities and deviants are the victims of these purposes. What I did not quite realize when I wrote my original thesis is that it is not so much a plea for the importance of American culture, or a theory of deviance, as it is a study in a particular kind of powerlessness.

My general views about homosexuality have not changed drastically over the last two years, mainly because I was more committed to academe than to the conventional family and sex role structure. Nevertheless, my idea of the possibilities has changed a good deal. The events of the last two years have included the rise of the Women's Liberation and Gay Liberation movements. Women's Liberation particularly has led me to *experience* the arbitrariness of our sex roles. I *know* now (rather than *think*) that the structure of sex roles is maintained by the acquiescence of *all* the participants who accept their fate as natural and legitimate. However, I doubt that the situation of female impersonators has substantially changed yet. I believe that much of what I wrote about them is still correct and even foresighted. In some places I rewrote the text if it struck me as dated. In others, I added footnotes to the original statements that show specifically how my thinking has changed.

As a liberal (who had never held a job) and as a woman who had never been trained to think that work was serious, I think I underestimated the importance of the economic exploitation of impersonators and street fairies when I first wrote about them. I have partially rectified this in the first and last chapters. And when I first recorded that impersonators believed the major and most fundamental di-

vision of the social world to be male/female I thought that I knew better. Now I agree with them, although I draw different conclusions from it than they do, and the same goes for their belief that American society produces people who want "a fast fuck, a quick drink and how much?" Perhaps what needs to be explained is why I was blind where they could see. Here we return to the questions posed by normalcy, or middle class culture. Middle class culture seems to me to have built-in social blindness, compounded by arrogance. I was prepared to find the views of deviants interesting, but never seriously considered that they could be correct. In the end, I have tried to let impersonators speak for themselves. They say a great deal about America.

# Acknowledgments

I wish to thank the female impersonators who shared their lives with me, especially Skip Arnold and Just Tempest. Without Skip there would be no book; it is our creation although, of course, he is not responsible for my conclusions. I hope that all the men who expected me to write a fair and sympathetic account of their lives will be pleased.

I also thank my teachers, Clifford Geertz, Julian Pitt-Rivers and, most of all, David M. Schneider, who was more helpful than he probably knows.

My fellow graduate students at the University of Chicago bolstered me through the initial shaky stages when the project was first conceived: Robert and Sherry Paul, Ben Apfelbaum, Harriet Whitehead, Cal Cottrell, and Charles Keil. More recently I have gotten editorial, emotional, and intellectual help on various parts of this book from Shirley Walton Fischler, Ed Hansen, Louise Fishman, Marty Babits, and Lee Kirby. Special thanks to my sisters in Upper West Side WITCH.

Mrs. Mollie Lamster, Mrs. Lubelfeld, and Mrs. Reisman, all of the Queens College Anthropology Department, typed the manuscript and took an interest.

# Note to the Reader

It has been suggested that I explain the significance of the title *Mother Camp*. In the mid-sixties, "camp" was an in-group word which denoted specifically homosexual humor (see Chapter Five). The most highly esteemed female impersonators were all "camps," virtuoso verbal clowns.

My use of the word "mother" is slightly more idiosyncratic. I intended it in a double sense. "Mother Camp" as an honorific implies something about the relationship of the female impersonator to his gay audience. A female impersonator will sometimes refer to himself as "mother," as in "Your mother's gonna explain all these dirty words to you." I also meant "mother" as an adjective modifying "camp," the latter word then referring to the whole system of humor. This reflects my belief that camp humor ultimately grows out of the incongruities and absurdities of the patriarchal nuclear family; for example, the incongruity between the sacred, idealized Mother, and the profane, obscene Woman. If camp humor takes such problems as its special subject, then the drag queen is its natural exponent. He himself is a magical dream figure: the fusion of mother and son. All this lies beyond the terrain covered in this book; the title simply points hopefully in that direction.

# Mother Camp: Female Impersonators in America

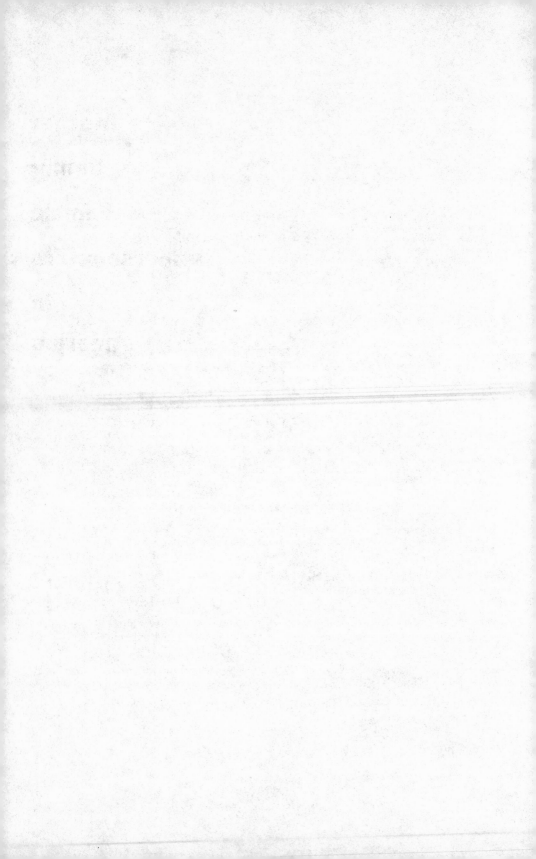

# On the Job

Americans, for the most part, evaluate a man's social status by his "occupation." The question "What does he do?" means "What is his work?" ("Job," "occupation," "profession," and "business" are synonyms with somewhat differing connotations.) In American theory, every man is equal in public, every man is king in his own home; but no one can or does pretend that all jobs are granted equal status.

Money and "Americanism" are also important criteria in judging a person's social standing.[1] The amount of money one has or earns is always considered, and can be critical in the more cynical measurements of that overriding American goal, "success." For instance, a criminal may be judged a "bigger success" than a prominent pediatrician if the criminal is richer. However, when Americans say "Money is all that counts in this country," they are generally implying that some other state of affairs would be more desirable.

Americanism is a generic for a host of social identifiers, many of them ascribed. In America, one ought to be "free, white, male, and twenty-one." A number of beliefs and behaviors are also "American," such as "know-how," cleanliness, patriotism, and ambition. Any contrast with the ideal image, whether in appearance or behavior, is un-American to some extent. For a century or more, immigrants have striven to adjust their lives and their physical appearance to the ideal, a process called assimilation. Gunnar Myrdal first pointed to the nightmare "dilemma" that has been created in this country by the "unassimilable" condition of black people. To belong to the contrasting ascribed categories "Negro," "woman," or "Jew," or the achieved ones of

---

[1] The concept of Americanism was introduced by Geoffrey Gorer, *The American People*, rev. ed. (New York: W. W. Norton, 1964), p. 193ff.

"hippie" or "Communist," drastically affects one's status, prestige, and honor, regardless of how rich or prestigious one's occupation.[2] As Gorer pointed out, to be lacking in, or to contrast with Americanism, is to be lacking in moral grace, since it is thought that Americanism can be achieved by an act of will. Those who are not "100 percent American" must be either ignorant or perverse.

Homosexuals are not accepted as 100 percent Americans, and they are certainly considered "perverse."[3] Homosexuality is a splotch on the American moral order; it violates the rooted assumption that "masculinity," a complex of desirable qualities, is "natural" for (appropriate to) the male. Masculinity is based on one's successful participation in the male spheres of business, the professions, production, money-making, and action-in-the-world. (Hence the importance of excluding women from these spheres.)

Masculinity also depends crucially on differentiation from, and dominance over women. The problem is not, strictly speaking, just that homosexuals reject women as sexual objects. The moral transgression is in the choice of another man as a sexual (and/or romantic) object. Since male-female sexual relations are the only "natural" model of sexuality, at least one of the men of a homosexual pair must, then, be "acting" the woman: passive, powerless, and unmanly. The dichotomy appears in American culture as rooted in "nature." One can just *be* a woman; it is a passive state. But one must *achieve* manhood. All a woman has to do is "open her legs" (a passive act), but a man has to "get it up" (that's "action").[4]

These assumptions and values operate in the homosexual subculture too. When homosexuals talk about "the stereotype," they refer to the stigma of effeminacy. Hooker and Hoffman both report that one "makes out" better in the "gay" (homosexual) sexual marketplace if one appears to be more "masculine."[5] A common homosexual assertion is that homosexuals are actually more masculine than heterosexuals because the latter are woman-controlled or contaminated and because it is more masculine to dominate another man than to dominate a woman. The "straight" (heterosexual) culture is vulnerable at this

[2] The point about women may not be obvious to male readers. Is America thought to be "feminine," "tender," "passive"? It seems likely that as a parallel to sex roles in the family, America is symbolized as "masculine" in relation to other nations (outside the family), while it may be seen as "feminine" in internal matters.

[3] Self-appointed 100 percent Americans who stand on the sidelines of peace demonstrations almost always yell "fag" along with other epithets. I doubt that this is only because of the long hair worn by some demonstrators. Peace = no "balls" = effeminate = "fag."

[4] A conversation with another anthropologist provided me with a shocking moment of self-realization and critical insight about this. He was talking about sidewalk pornography in "his" culture and mentioned "cunt symbols." I was really puzzled for a moment and asked, "How can you symbolize nothing?" Then, I *heard* what I had said.

[5] Evelyn Hooker, "Male Homosexuals and their Worlds," in *Sexual Inversion,* Judd Marmor, ed. (New York: Basic Books, 1965); Martin Hoffman, *The Gay World* (New York: Basic Books, 1968).

point. It cannot really explain why homosexuality is so rampant in especially masculine areas such as the contact sports, the Army, and prisons.[6]

Given the obsessive cultural concern with "masculinity" which is reflected in the dominant interpretation of homosexual behavior and the denials and counter charges by homosexuals, it is not surprising that homsexuality is symbolized in American culture by transvestism. The homosexual term for a transvestite is "drag queen." "Queen" is a generic noun for any homosexual man. "Drag" can be used as an adjective or a noun. As a noun it means the clothing of one sex when worn by the other sex (a suit and tie worn by a women also constitute drag).[7] The ability to "do drag" is widespread in the gay world, and many of the larger social events include or focus on drag ("drag balls," "costume parties," etc.). Drag queens symbolize homosexuality despite the truthful assertions of many homosexuals that they never go to see professional drag queens (called female impersonators for the benefit of the straight world) perform, never wear drag themselves, and prefer "masculine" men.

This book is about professional drag queens, or female impersonators. As Goffman pointed out, stigmatized groups and categories of persons may be represented by two opposing roles. On the one hand there is the "gentlemen deviant," the person who is engaged in proving to himself and others that persons in the stigmatized category can be just as normal and competent as heterosexuals, ". . . nice persons like ourselves, in spite of the reputation of their kind."[8] At this pole we find the "masculine," "respectable" homosexuals, the leaders of most homophile organizations and so on. At the opposite pole there are the persons who most visibly and flagrantly embody the stigma, "drag queens," men who dress and act "like women."

Professional drag queens are, therefore, professional homosexuals; they represent the stigma of the gay world. Not surprisingly, as professional homosexuals, drag queens find their occupation to be a source of dishonor, especially in relation to the straight world. Their situation in the gay world is more complex. The clever drag queen possesses skills that are widely distributed and prized in the gay world: verbal facility and wit, a sense of "camp" (homosexual humor and taste), and the ability to do both "glamorous" and comic drag. In exclusively gay settings such as bars and parties, drag queens may be almost lionized. But in public – that is, any domain belonging to the straight world – the situation is far different. Female impersonators say that in

---

[6] Gorer's analysis of the ubiquitous "homosexual panic" is particularly good (pp. 125–32). He points out the constant fear of homosexuality in male activities, noting for example the pressure on young men in the Army to pin up "cheese-cake" photographs by their bunks to encourage heterosexual fantasy.

[7] "Drag" has come to have a broader referent: any clothing that signifies a social role, for instance a fireman's suit or farmer's overalls. The concept of drag is embodied in a complex homosexual attitude toward social roles.

[8] Irving Goffman, *Stigma* (Englewood Cliffs, N.J.: Prentice-Hall, 1963) p. 111.

public they never "recognize" a homosexual whom they know unless they are recognized first. One homosexual man put it to me succinctly when I asked him if he had ever done professional drag: "Hell no," he exclaimed, "it's bad enough just bein' a cocksucker, ain't it?" Because female impersonators are an occupational group, I focused my observations on performances. This chapter especially focuses on two distinct patterns found within the group for integrating the stigmatized occupation with other patterns of identity and action.

Formally, female impersonators are all professional performers. They receive a regular salary for their specialized service: entertaining audiences. Formally, they are like many other types of professional (paid) performers such as movie, television, and stage actors, musicians, dancers, circus clowns, strippers, and chorus girls. These occupations and many others make up the professional entertainment industry, or what is colloquially called "show business."[9]

Female impersonators typically perform in bars and nightclubs. In most cases these are public places run by profit-seeking owners and managers who have no interest in impersonators other than as audience-attracting employees.[10] Some clubs are defined (by management and patrons) as "straight" or "tourist" bars, and others as "gay" bars. The bars are usually located in entertainment or gay areas of large cities such as New York, Chicago, and San Francisco, but sometimes in middle-sized cities, too, such as Toledo, Phoenix, and Indianapolis. Like other nightclub performers, female impersonators perform at night. Usually they perform three shows a night, for instance at nine, eleven, and one o'clock, and sometimes four shows on Saturday night. They generally work six nights a week. Impersonators work long hours for little pay. Two-hundred dollars a week is considered a very good salary. A few "big names" make much more, but most impersonators earn $100 a week or less.

One can only guess at the number of professional female impersonators. Few of them belong to any formal organization through which one might count them.[11] The job situation is extremely fluid, and the performers move around a great deal from city to city. At any given time a certain percentage of performers

[9]Of course not all "show biz" people are performers. The subculture includes many back-stage and off-stage occupations. Some kinds of performers resist the "show biz" label and associations, especially those engaged in "high culture" (symphony musicians) and the *avant garde* (underground film makers, modern dancers).

[10]There were few exceptions to the rule that clubs and bars are owned and managed by heterosexuals (many of whom were reputed to have underworld connections). Informants stated that this was desirable, citing assumed difficulties that homosexuals, particularly other impersonators, would have "keeping the queens in line." Most exceptions seem to be in San Francisco and Los Angeles, where gay bars are run by small entrepreneurs rather than syndicates. But even in San Francisco, the most prestigeous impersonation nightclub in the country is owned and managed by an Italian family.

[11]Some female impersonators are members of the American Guild of Variety Artists (AFL-CIO), a functioning but relatively weak union of various residual performance specialities (jugglers, magicians, animal acts, etc.).

will be out of work or between jobs. There is also much movement in and out of the profession. Most performers think that the number of impersonators is increasing. A very knowledgeable informant who had been in the business for fifteen years and knew many other performers estimated that there were perhaps 500 full-time, currently-active professional female impersonators in the country as of July, 1966.

Impersonators concentrate in larger cities where there are jobs.[12] The jobs fluctuate drastically, largely in response to police policy. For instance, in the winter of 1965-1966 there were seven clubs in the Chicago area that had full time drag shows. These provided about thirty jobs. But in the spring of 1966 the police began to harass and raid the clubs, with the result that by summer there were only two shows left. This reduced the total number of jobs to about ten. Those who were put out of work had to leave town or find other kinds of jobs. During most of the duration of my field work, the principal professional (and also social) centers were New York City, Chicago, New Orleans, Kansas City, San Francisco, and Los Angeles.

Female impersonators are highly specialized performers. The specialty is defined by the fact that its members are men who perform exclusively, or principally, in the social character of women.[13] In order to create the female character, female impersonators always use some props which help to create the partial or complete visual appearance of a woman. The props can range from a string of beads superimposed on a man's suit, to the full visual panoply of "femininity": long hair (wig or own hair), "feminine" make-up and dress, "feminine" jewelry, bosom (false or hormone-induced), and high-heeled shoes.[14]

[12] Not all large cities provide jobs. For instance, Boston apparently has had *no* jobs for female impersonators recently, nor has Philadelphia.

[13] There also women who perform as men: male impersonators ("drag butches"). They are a recognized part of the profession, but there are very few of them. I saw only one male impersonator perform during the field work, but heard of several others. The relative scarcity of male impersonation presents important theoretical problems.

Of course, known legitimate performers sometimes do drag in the movies and on TV but are not thought of as drag queens. During the vaudeville era, a number of legitimate performers could do drag, among other skills. See for instance Albert F. McLean, *American Vaudeville as Ritual* (Lexington: University of Kentucky Press, 1965). The development of a specialized and segregated profession of female impersonation may be a recent phenomenon, caused perhaps by the advent of mass media (from which female impersonators have been virtually excluded) and the growth of the homosexual community.

[14] It should be understood that by "women" I mean the signs and symbols, some obvious and some subtle, of the socially defined category in American culture. On the cross-cultural level, it is obvious that female impersonators look like American "women," not like Hopi "women" or Chinese peasant "women." What is not so obvious is the relationship *within* American culture between biology, concepts of biology ("nature"), and sex-role symbols. It seems self-evident that persons classified as "men" would have to create artificially the image of a "woman," but of course "women" create the image "artificially" too. Note that the only item listed that is intrinsically more "faked" for a male is the bosom. But what of padded bras? As of 1969, beads and long hair are no longer exclusively "feminine" symbols.

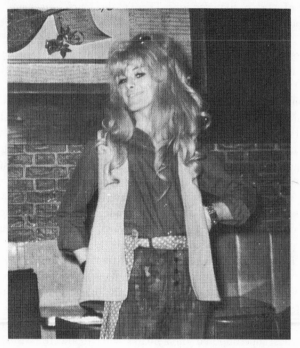

Mychelle Stevens

This form of specialization is thought by everyone, including its practitioners (the impersonators), to be extreme, bizarre, and morally questionable. Nevertheless, female impersonators describe their performances as "work"; impersonation is described as at least a "job," at best a "profession." The identity is of very great importance to impersonators. It marks them off from "freaks," "hustlers," the insane, and many other anomalous social types whose activities can in no way be incorporated into the legitimate order of things. It forms a tenuous but vital association with the glamorous forms of professional entertainment. Female impersonation may be "a left field of show business," as one drag queen told me, but left field is still in the ball park.

All female impersonators are thought to be members of the homosexual subculture or gay world. This was explained to me very succinctly by one impersonator in response to my question, "Are there any straight impersonators?" He replied, "In practice there may be a few, but in theory there can't be any. How could you do this work and not have something wrong with you?" Empirically, all impersonators whom I met or heard of had "come out" (identified themselves as homosexual, begun participation in the gay world)

*before* becoming impersonators; all participated actively in gay institutions and social networks, except for one very prominent man who was currently heterosexually married. (His public assertions of straight status annoyed and amused other impersonators.) But more than this, the work is defined as "queer" in itself. The assumption upon which both performers and audiences operate is that no one but a "queer" would want to perform as a woman. It is the nature of the performances rather than homosexuality per se that accounts for the *extreme* stigmatization of drag queens. Many actors, dancers, and artists are thought to be homosexual, yet they seem to be marginal and suspect rather than outcast. Female impersonators form an illegitimate junction of the homosexual and show business subcultures: they can be considered as performing *homosexuals* or homosexual *performers*. It is possible to get in drag "for a camp" (for fun, informally) and remain a respectable homosexual (to other homosexuals, that is). But to perform *professionally* (publicly) in women's clothing stigmatizes impersonators within the gay world. At the same time, to perform professionally in women's clothing stigmatizes them within the show business world.

Because of their special (stigmatized) relationship to the show business and homosexual subcultures, and of course because they all work together, female impersonators conceive of themselves as a group. Impersonators form loose social networks within and between American cities. News about jobs and the doings of friends in other cities is continually circulated by queens passing through or newly arrived. Although impersonators believe they share significant aspects of their life situation, particularly their homosexuality and the kind of work they do, antagonism and social distance indicate a split within the group. The split reflects fundamental issues in the status and direction of all American "minority groups." The same issues are crucial for the whole gay world, for the blacks, the "hip," women, and all those who are unrepresented politically and symbolically in America.

There are two different patterns of being a female impersonator. Each pattern consists of a characteristic presentation of self, life style, and attitudes toward basic life problems. I will distinguish the patterns by the terms "street" impersonators and "stage" impersonators. In terms of performances, street impersonators tend to do "record acts" and dancing, while stage impersonators tend to work "live." Live work is generally higher paid and is thought to demand more "talent," since it involved a verbal as well as visual impersonation. Record or pantomine artists mouth the words of a phonograph record as they perform. Sometimes an entire show will have only record artists, but often the same show will have both live and record, so that the two types of performers often work together. The dichotomy also correlates with age; most younger performers (under thirty) tend toward the street style, most older ones toward the stage style. During my field work, some performers in their late twenties were

attempting to switch to stage styles, but with limited success. It is possible that the age differential represents an historical change in the profession, a kind of downward mobility for the profession as a whole, rather than a life-cycle progression. Most older performers believed the former to be true.[15]

The two patterns may be seen as two orientations toward the problem of moral stigmatization. The street pattern is a *fusion* of the "street fairy" life with the profession of female impersonation. Street fairies are jobless young homosexual men who publicly epitomize the homosexual stereotype and are the underclass of the gay world. For street impersonators, the job is one element in a consistently alienated life style (which may be distinguished from the alienated *attitudes* of many Americans). Street impersonators are never off stage. As one stage impersonator told me, all they have to do to go to work is put on a wig. Their way of life is collective, illegal, and immediate (present oriented). Its central experiences are confrontation, prostitution, and drug "highs."

The stage pattern, on the other hand, *segregates* the stigma from the personal life by limiting it to the stage context as much as possible. The work is viewed as a profession with goals and standards rather than as a job. Stage impersonators are "individualistic," relatively "respectable," and often alcoholic. They refer contemptuously to street performers as "tacky street fairies." The latter retaliate with undercutting references to the common stigma: "Who does that phoney bitch think *she* is? She's as queer as the rest of us!"[16]

Nothing is more characteristic of the street impersonator than his public presentation of himself. Street fairies specialize in public, confrontational deviance. While respectable homosexuals and stage impersonators attempt to "pass" or at least draw a minimum of attention to themselves in public situations, street impersonators make themselves conspicuous. They tend to go places in groups, to use streets as gathering places rather than thoroughfares, and to flaunt an extremely "nellie" (effeminate) appearance and style of behavior:

It is early afternoon in Kansas City, very hot: Tiger and Billy showed up (at the hotel where I was staying) to take me out. Tiger was wearing cut-off blue jeans and a jersey top with narrow blue stripes.[17] He is about six feet tall, very skinny. His arms and legs are covered with red hair and freckles. The clothes are

[15] Roger Baker implies that the profession is undergoing a historical process of "degeneration" in both England and America. See his *Drag: A History of Female Impersonation on the Stage* (London: Triton Books, 1968) pp. 209–25.

[16] Female impersonators consistently use feminine pronouns of address and reference among themselves. This is a common, though not universal, gay practice.

[17] I have changed the names of impersonators throughout, although I have attempted to preserve their flavor. Impersonators almost always adopt stage names. These names tend to be ambiguous about sex-role identification. The original (male role) given names are used rarely or not at all in social situations. Quoted excerpts are from my field notes or interviews.

skin tight. On one pinky he wears a gold band which has left a residue of green on the first joint. He has on ladies' sandals, which are much used and falling apart. His face is pinched and thin, but mobile and expressive . . . an interesting face, much like the French mimes. Today he has done something which I have not seen him do before: he is wearing make-up. His eyes, which are smallish, green, and sad, are rimmed and smudged all around with a thick line of eye liner, and he has gobs of mascara on the lashes. He has carelessly drawn on eyebrows more or less over the place where his own are shaved off. All this is partially covered by large dark glasses which he nervously whips on and off when confronting a salesperson or a waitress, but they don't hide the make-up which he has splotched on his face and neck; it has been sweated off in places. His long red hair is combed up all over his head in an upsweep of curls. When Tiger walks, he sways (the walk referred to as "swishing" by homosexuals). His arms never hang "naturally" at his sides, but are held out from his body at rigid angles, with long thin hands projecting like plumes. We walk into a cheap department store; somebody whistles. Tiger turns, one hip hooked out, one arm extended, palm turned up, head thrown back at an angle. He declaims, in a loud stagey voice, "My, the peasants are restless today." A moment later he leans over toward me with an ironic smirk, pats his hair in place: "Should I go home and put more make-up on, or do you think I look fantastic enough already?"

Where Tiger is fantastic and aggressive, Billy is apologetic. He is twenty-one or younger, a slender boy with bleached long hair and pretty legs. His features are pleasing but nondescript. I have never seen him overtly hostile or aggressive. There is always a placating expression on his face. His mouth is small and slightly pouting. He has a quiet voice to which no one listens. He is always interrupted. Tiger sweeps him along like a dinghy behind a motor launch. Billy's arms and legs are shaved, but the bristle shows through already. He is pale and soft looking. He is wearing incredibly short shorts, cut-off white levis, very tight. "*Really,* Mary," Tiger smirks, "don't you think those shorts are a *bit* much?" We can't think of a place to go and eat where we won't risk being thrown out, much less stared at.

Finally I said to Tiger that I didn't understand why he had to ask for trouble on the street (I admit my nerves were pretty frayed by this time). He said he wasn't going to dress to please "those fools." "What should I do," he asked me sarcastically, "get a crew cut and buy a sweatshirt?"

Despite their appearance, street impersonators usually maintain social distance from the true street fairies as long as they hold a job. Since impersonators work at night, they do not "hang out" with the street fairies in the hustling bars or on the streets. When street fairies come to one of the clubs, impersonators (both stage and street) discourage them from coming backstage. In the restaurants in the club area where the impersonators often go after work, the working impersonators very rarely sit with street fairies or converse with them, even though they often know them by name:

I am sitting with a street impersonator, Tiger, in an all-night restaurant after work, about one-thirty or two o'clock in the morning. Sitting behind us were two groups: a foursome, one of whom was a drag butch, and another foursome, one of whom was a street fairy. This street fairy walked by us: "she" was wearing slacks I think, some kind of loose-flowing black top, earrings, "her" own hair ratted up and back with spit curls over each ear, and painted-on eyebrows . . . about twenty years old. Tiger made a face as this street fairy walked by, saying to me, "Do you see that queen? My God, and to think I used to look like that. I used to wear my own hair a foot over my head in an upsweep, and I was always rinsing and dyeing it." As the street fairy walked by us again "she" said hello to Tiger calling him by name, but shyly and deferentially. Tiger said "Hi" back, but very curtly, and made a face to me; he said he couldn't remember the tacky queen's name.

The street fairies seemed to be quite in awe of the impersonators, and treated them deferentially. They often told me that they had worked at some previous time, and implied that they were just out of work, or waiting to get a break into the business. Indeed, all but one of the Kansas City street impersonators had been street fairies before becoming impersonators. If they lost their jobs or quit, they had no place to go but back to the street. When stage impersonators talked about quitting, they said they wanted to "go legit." But when I asked a street performer what drag queens do when they are out of work, he said, "They get their butts out on the street, my dear, and they sell their little twats for whatever they can get for them."

When I returned to Kansas City after an absence of four months, two boys who had been street impersonators had lost their jobs and were indistinguishable from street fairies. Both had grown their own hair shoulder length,[18] were wearing make-up on the street, "passing" as girls in certain situations, "out of their minds on pills," and hustling full time. ("Hustling" means prostitution, also referred to as "turning tricks." This should be distinguished from "tricking," which means looking for a sex *partner* [not customer].) Both were socially integrated into street fairy groups. The stage impersonators, who had somewhat grudgingly accepted them as colleagues before, would no longer speak to them:

Tris barely speaks to Billy now. At the drag contest at the Red Sofa (a drag bar) on Halloween, he reportedly "cut Billy dead." When Billy protested, Tris said to him, "I don't even want to know you any more; you're nothing but a tramp." Billy told me he was very hurt by this. When I mentioned it to Tris, he said he would say the same thing again. He said, "Billy never was a female

[18]I am intensely curious about the fate of this subcultural trait since the advent of long hair for heterosexual "hippies" and radicals. In 1965–1966, "growing your own hair" ("like a girl") was a sure sign of final defiance of society's opinion. But even at that time, the queens were beginning to complain that "you can't tell boys from girls anymore," or "can't tell who's gay anymore."

impersonator and she's not even really a drag queen.[19] She's just a gutter fairy."
I asked if he said this because Billy hustled. He said certainly not, show him the
drag queen who hadn't ever hustled or tried to hustle. It was simply because
Billy had never gotten his own act. He had never improved beyond what he was
when I was last here (four months ago), just a pallid imitation of Godiva,
Ronnie, etc. That was his peak career and maybe it was a good thing he quit
then.

Tris said of the street fairies that they are pitiful, but he doesn't run a charity
service. He can't stand them, he says. Tris has shown resistance to my having
anything to do with them, and especially with Billy, presumably because Billy is
déclassé.

When I asked Tris about Godiva, who had also become a street fairy, he said,
"Now Godiva is somebody with talent. Godiva is a good example of somebody
who was beginning to really go the suicide route. She lost her job and, of course,
the street fairies were extremely cruel to her."

"Why?" I asked.

He said, "Because she was a fallen idol; she had lost her job and she wasn't
really a street fairy; she was a fallen female impersonator. And no one's as cruel
as street fairies. Then after a while it became all right; they stopped being cruel
to her because she turned into a decent street fairy. But now Godiva is smart,
and I'm glad you came, because you had some effect on this. She saw you
coming back into town, and you weren't going to interview her any more. She
wasn't a professional. So now she's picked herself up, thank God, and is going to
go off to Toledo and pull herself out of the mess that she was getting herself in
with this street fairy thing." [Godiva had a job offer in Toledo.]

As performers, the street impersonators tend to describe female imperson-
ation as a "job" rather than as a "profession." They do not make statements
about professional standards or pride, resist assuming responsibility, and view
the work instrumentally, that is, as a way of making money to live. Their stated
goal is usually to do as little "work" as possible for the greatest possible return.
Only fools and "suckers" put out, try hard. It was this unwillingness to put
out — not lack of talent, as the stage impersonators would have it — that was
stated by some street impersonators as the reason that they so often do the less
demanding record acts. As one boy put it to a stage impersonator who was
criticizing the record acts, "Records are boring, Mary, but it's the easiest thing
you can do."

On the stage, the street impersonators are sometimes openly contemptuous of
the audience. They tend to perform as if the stage were a dramatic encapsulation
of the street confrontations with the public. If they are not openly contemp-
tuous (and this they manage to convey either verbally or by the exaggerated

[19]The terms "female impersonator" and "drag queen" are sometimes distinguished to
make invidious comparisons. Only professionals are called the former, while any
homosexual in drag (including impersonators) can be called the latter.

indifference of their movements), they often seem wrapped in a trance-like state, never looking at the audience, and simply going through their routines. Street impersonators are oriented toward their friends backstage; they often speak to other performers during routines.

Off stage, the street pattern is to live in groups of three or more. Sometimes residential groups are made up entirely of impersonators, and sometimes they include one or two street fairies, female prostitutes, or male hustlers. The groups live in cheap hotels or in apartments in the immediate vicinity of the club. The apartments that I saw were sparsely and casually furnished. Street impersonators travel light. Conceptions of privacy and the nature of the boundary provided by the apartment contrast strongly with the notions of the middle classes. The apartments are not "homes." They are places to come in off the street, places to "hole up" during the day. "Husbands," "tricks," and numerous acquaintances from the street life come in and out constantly. (The word "trick" can be used to describe either a paying or nonpaying sex partner, as long as the relationship is brief and impersonal. Any friend who needs a place to rest, recover from a "high," or get a new one, can generally "fall by" and stay for a couple of hours or a couple of weeks.

Although the working queens are central to these social groups, the locations of the apartments and the personnel of the groups are anything but permanent. In Kansas City each of the street impersonators made about six moves in the course of one year:

*December 1965:* Tiger lives with Godiva and another queen, Lola, who is out of work and taking hormones – "becoming a woman," as they say. The apartment is a block from the club, large, but containing practically no furniture. They are supposed to move next week, and so far have done nothing about finding another place, which will be difficult in any case because Tiger says they won't move without Lola, who is not only Negro, but, as Tris said, "not the answer to racial equality." They have to move because they throw trash out on the back porch, have wild parties to which the police sometimes are uninvited guests, and Tiger called the landlord a cocksucker or some such thing. When I arrive (about three p.m.) Lola and Godiva are sleeping on a rumpled-up mattress on the floor in one of the back rooms.

Tiger and I go out and when we get back to the apartment, Lola is entertaining three very rough-looking young men . . . white. Lola is wearing a long black wig and a flowing nightgown. I retire to the back, as my presence is obviously making them uncomfortable. In the back, watching TV, is another rough-looking young man, who later turns out to be Tiger's boyfriend. Tiger tells me he doesn't know "those fools" with Lola. Later on a girl with long hair and a lot of make-up comes in with a bag of groceries. Tiger says she is a whore. As we leave, Tiger's boyfriend says he'll go down and shoot a little pool with the boys tonight.

*July, 1966:* Tiger has abruptly abandoned the "ordered" life. At some point he gave up his apartment and is living in a local cheap hotel with Bunny (another street

impersonator) and others (including a "hooker" — female whore — and a male hustler) [Male hustlers and street fairies both "turn tricks" but the former are "masculine" in appearance and are said to be "masculine" in sexual acts. They will not perform fellatio or receive anal intercourse.] Tiger came this morning to see me, and he looks half dead . . . lost a lot of weight, looks gray and sick. Also sustained a beating from a man in his hotel, who beat him up mainly because he hates queers (according to Tiger). Tiger was, as he said, "sick and sad," because he "never realized they [straights] hate us so much." It seems all the hotel personnel just stood around and watched the beating, and even acted like this man was some kind of hero. It seems doubtful that anything legal will be done, due to Tiger's state of disorganization, lack of position and money, and the club owner's satisfaction with nonrecurrence only (Tiger got the club owner to call up the hotel manager and complain). Because Tiger was afraid of the man at the hotel, he moved out with his group.

*November, 1966:* Tris says Tiger is worse than ever. Pills, the F.B.I., Vice squad, etc. are on his tail. This is confirmed by Jim, the bartender at the club, who says Tiger had been under suspicion of selling pills to others, especially to kids. (Tiger denied this, said he'd given them away, but never sold them). A while ago, Tris says, he was called in the middle of the night by the bonding agency to vouch for Tiger and another queen. There had been a bang-up fight at Tiger's place — the central issue was, had Queen X kicked in Tiger's TV, or had Tiger thrown the TV at Queen X? Tiger was evicted as a result, but the charges were dropped or something.

The effect of the residential groups, since they are usually made of two or more impersonators, is to fuse the work and home lives. Work and home are aspects of survival, of the maintenance of the collective deviant identity. Not only do the residential groups provide mutual moral and financial support in a world conceived to be universally hostile, but, as one stage impersonator who had gone through a street phase said, "Those [street] queens do not have a home face, but only a work face. By living together you surround yourself with your own image by surrounding yourself with other images."

While the group itself may be the major support of the deviant "image," another strong support is the drug "high." It appears that one of the major responsibilities of leaders in the street groups was the acquisition and distribution of pills. The pills, mainly seconal, benzedrine, and amphetamines, produce various emotional states favored by street groups. They say the pills keep you "stoned" or "out of it." The pills are consumed in huge quantities by many street impersonators, street fairies, and their allies in the street life; familiarity with their vernacular names and knowledge of their effects are standard subcultural knowledge.[20]

[20]See Hubert Selby, Jr., *Last Exit to Brooklyn* (New York: Grove Press, 1957) Part II, "The Queen Is Dead," for a fictionalized account of pills (among other things) in the street subculture.

Use of the pills and other drugs is frowned on by stage impersonators, and also by club owners and managers. The latter want the impersonators to drink alcohol, and do not want trouble with narcotics agents. Impersonators say that some club managers will not hire a queen who is known to be habitually stoned on pills. Pills are also said to interfere with performance ability. These pressures tend to keep down consumption among street impersonators, at least around the club.

Inability to moderate the use of pills or resumption of a full-time high seem often to signal or accompany a "fall" back to street fairy status. In contrast, keeping off the pills altogether signals attempts to "reform," that is, give up the street life and move to the stage pattern:

As Tris (a stage impersonator) and Jim (a bartender) and I were leaving the club last night to go to the car, Jean (a street impersonator) came out with a very scraggy-looking women whom Tris says Jean used to pimp for. Jean swayed over and announced, "I'm drunk." To my consternation, Tris said, "Good for you," and by way of approval and award asked Jean to go shopping with him next week. When I questioned Tris later, he explained that he was proud of Jean for being drunk instead of high on pills and dope. It is clear that in Tris's mind, alcoholism is much preferable to drug addiction (he is alcoholic). Tris claims that alcohol interferes less with performance, but there seems more to it. Tris fears and dislikes the unconventionality of drugs and the society of drugs, which at this level is comprised of hustlers, whores, and thieves.

A few months later, Jean went on another reform kick. He cut his hair, gave up pills, and most important, planned to move a couple of miles from the club to a house owned and occupied by a call girl and her small son. As Jean proudly explained to me, this girl "didn't turn any street tricks at all." He was quite aware that he would have to "get away from those crazy queens" (his street group) in order to carry out his planned reform, which included leading a more respectable, less flamboyant life, and eventually getting out of drag for legit show business. However, I heard subsequently that he lost his job for being stoned and had fallen back to street fairy status.

Finally, among the street impersonator groups, anarchy and violence are part of the way of life. Appointments are routinely broken, not only with me but with friends as well. Plans are rarely made for more than a day in advance. Long-term goals and commitments of any kind are avoided. Physical violence is commonplace, both within the groups and with outsiders. Impersonators know how to take (and even give) beatings. Street impersonators literally live outside the law, in the use of assault, in the distribution and consumption of drugs, in the nature of their sexual activities including the sale of sex, and often in their very physical appearance. But they do live within the *police* system. The impersonators are in continuous interaction with the local police, especially the vice squad. In the process, stable and fairly dependable mutual expectations have

developed. In Kansas City at least, the street impersonators and even the street fairies who have been in town long enough to "learn the ropes" are in a state of relative mutual cooperation with the police. It is the isolated vice and the new-in-town vice that are particularly vulnerable.[21]

The street life adds up to a group way of life dedicated to "staying out of it": out of the law, out of "normal" rational states of consciousness, and out of any "respectable" expectations, which the street groups attribute to "straights" and gay people who emulate straights, those "phony pink tea fairies." As a solution to the problems of interaction with the institutional order, the subculture represents collective withdrawal and alienation. Street groups make few distinctions between various respectable segments of society, for instance between working and middle class. From their perspective, all of respectable society seems square, distant, and hypocritical. From their "place" at the very bottom of the moral and status structure, they are in a strategic position to experience the numerous discrepancies between the ideals of American culture and the realities.

Stage impersonators contrast most strikingly with street impersonators in their public presentations of themselves (to employ Goffman's useful concept). How should a morally degraded person handle himself in public? As one very experienced stage impersonator said, "The smart whore does not run with other whores." In interviews, stage impersonators *all* insisted on two points: first, that off stage, they restrict their contacts with other impersonators, and second, that in public places they attempt to "pass" as "normal" or at least appear as inconspicuous as possible. Direct observations confirmed both assertions. While street impersonators are androgynous, dramatic, and highly "visible" off stage, stage impersonators tend to look like bland, colorless men. Compare the following description of a very high status impersonator with those of street impersonators and their apartments:

Dodie Turner lives in the East Seventies (New York City) in a one-bedroom apartment, apparently alone except for an old dog. The address and the place are not posh, but quite respectable, and on the fringes of a fashionable area. Even so, at the end of the interview he apologized for the place, saying he realized that perhaps it didn't seem grand enough for someone in his position, but it was really like a stopping place or a hotel, since he traveled so much. The place was very neat and in good taste. As Dodie later said, nothing about the place proclaims his profession. His taste is not "campy." He displays no pictures of himself, either in drag or out.

Dodie himself seems about forty, but is probably a little older. He looks extremely well-scrubbed and neat, and has a healthy tan. His hair is brown, of

[21]This may not be so true in other cities. Kansas City is said to be a "good town for queens" in this matter. In Chicago, understandings with the police broke down when a local Mafia "big shot" was assassinated.

medium length (not over the ears), and well cut. His features are sharp and his expression is shrewd. He has his eyebrows (many impersonators shave their eyebrows off). The day I saw him, he wore a freshly pressed sport shirt, black trousers, men's house slippers. He had a medal of some kind around his neck, and a rather heavy watch or I.D. I noticed that his legs weren't shaved. He is physically on the small side, perhaps five feet eight inches tall, slender, and well kept. Everything contributes to the impression of a well cared-for, rather orderly life, and a respectable presentation to public and maybe even friends. His gayness shows in his high pitched, rather stagey voice, the use of subdued but recognizably gay intonation, and slightly fluttery hand movements.

Here is a description of another high status impersonator as he seemed to me when I interviewed him:

The apartment is in Manhattan, but in the theatre district, nowhere near where the impersonator works. I was asked for dinner as well as an interview. I was ushered into the apartment by Bo Sutter, and I had to control my surprise at his appearance out of drag. This has happened with all the queens, but his was the most startling case. Bo out of drag is a rather ordinary looking person. He looks just completely different. He is short, maybe five feet six inches tall, and *very* fat, almost obese. He wears no make-up, although he has almost no eyebrows. However, he has the kind of face on which this looks fairly natural. He is white, probably in his forties. His nails are short. There is nothing about him that indicates his profession, His hair is short, brown, curly. He looks like a smallish bulldog, but the face is alert, the eyes blue and intelligent; throughout the evening I constantly had the impression of an extremely bright, quick person, of a mind that was scrutinizing me, at least as well as I could analyze it. He speaks well, has a rich voice, well articulated speech, and assumes various accents and intonations at will. This is what "gives him away" -- a certain flamboyancy, a very conscious affectation.

A third impersonator had no national reputation but was often described, by gay people, as "the most popular [drag] queen in Chicago." This man was particularly interesting because unlike most stage impersonators he worked to records and to a gay audience. In fact, the interview showed that he hardly knew any heterosexual people. He was a very distinctive and colorful performer, given to flamboyant impersonations of Mae West and Sophie Tucker. He was always introduced on stage as "Wanda, that dirty old lady!"

I first met Wanda off stage in one of the Chicago drag bars. He was sitting at the far end of the bar with several young and attractive men standing around him. He was very drunk. I was shocked at his appearance out of drag. In fact, I probably had seen him out of drag at the bar where he works (between sets) and not recognized him. Wanda out of drag seemed a non-entity. Completely colorless, pudgy, balding fast, wearing baggy pants and a mouse colored, ill-fitting shirt. He looked about forty-five years old.

Stage impersonators tend to live farther away from clubs than street impersonators, and they almost always live alone. In this, as in much else, stage impersonators act on basically middle-class conceptions of appropriate living arrangements. On the other hand, when Tiger, a street impersonator, lived alone briefly, he complained of loneliness and boredom.

Stage impersonators are quite concerned with "professionalism" and can be articulate about the history of impersonation (most know about drag in the old vaudeville days), goals and standards of performance, and subtleties of relating to various types of audiences. They sometimes display minute knowledge of the personal and special expertise of the show business world, particularly pertaining to the nightclub business and legitimate theatre. They stress whatever personal contact they have had with "stars." At the same time, they express nothing but contempt for queens who refuse to segregate their activities into clearly defined work and private domains:[22]

**Esther Newton**:   Why, by the way, don't you like "drag queen?" You prefer the term "female impersonator?"

**Informant**:   To me I think "drag queen" is sort of like a street fairy puttin' a dress on. Tryin' to impress somebody, but "female impersonator" sounds more professional.

**EN**:   What about . . . let's start from scratch. What is a "street fairy?"

**I**:   It's a little painted queen that wants to run around with make-up on in the street and have long hair, and everything, to draw attention.

**EN**:   These are . . .

**I** (interrupting):   They would put a dress on at a minute's notice and get up there and make a fool of theirself.

**EN**:   I want you to make a distinction between street fairies and people who are professional. What's the difference?

**I**:   (long pause) Well, in the first place, when I put my make-up on, I am putting it on for a reason. I *never* wear make-up out on the street, because I don't think anyone needs a neon sign telling what they are! These little street fairies evidently can't get enough attention, so they use this make-up, pile their hair up, and all this, just to draw attention. (His tone is vehement, contemptuous.) *I* have my attention when I'm on stage; they have to have it by looking absolutely ridiculous.

**EN**:   Could a street fairy become a professional?

**I**:   Probably . . . there have been. Maybe some of the kids that are in the profession now were street fairies at one time. But I never did like make-up out on the street. To me it always stands out like a sore thumb; you can always tell . . . (hesitates) when a fella's got make-up on.

[22]Whenever interview material is quoted "EN" refers to myself and "I" refers to the informant.

Another stage man expressed the desire for respectability and social acceptance:

You get respect when you deserve respect. Look at these nellie queens going down the street with make-up and carrying on! How can you respect them? You can do anything in this life if you do it with discretion . . . . I was good to the kids in [a large traveling drag show], but I never ran with the pack. I didn't go out to eat with them after the show, or run around in bars. I went to nice places, and I went out with girls. And I get respect. You have to live in society, whether you like it or not. And sometimes when you advertise your business, you're out of business pretty quick.

The extreme sensitivity of stage impersonators to public recognition and stigmatization leads to the development of baroque systems of personal and territorial avoidance:

I don't . . . there's a lot of types of queens that I don't dig, I don't like, I don't associate with. For instance, I would not go out or be seen with Misty [a street impersonator]. Not because she's Negro, because that doesn't faze me at all. I'd be seen anywhere with Toni [also a Negro impersonator, but respectable. This statement was true, and not a cover for racial prejudice.] I would be seen anywhere with a lot of queens in the business. But there are some queens I wouldn't step outside with. Uh, out of the neighborhood, I mean [the area of the clubs, which was defined as gay, therefore somewhat safe from the public]. I might be seen in the Coffee Cup [a local restaurant which is gay at night] with them, but even then, in some cases I'm embarrassed. Because I don't act like a queen on the streets. Even though I work in drag. And I don't see any reason why anyone should. If I want to wear a sign, *I'll* wear it. Don't . . . you're not going to wear it for me. That how I feel about gay life. I think what you do in bed is your business; what you do on the street is everybody's business.

Not only does avoidance of nellie behavior and associates enable one to avoid public identification as a deviant; the segregation of symbols into work/home, public/private domains has profound implications. The essence of the stage impersonators' solution to the stigma involved in female impersonation is the limitation of drag – the symbol of feminine identification and homosexuality – to the stage context. For if drag is work or a profession, a man might take some pride in doing it well; if it is work, it is not home, it is not where a man "lives" in the deepest sense; if it is work, a man could always quit.

In contrast, the street impersonators' way of life defies the established institutions and "normal" people. The street life is by definition antiestablishment; the street queen who becomes respectable will no longer be a street queen. I was not surprised to see that the first collective homosexual revolt in history, the "battle of the Stonewall" (named after a gay bar in Greenwich

Village, New York, where gay people fought the police for several nights after the police attempted to close the bar) was instigated by street fairies.[23] Street fairies have nothing to lose.

[23]During 1965-1966 I rarely heard talk of collective defiance of straight society, although in San Francisco, the Mattachine Society and S.I.R. (Society for Individual Rights) were pushing for "minority rights" and an alliance with Negroes and Mexican-Americans. In general, though, the potential for collective action to *change* society was latent. Most gay people attempted to accommodate in one way or another. One night I heard a drag queen say to a middle-class gay audience, "Let's all get naked in a big black car and go beat up some straight people!" There were laughter and wild cheering, but nobody moved. For the Stonewall story, see *The New York Times,* 27 June 1969, and subsequent issues.

# The "Queens"

Female impersonators are both performing homosexuals and homosexual performers. The juxtaposition of the nouns indicates that whether one considers impersonators in the context of show business or in the context of the homosexual subculture, the reverse qualifying adjective will apply. In whatever order one chooses to emphasize them, the two terms of the equation cannot be separated. The first chapter was about drag queens as performers and professionals. This chapter describes certain features of their homosexual world.

Female impersonators are an integral part of the homosexual subculture, and yet collectively they are a separate group within it. Many of the most distinctive characteristics and problems of female impersonators as a group spring from their membership in the homosexual subculture on the one hand, and their special relationship to it on the other.

Homosexuals, like many other American social groups, do not constitute a traditional "community." The concept is useful though, because it clearly contrasts with the notion that homosexuals are simply a category of deviant people. As Kinsey has pointed out, the general public and many so-called scholarly writers tend to classify as homosexual anyone who has had *any* homosexual experience, and as heterosexual only those who have had *no* homosexual experience.[1] Since the publication of the Kinsey statistics on the frequency of homosexual occurrence in the American male (1948), even some optimistic homosexuals have used the "one out of six" statistic as a

[1] Alfred Kinsey, *et al. Sexual Behavior in the Human Female* (Philadelphia; Saunders, 1953) p. 469. The similarity here to American folk racial classification, whereby any person who is "Negro" to the slightest degree is Black, and only "pure" whites are White is not coincidental. The "badness" of a stigma can often be judged from its power of contamination.

population base for the number of homosexuals in this country. While the use of this figure as part of ideology may in future change social reality, it does not represent social reality now, nor in practice do homosexuals identify themselves and their group by means of Kinsey's definition.

Not all self-defined homosexuals belong to the homosexual community, however. The community is an on-going social reality in, around, and against which people align themselves according to their own self-definitions. Many kinds and degrees of participation in the community are possible and available, and people move in and out of various statuses at different times in their lives.

The community centers around formal voluntary associations (Mattachine Society, Daughters of Bilitis, etc.), informal institutions (bars, baths, parks) and most of all, informal social groups, such as those described by Sonenschein and by Leznoff and Westley, which have their most characteristic expression in parties and living arrangements.[2]

All of these institutions and groupings collectively are called "the gay world," and participation in them is termed "gay life." The separation of the gay world and its inclusiveness as a mode of existence were much emphasized by my informants who stated that it was a "walk of life"; that one is not a "homosexual" but that one "lives homosexuality."[3]

In Kansas City and Chicago, both overt and covert homosexuals were found to "live homosexuality."[4] The overts live their *entire* lives within the context of the community; the coverts live their entire *nonworking* lives within it. That is, the coverts are "straight" during working hours, but most social activities are conducted with and with reference to other homosexuals. These overts and coverts together form the core of the homosexual community. They may constitute approximately 3 percent of the American population and are located almost exclusively in large- and medium-sized urban centers.

Homosexual *communities* are entirely urban and suburban phenomena.[5] They depend on the anonymity and segmentation of metropolitan life. Potential recruits to "gay life" migrate to cities so much so that in San Francisco the

[2] David Sonenschein, "A Typology of Homosexual Relationships" (unpublished manuscript, 1966) and "The Ethnography of Male Homosexual Relationships," (Paper read at the meetings of the Central States Anthropological Society, Chicago, Illinois, 1967). Maurice Leznoff and W. A. Westley, "The Homosexual Community," *Social Problems* 3 (1956): 257-63,

[3] Gay life is rather like the early Christian Church: it exists wherever and whenever two gay people gather together.

[4] The overt-covert dichotomy was made by Leznoff and Westley (ibid.). They found a strong correlation of covertness with high occupational status. Gay people recognize this correlation. Homosexuals who participate in gay life with extreme discretion are sometimes referred to as "closet queens" meaning that they are hiding. Readers of "Come Out!" the newspaper of the radical Gay Liberation Front in New York are urged to "come out of the closet."

[5] Places such as Fire Island's Cherry Grove are not part of rural social systems, but are isolated vacation extensions of metropolitan culture.

Mattachine Society describes the in-migration of young homosexuals as a major "social problem," especially for the central city.[6] In the cities, the hard core (that is, the most active participants) of the homosexual community tend to favor special residential areas, and these areas become focal orientation points even for the many members who do not live there. The homosexual inhabitants of these areas of great concentration generally give the area a name such as "fairy heights," or "lesbian row." In a large city there will be several such concentrations differing in rental prices and social status. For instance, in Chicago the middle-class residential core is in Oldtown and environs, the working-class core is on the West Side, and the lower class in the near and far North Sides.[7]

A similar breakdown for New York City might be: upper and middle class: East Sixties to Eighties and Brooklyn Heights; middle and lower class: Greenwich Village; lower class: West Seventies, Times Square area, lower East Side. Bars are usually located in or near these cores. The residential cores, while they are geographical focal points, do not circumscribe or confine the homosexual community of any city. Not only do people move in and out of these cores, change cores, and so on, but the social network extends to people who live in every part of the city (including the suburbs and even exurbs), people who live with their parents, people who are stationed at nearby army bases, and so on.

The principal mode of communication between homosexual communities is through individual mobility, although lately guidebooks of homosexual bars and institutions, the printed matter of the homosexual organizations, as well as homosexual fiction have augmented social networks. Homosexuals boast that they can be quickly "at home" in any city in the world. It is not unusual to see groups of German, English, and French homosexuals on the "gay" beaches adjacent to residential cores in Chicago, and the homosexual community in New York City especially is probably extremely cosmopolitan.

All people who define themselves as "gay" are placing themselves with other homosexuals as opposed to heterosexuals. However, this by no means implies that homosexuals are united, or that they are prepared to act in unison on any issue whatsoever, be it moral, political, religious, or economic. Indeed, the *only* thing they *all* share is the name itself, together with the agreement that they are deviant. Although one can discern the beginnings of a homosexual movement, the fragmenting differences between homosexuals still outweigh any potential solidarity.[8]

---

[6] Rechy's semifictional account, *City of Night* (New York: Grove Press, 1963) describes the situation of these young men.

[7] This does not include the specifically Negro cores, which are located in Hyde Park and probably in the ghetto.

[8] I do not mean to underestimate the emotional and symbolic power of the category. As

Some homosexuals consider themselves essentially normal members of society, deviating *only* in the choice of a sexual partner, a deviance that they conceptually minimize. At the other extreme, some homosexuals see themselves as *completely* outside conventional society. Those who minimize their deviance are likely to reject most contact with the gay world. They may live quietly with a lover who is passed off to the straight friends as a roommate. An alternate style is to live socially in the straight world with a wife and family, refuse all gay social contacts, and participate in the gay world by anonymous sexual contacts in public toilets. These people are connected with, but marginal to, the homosexual community. At the other extreme, many homosexuals organize their entire lives, including their working lives, around the self-definition and the deviance. They are, in the fullest sense, what Lemert has called "secondary deviants":

Secondary deviation refers to a special class of socially defined responses which people make to problems created by the societal reaction to their deviance. These problems are essentially moral problems which revolve around stigmatization, punishments, segregation, and social control. Their general effect is to differentiate the symbolic and interactional environment to which the person responds, so that early or adult socialization is categorically affected. They become central facts of existence for those experiencing them, altering psychic structure, producing specialized organization of social roles and self-regarding attitudes. Actions which have these roles and self attitudes as their referents make up secondary deviance. The secondary deviant, as opposed to his actions, is a person whose life and identify are organized around the facts of deviance.[9]

Even people who consider themselves fully part of the homosexual community, or "in" gay life, are internally subdivided in ways that profoundly affect their identities and patterns of social interactions. The two most fundamental divisions are the overt-covert distinction and the male-female gender division.

Overt-covert distinctions correlate to some extent with social class, but by no means invariably. I met a number of homosexuals who were construction and factory workers, sailors, waiters, and so on, who were just as covert as people working in upper status jobs. Covert means only that one cannot be publicly identified by the straight world and its representatives, such as bosses,

---

a perception of commonality, it overrides *in the first instance*, distinctions of race, sex, class, generation, and even nationality. Homosexuals are much closer to constituting a political force today than they were in 1968. The younger generation of homosexuals have been politicized and are pushing for political unity within the framework of radical politics.

[9]Edwin Lemert, "The Concept of Secondary Deviation," in *Human Deviance, Social Problems and Social Control* (2d ed.) (Englewood Cliffs, N.J.: Prentice-Hall, 1972), p. 73.

co-workers, family, landladies, teachers, and the man on the street. One hides, or attempts to hide, one's homosexual identity *from straight people*. In Goffman's terminology, one attempts to manage one's discreditability through control of personal front and restriction of information about one's personal life.[10]

The desire to avoid "guilt by association" on the part of covert homosexuals causes the most fundamental division in homosexual social life. But it must not be seen as a fixed principle that categorically places individuals on one side of the fence or the other. Rather it is a dynamic principle, one that continually causes tension and the redrawing of social lines. Of course, at the extremes there are individuals who are loud, aggressive, and declarative about their homosexuality at almost all times and in an immediately recognizable manner, and at the other pole, those whose behavior almost never incriminates them and whose sexual and social lives are a closed book. But the great majority fall somewhere in between; any given person's "obviousness" is largely relative and situational. Joe may feel that John is "too obvious" to be seen with publicly, while Bill may not feel that John is "too obvious" at all. Furthermore, if John himself feels that he is not "obvious," he will bitterly resent Joe's avoidance. The resentment will be compounded because the avoidance contains an accusation. If I belong to a secret society and a member is threatening to give out knowledge of his and my membership, he is guilty of disloyalty or indiscretion. But the overt homosexual is accused of a more degrading crime, that of being "too nellie," that is roughly, "too effeminate," or in the lesbian case, "too butch," "too masculine." In effect, I will not associate with you because you are too stigmatized. I saw this principle in action again and again:

1.   Jane is furious with Judy because Judy said hello to her on the street when she was walking with a straight couple. Jane says, "Judy is too butch-looking. My straight friends said, 'How do you know *her?*' and I had to make up a big story. Judy should have known better than that. I told her never to recognize me on the street unless I was alone." But Jane often goes to the opera with Judy.

2.   Gus is very fond of Tim personally, and has used his influence as leader of a respectable group to get Tim invited to parties where Tim is appreciated as a clown. However, Gus considers Tim "too nellie" to be seen with publicly. One of Gus's friends relates to me with great relish how Tim once approached Gus on Wells Street and walked down the whole length of it with him. The friend says that Gus was squirming and looking down at the sidewalk out of embarrassment,

[10]Irving Goffman, *Stigma* (Englewood Cliffs, N.J.: Prentice-Hall, Inc., 1963). A number of politically militant homosexuals are now overt as a matter of principle, that is, they wear homosexual lapel buttons and/or verbally announce their homosexuality publicly. It is of interest that many of these people are not overt in the older sense; they don't look or act like homosexuals.

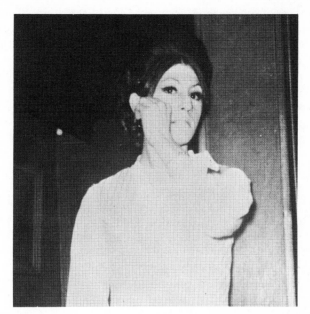

Linda Hardy

but didn't have the heart to snub Tim completely. The friend says this shows how much Gus really likes Tim, because Gus is usually the soul of discretion and carefulness, and looks out only for himself.

The point here is that overtness is not in fact a fixed quality that invariably divides the sheep from the goats, but is rather a continuum, and that people vary a great deal as to how they fall on it situationally, and relative to comparison with others. However, there are groups that are consistently placed near one pole or the other. This may be viewed as a hierarchy of stigmatization, or "obviousness." Any particular group will tend to draw the line just below itself. For instance, female impersonators are considered by most homosexuals to be too overt. They are consistently placed on the low end of the continuum of stigmatization, and one of the first things that female impersonators must learn is not to recognize anyone on the street or in any other public place unless they are recognized first. Yet female impersonators who believe themselves to be less overt try to avoid public association with female impersonators whom they consider "too obvious," and very few female impersonators will associate publicly with "street fairies," boys who wear make-up on the street, because "there's no point in wearing a sign. I believe I can pass." Those on the low end resent those above them.

The question of the gender division among homosexuals could be the subject of another book. The questions of political, normative, social, and ideological relations between homosexual men and homosexual women are debated by both. Although the men are in the majority and set the overall tone of "gay life," the women are an integral part of the scene. It is said that the degree to which the men and women socialize with each other varies from city to city. It certainly does from group to group within any one city, such as Chicago. For instance, two groups of middle-class "respectables," one male and the other female, center their bar life in an Oldtown bar that caters about equally to men and women. In this bar the men and women mingle and socialize freely, sit at the same tables, dance together, and so on. Many small and all large parties and social events sponsored by members of each group are integrated, so much so that both men and women belonging to each group speak of themselves sometimes collectively as "the Oldtown crowd." Male and female members of the Oldtown crowd very frequently go out to restaurants, the opera, symphonies, antique shows, and office parties in pairs or foursomes. Not only are personal friendships formed, but members approve of this policy in principle, saying that it makes good "cover." However, another group of lower middle-class girls who form the membership of the Daughters of Bilitis (a lesbian organization) apparently associate with men very little, although they have some personal links with women in the "Oldtown crowd."

Numerically, most homosexual bars in Chicago are exclusively or largely male, and females are not welcomed. Two bars are mostly female, although men are tolerated. At all status levels, a person's greatest interaction and allegiance is with his or her same sex group, but a complex social network exists between the sex groups. There is, however, a great deal of latent tension which can always be mobilized. This is nicely reflected in linguistic usage. When a person wants to emphasize solidarity between the sex groups, he (or she) refers to the opposites as "the gay boys (guys)," conversely "the gay girls," and all collectively as "the gay kids"[11] or "gay people." When he (or she) wants to emphasize differences, usually with a negative tone, he refers to the opposites as "faggots" or conversely, "dykes" or "lesbians." Male homosexual informants who do not like women consistently use "gay kids" or "homosexuals" to refer *only* to men and use the term "lesbian" to refer to women. At the extreme, some individuals completely repudiate commonality with homosexual women:

EN:   Why don't you like X (a lesbian)?
I:    Because I don't like women, (or worse) "broads," (or even worse) "fish."

[11] The widespread use of these juvenile nouns among homosexuals is certainly significant.

The ratio of male to female homosexuals has been debated in the literature and among homosexuals themselves. Whatever the ratio may be between those of each sex who have engaged in homosexual *acts* or even who *define themselves* as homosexuals, there can be no doubt that men far outnumber the women *in gay life*. My impression over a two-year period was that men outnumber women by a ratio of at least four to one. The males considered as a group, have a much more elaborate subculture and contribute disproportionately to distinctively homosexual concepts, styles, and terminology. Although the women distinguish among themselves in roughly the way the men do as to over-covert, masculine-feminine, race, age, and social class, they are not as intricately subdivided along one dimension: specialized subtype of sexual deviance. There are no feminine counterparts of the male S-M queens, T-room queens, chicken queens, park queens, brownie queens, butch hustlers, dinge queens, hormone queens, and so on.[12] This difference surely reflects the more restrictive conception and expression of sexuality that lesbians share with heterosexual women.[13]

Of course age, race, and social class distinctions are important in the homosexual community. Age sets are much more apparent among the men than the women. The men place an extreme value on youth. A person of thirty is considered old. Men over forty are seen as desexualized and are often referred to as "aunties." Aging is seen as a paramount and agonizing life problem. There is a definite tendency for primary and reference groups to be of similar age. The segregation is roughly by decades: "chickens" under twenty; the "young crowd," twenties; the older crowd, thirties; and "aunties," forty and over.

In Chicago, racial segregation among homosexuals is not enforced. There is a good deal of segregation based on residence, that is, there is said to be a distinct homosexual subcommunity in the Black ghetto. It is apparently easy, however, for individual Negroes to cross this line and frequent bars, parties, and so on, in white residential areas; at least many of them do so. In Hyde Park, a residentially

[12]The noun "queen," denoting male homosexual (and connoting much more), admits of numerous imaginative modifiers. Many of these modifiers refer to sexual practices: S-M = sado-masochist sex; T-room = toilet (public) sex; chicken = young boy, therefore, chicken queen = likes sex with young boys; park queen = likes sex in parks; brownie queen = desires sexual intercourse through his anus; dinge queen = likes sex with Negroes; hormone queen = someone who takes female hormone shots or pills.

Some of these terms, such as S-M queens and butch hustlers (male prostitutes who are masculine, as opposed to nellie hustlers) denote whole social subgroups, that is, a social commonality and distinct social roles have been built up around the common sexual role or interest. Other terms denote individual sexual preference, may have moral and value overtones, but do not provide the basis for distinct social roles or groupings, e.g., dinge queens, brownie queens. The few equivalent feminine distinctions are in this category, e.g., muff-diver = likes to perform cunnilingus.

[13]William Simon and John Gagnon, "The Lesbians: A Preliminary Overview" (Unpublished manuscript, 1967).

integrated area, the homosexual social groups of both men and women are integrated, as is the one gay bar. While I heard disparaging remarks about homosexuals who preferred Negro sex partners (dinge queens), social discrimination against Negroes is generally discouraged: "We can't afford that," or "We should know better," were typical replies to my questions about racial prejudice. In Kansas City, on the other hand, I seldom met a black homosexual, and I assume that they tend to be confined to the ghetto.

Finally, social class distinctions are important. As in the heterosexual world, one of the most important methods of "placing" any given individual, of hooking him into his place in the social structure, in his work. For instance, people with upper-status professions tend not to associate with minor clerical workers, who in turn tend not to associate with menial laborers.

That is to say, a person's social status is primarily based on his supposed or demonstrated social class membership in the straight world. This makes sense because gay life is not based on productive relationships: it has an economics but no economy. Strictly speaking, the gay world has no class system. Nevertheless, gay life has recognizable social strata that are accorded differential value. People speak about "high-class," "middle-class," and "low-class" bars, parties, clothes, and people. Social status is seen in the usual American way as personal attributes or life style, and the money that supports it.

Two differences in addition to the lack of an economy are worth noting. Both operate to telescope social class distinctions, particularly within the three major classes. Homosexuals are drawn from the full range of American social classes, but there are not enough homosexuals to recreate the whole complexity of the American system. So, for instance, while in the straight world the difference between a college professor and a high school teacher might seem major, in the male homosexual world it is relatively unimportant, and the two men might be in the same primary group. Second, there are no families in the gay world, and there is no class of persons classified as noncompeting sexual objects (women). This makes for much less stability (or rigidity) in the social structure. My impression is that social networks more often extend across barriers that would be formidable in the straight world.

Homosexuals who belong to professions that include a relatively large number of homosexuals tend to form subgroups built on common membership in the profession. In Chicago there are whole occupational groups that are considered part of the gay world, such as the "hairburners" (hairdressers), the "window dressers," and subgroups built on some professional institution or business: "the Art Institute crowd," the "Marshall Field crowd," the "theatre crowd." These are exceptions, however. Most job-based and professional groups are explicitly or implicitly heterosexual, and the individual homosexual passes or accommodates as best he can. The other kind of exception is found among certain highly

sophisticated urban occupational groups whose occupations form subcultures of their own, and where the members do not care about each other's sexual preferences: the art world, the theatre world, the fashion world, where homosexuals may sometimes participate openly *as* homosexuals.

The structure of the gay world is closely related to its flavor, quality, or style, which is nearly as distinctive as that of urban Negroes, and probably now more distinctive than that of urban Jews. To talk about homosexual style, it is necessary to bear in mind the broad distinctions among lower-, middle-, and upper-status homosexuals. These groups are different because their members are drawn from the lower, middle, and upper classes of heterosexual society. But they are also different because they each have distinctive life problems as homosexuals. Another way of looking at this is to say that the kinds of problems that are posed by being homosexual vary with social class.

Distinctive homosexual styles issue principally from the upper- and lower-status groups. The "uppers" seem to be composed mainly of men (and women) in the arts and related fields, including both commercial arts (acting, photography, advertising, fashion, etc.) and noncommercial or "pure" arts (painting, dancing, etc.) The uppers are in direct or indirect contact with the wealthy and sophisticated segments of the straight world, i.e., the upper and upper-middle classes; these gay uppers are the artistic and taste specialists for the rich. As a consequence, the rich, the sophisticated, and the cultural leaders are heavily influenced by the taste and ideas of the uppers, who in turn are themselves influenced. There is probably a lot of overlap; some homosexual uppers seem to be people from straight upper-class backgrounds who have become artists. The taste and style of the homosexual uppers is strenuously imitated by the middle- and to some extent lower-status groups. This is possible because social networks and interpersonal contacts are much more fluid than in the straight world. Another factor probably is the widespread belief that homosexuals are especially sensitive to matters of aesthetics and refinement. I know a good many homosexuals who admit that they knew nothing about "culture" until they became involved in the gay world, where such knowledge is valued and "pushed." A very widespread characteristic of the homosexual community is attempted assumption of upper patterns of speech, taste, dress, and furnishings – patterns that are not at all commensurate with income or status, as this is generally understood in the heterosexual world. It is found most intensely in the essentially lower-middle-class young men who were referred to by my informants as "ribbon clerks," those who were "paying for their Brooks Brothers suit on time."

At the other extreme are the low-status homosexuals who are socially avoided and morally despised by the middles and uppers, but who, in their flamboyant stylization and distinctive adaptations to extreme alienation, rival and even

surpass the uppers. This applies especially to the low-status queens, who represent a role model of extraordinary coherence and power.[14]

While many of the lowers and uppers may be openly homosexual, the distinctive characteristic of the middles is the necessity to hide, to live a double life.[15] This limits their development of a public style.[16] Their private style, however, resembles the more open and expressive styles developed by the uppers and lowers. The common concern of the middles as a group is secrecy, recognition, and the conscious manipulation of roles that will allow them to maintain two quite separate and conflicting life spheres. Individuals in the middle-status group form the backbone of the homosexual audience for female impersonators. In the female impersonator show, the covert homosexual can see the homosexual identity acted out openly, and this he evidently regards with mixed proportions of disapproval, envy, and delight.

## THE DEVIANT CAREER

Many studies of homosexuals and other communal deviants, such as prostitutes and criminals, have discussed the etiology of the individual deviant, but very few have attempted to describe or understand what happens to the deviant once he has joined the community of his peers. The social structure of the homosexual community can be described from the point of view of the individual as being what Merton calls a status-sequence:

Considered as changing in the course of time, the succession of statuses occurring with sufficient frequency as to be socially patterned will be designated as a *status-sequence*, as in the case, for example, of the statuses successively

---

[14]The "queen" is the central homosexual role at every level, but has somewhat different content in each. Lower-status queens have been intensively fictionalized. See, for instance, "The Queen Is Dead" (Selby 1957:23-81) and "Miss Destiny: The Fabulous Wedding" (Rechy 1963:102-29). A good comparison can be made with Genet's French queens, especially "Devine" in *Our Lady of the Flowers* (1963).

[15]There are probably many men who are uppers in respect to power and money whose need to hide is greater than that of the middles, in that they have more to lose. The case of Roy Jenkins during the Johnson administration shows that uppers who do need to hide may not participate, except very marginally, in the homosexual subculture. Ironically, this marginal participation is the most degrading and dangerous, from the point of view of capture by the police, blackmail, and so on.

[16]Interestingly enough, even the public style of confessed middle-status homosexuals, such as the leaders of Mattachine Society, is very subdued and "straight." This may be because these organizations represent the middle-status respectables who want to make the "straights" believe that homosexuals differ from them only in the matter of sexual preference. To do this, they have to contradict the heterosexual perception (represented in stereotypical thinking) that homosexuals look and act very differently from straights.

occupied by a medical student, intern, resident, and independent medical practitioner.[17]

A related concept is that of the "deviant career" that postulates a culturally patterned status-sequence for individual deviants within the deviant community.[18] Of course, status-sequences within the homosexual community are much more flexible and open to variation that those in Merton's institutionalized and formalized example above, as are all noninstitutionalized "career" patterns.

The status of female impersonator has two fundamental and inseparable parts, show business and homosexuality. Just as "blues singer" is a status in the context of Black culture,[19] "female impersonator" is a status in the context of the gay world. This is simply to say that becoming a female impersonator is a status choice in the deviant career of the homosexual in the homosexual community, or that the status is one of those offered by the community. Every informant I questioned had entered the homosexual community and become in Lemert's terms, a "secondary deviant," that is, one whose identity is based on deviance, before becoming a female impersonator. I never heard of one for whom the status-sequence was reversed, who became a female impersonator and then a homosexual. This is not to deny that some female impersonators hold show business jobs before becoming impersonators, and in this sense the status can be seen as part of a show business career. But the peculiar skills involved in being a female impersonator were learned in the gay world, not in show business.

The first stage in the process of becoming a female impersonator is, therefore, the recognition of oneself as homosexual and entry into the homosexual community. Unfortunately, I wasn't able to get much detail about this part of the informants' past; the impersonators preferred not to talk about it. I had the general impression that for most this had been an intensely painful experience that they wanted to forget. No matter how hard I tried to make clear that my questions were not psychological, they were interpreted and resisted as such. I saw and learned enough, however, to place female impersonators in a general framework of "entry" problems.

Some people sneak into the gay world; others burst in. At one polar extreme, the covert homosexual makes a precipitous distinction between his roles in the straight world and his roles in the gay world. The former typically include his working roles, and the professional and the social roles derived from work; his

[17]Robert K. Merton, *Social Theory and Social Structure* (New York: Free Press, 1957), p. 370.

[18]Lemert, "The Concept of Secondary Deviation," p. 50.

[19]Recently the blues singing style has been "lifted" by young white singers, but many attributes of the status cannot be reproduced in the context of white youth culture. For a good discussion of the Black blues singer, see Charles Keil, *The Urban Blues* (Chicago: University of Chicago Press, 1966).

family roles, which can be with his parents and siblings, or even with a wife and children; and his social roles with friends who knew him before his entry into the gay world, i.e., his "straight friends." In addition to these more intimate situations, he preserves a "straight face" on things in any public situation. His participation in the gay world is kept completely separate from his public roles. The distinguishing mark of the covert homosexual is the double life, wherever the line may fall between the two worlds. But, most crucially, that line must fall between work and social life.

The overt homosexual, as an ideal type, withdraws from *any participation* in the straight world. All his contact with it (and some contact is unavoidable), is in the nature of *confrontation*. The extreme overt homosexual is unwilling or unable to present a heterosexual "front" to anyone at any time. His entire social life is conducted with other homosexuals and heterosexuals who "know." He does not participate in the "straight" working world, but rather finds some means of support that does not take him out of the gay world. This can mean being kept by another man, hustling, pushing narcotics, pimping, or it can mean a job in the gay world, such as bartending or waiting tables in a gay bar or restaurant, or female impersonation. A compromise position is to take a job that does not involve direct services to the gay world, but in which open homosexuality is tolerated, such as hairdressing or window trimming. (A different solution is "passing," that is, participating in the working world as the other sex.) If the characteristic mark of the covert homosexual is the double life, that of the overt homosexual is the single fused identity marked by complete absorption into the gay world and constant confrontation with the straight one. Stage impersonators try to model themselves on the covert plan, while street impersonators are overt. The overt-covert distinction is directly related to a second polarity, that between "butch" and "nellie." These terms can be roughly translated as masculine (butch) and feminine (nellie). They are central to the expressive and social styles of the homosexual subculture.[20]

Here I am interested in butch and nellie styles as aspects of the management of personal front, in Goffman's terms. All homosexuals have personal styles that will be described by their fellows as either butch or nellie or some composite of

[20]Female homosexuals also make a distinction between "butch" and "fem" that is equally important to them. But, of course, the signs are reversed, since in contrast to the "butch" man, the "butch" lesbian is the more "deviant." Oddly enough, "butch" and "nellie" as applied to males can only be used as adjectives: "He is butch," but not "He is *a* butch" or "He is *a* nellie." This holds true even when the gender of the pronoun is reversed, as it often is in referring to male homosexuals. You cannot say "She is a nellie" (using "nellie" as a noun), although you can say "She is a queen" and be referring to a male. "Butch" and "fem" as applied to lesbians can be used as either adjectives or nouns, however: "She is fem (or butch)," or "She is *a* fem (or butch)." Male homosexuality, therefore, makes a linguistic distinction between expressive style "nellie" (adjective) and essential identity "queen" (noun), whereas female homosexuality makes "butch" cover both.

the two. The nellie male homosexual and the butch lesbian who attempt to participate in the straight world must usually either counteract the information given by their styles (for instance by being married, divorced, or by talking conspicuously about relations with the opposite sex), or they must manage these deviant styles so as to suppress them in straight company, and express them only in the appropriate homosexual context. So, for instance, many covert male homosexuals attempt to present a butch front in straight situations, but become quite nellie in homosexual situations.[21] The covert homosexual hopes that he cannot be "spotted" in heterosexual social contexts, and one of the major elements of cover or "the mask" is the suppression of nellie style.[22] The overt homosexual, on the other hand, makes no attempt to cover his nellie style in public situations and may, on the contrary, positively flaunt and accentuate his nellie behavior as part of his confrontation with the straights.

All of this is basic to the situation of the proto-female impersonator who is just entering gay life. Obviously all homosexuals have faced the entry crisis somehow, and yet only a very few become female impersonators. But becoming a female impersonator seems often to evolve out of an entry experience that is shared by many, but by no means all homosexuals. This can be conveniently termed "the drag phase":

". . . the point in some homosexuals' lives at which they go through a siege of intensely public and exhibitionistic behavior during which they flaunt strongly feminine types of behavior. Few homosexuals enter into an exclusive wearing of female clothing even for commercial purposes (impersonation or prostitution), but many homosexuals have had to manage a "drag" phase.[23]

For the basically covert homosexual, entry into the gay world means acquiring a second life that must be kept separate from the first. Outwardly,

---

[21] For the purposes of this discussion it is useful to equate butch front and style with socially acceptable masculine style. Homosexuals themselves often make this comparison by saying that the butch homosexuals are the ones who look and act like "normal" men. However, for distinctions within the homosexual community, butch becomes an element of style on a distinctively homosexual scale. Leather clothing, for example, is described as butch even though "leather queens" do not look like straight men.

[22] Effective cover has its opposite problem, that one may not be identifiable as a homosexual even when one wants to be. At the extreme, one is thought to be straight even in homosexual contexts. At the least, one may sometimes want to make oneself known to another homosexual or suspected homosexual in a public situation. It is generally assumed that other homosexuals will pick up cues that heterosexuals will miss. Many homosexuals boast that they "can always spot one." However, in situations of ambiguous identity, homosexuals have developed extremely subtle and elaborate systems of recognition, which, however, are not sufficiently shared to be failure-proof. The process of sending out subtle cues or "feelers" is called "dropping the hairpin." (This phrase is also used when one has made an outright admission of homosexuality.) This expression is clearly related to "letting your hair down," which has connotations of both frankness and femininity.

[23] Personal communication from William Simon and John Gagnon, 1965.

there may be very little change in his life patterns. Gradually his straight relationships may be attenuated, as he becomes more and more involved in and committed to gay life, but important working and family relationships may remain outwardly unchanged if he can hide his other life. On the other hand, the person who bursts into gay life by entering a public drag phase is risking or even inviting "social suicide." All pre-entry relationships, including familial ones, will be broken unless the heterosexuals can tolerate the change in a way that is acceptable to the new homosexual. In such cases it is frequently found that the new homosexual previously had weak ties in the heterosexual world.

There are two distinct types of entry (which in practice are not so cleanly defined): the process of becoming a covert homosexual, and the process of becoming an overt homosexual. The former is associated with the development of a double life, the cultivation of a butch public style that may or may not contrast with a "nellie" homosexual style, and continuity in pre-entry life situation. The latter is associated with total withdrawal from the butch styles necessary to participate in the "normal" world, and total immersion in the gay world built around a fused nellie style and identity.

My impression is that the proto-female impersonator almost always tends toward overt entry, and that the "social suicide" and nellie style are important pre-conditions to the assumption of the extremely deviant status of female impersonator. Every informant who told me how he got into female impersonation described himself as a person who (1) was already committed to and knowledgeable about the homosexual community, and (2) already had done "drag" as part of this commitment.

Being gay and doing drag are not the same. The relationship between homosexuality and sex role identification is complicated. The ability to impersonate women is not widely learned by males in American culture. Any serious (as opposed to farcical) attempt to impersonate the opposite sex is not part of the approved male (or female) role. However, the skills involved in female impersonation are widely known in the homosexual subculture and, in certain contexts, the use of these skills is subculturally approved. There are many opportunities for the male homosexual who is so inclined to "get in drag" in a social context. The most formal of these is the annual Halloween "drag ball," which is traditional in most large cities. Since the central event of most of these balls is a beauty contest, most of the participants make a serious attempt at impersonation through the use of "high drag," that is, very formal female attire and all that goes with it – high heels, elaborate hair-do (usually a wig), feminine make-up, and formal accessories, and if possible, a male escort in formal men's evening wear. The Halloween balls are, moreover, not the only formal events that provide opportunities for drag. For instance, the homosexual community on Fire Island, New York, sponsors a drag ball and contest during the summer; some cities have New Year's balls as well.

Skip Arnold

There are also numerous parties given in the homosexual community at which guests are encouraged or at least permitted to wear drag. These may be private parties of small cliques or large relatively open parties. Depending on the context and the social group, this may range from "high drag" to simple clowning in a woman's hat and a little make-up. All of this can be done in the privacy of the home. The limiting condition on drag in public places is its illegality. Thus on Halloween, drag is legal as a masquerade, and in predominantly homosexual

communities such as Cherry Grove (Fire Island), the police are not always stringent. But under any other conditions, the person who wants to wear drag must be able to pass for a woman on the street or else risk arrest. My own impression from having seen a great deal of amateur drag is that very few homosexuals can pass successfully. This stops people from wearing drag in public, and it limits going to homosexual parties and bars in drag because one has to pass through public places to get there. In spite of this, I have occasionally spotted men in full drag on city streets.

At the most informal level, a great deal of "camping" goes on wherever gay people congregate at parties, bars, and beaches, in which female identification of one sort or another is a large component. This is equivalent to saying that homosexual gatherings do not discourage, and frequently encourage, by means of an appreciative audience, the expression of this identification. Much of this "camping" is highly imaginative drag with few props:

In a small, racially mixed homosexual bar in Chicago, I saw a tall, thin Negro do a perfect imitation of a middle-aged Negro matron at a Gospel church to the accompaniment of a gospel-type song on the juke box. He was wearing slacks, a sports shirt, and no make-up or conspicuous jewelry. His only prop was a small but fantastic feathered hat, which had come into his hands while being passed around the bar. Using his bar stool as a base, he jumped up and down in time to the musical climaxes, waving his arms in the air, swooning, and shouting "Amen" and "Jesus loves me," until he had approximated "getting the spirit," which was indicated by flailing arms, rolled-back eyes, and twitching muscular movements. The crowd at the bar, and especially the Negroes, who presumably had had opportunity to witness this phenomenon in its original context, were convulsed with enthusiastic laughter, and shouted "Amen" back at the appropriate choral points to encourage him.

In a small homosexual bar in Chicago, I saw a young white homosexual do a burlesque imitation with no props at all. He was wearing light eye make-up, slacks, and a red and black ski sweater. He was sitting on a bar stool at the end of the bar when the band began to play a burlesque type song. He pulled his legs up onto the stool, so that his feet were resting on the seat and his knees were pulled up to his chest *underneath* the sweater and slightly apart. This created a strong suggestion of two large and pendulous breasts. By moving these "breasts" in time to the burlesque music, he imitated the unmistakable chest movements of a stripper. Those sitting around the bar laughed and clapped, encouraging the young man to greater efforts. The female impersonator sitting next to me said, "Watch what that queen [the young man] does. That is fine camp."

Now it is highly likely that many or most proto-female impersonators have worn female attire before they ever became involved in the homosexual

community. It is logical to suppose that an underlying psychological conflict in sex role identification has been a major factor in pushing the proto-female impersonator toward the homosexual community (as it probably is a strong factor for many homosexuals), and that many of them will have acted out this conflict in private. But the point is that membership in the homosexual community *socializes* this conflict by providing it with a form and an audience. There is no communication between performer and audience without shared meanings. In fact *the* distinguishing characteristic of drag, as opposed to heterosexual transvestism, is its group character; *all* drag, whether formal, informal, or professional, has a theatrical structure and style. There is no drag without an actor and his audience, and there is no drag without drama (or theatricality). Men who become female impersonators have all, as far as I could determine, undergone this socialization of their deviance in the homosexual community *first*. In this context, the decision to become a female impersonator, whether tentative or abrupt, is simply a professionalization of an informally learned social skill.

By whatever particular route a young man (beginning drag queens are usually in their late teens or early twenties) take his first steps in a drag career, he will always have learned the rudiments of female impersonation as it is understood in the homosexual community. The "drag phase" may be acted out in strictly homosexual settings, such as bars, parties, and balls. The support and encouragement of other homosexuals apparently figures strongly in the decision to try professional female impersonation. The experiments of the pre-professional drag phase not only give the opportunity simply "to try on drag for size," but to receive (or not receive; this is, after all, a selection process) the applause of various informal audiences. The drag queen looks in the mirror of the audience and sees his female image reflected back approvingly. It is through the process of group support and approval that the drag queen creates himself. The transformation culminates in the female impersonator's first job, where the approval of the mirror is ratified by the payment of cold, hard cash, an event of tremendous symbolic importance:

EN:   Did you do any drag before you started working?

I:   I did, back home . . . I used to go . . . there's one gay club in Covington, Kentucky. I did shows there. I did 'em just for my own self-satisfaction. At parties, I used to entertain, and like this. I went to one place in Cleveland. They had just this one-night affair, a big buffet supper. And this one kid from Dayton was gonna drive down and work there as a waiter or something and asked if I would be interested in going down, that they would pay me well. And I went down. I did three songs. They paid me seventy-five dollars and flew me back home. So I think . . . if you're that good, I certainly would call myself just as professional a performer as anyone else.

Some informants indicated that they had gone through a "street fairy" phase as a prelude to professional female impersonation. Street fairies are the pariahs of the homosexual subculture (See Chapter One). They are young homosexual men who do not work, who flaunt an aggressively nellie style in public (penciled eye-brows, facial make-up, long teased hair, fingernail polish, charm bracelets, exaggeratedly effeminate body postures, etc.). The distinguishing characteristics of the street fairy are (usually) his poverty and his public assumption of a modified drag style. Among his heroes, if he recognizes any, will be the professional drag queens, who, from his point of view, are street fairies who have "made it": The impersonators make money on a regular basis for "easy work," they can wear full drag legitimately and often, they have a guaranteed audience whose approval is symbolized by the cover charge or price of a drink, and they have a certain prestige and status.

The young street fairy who wants to work will begin by hanging around bars where drag is performed with the aim of "crashing" the drag queen set socially, meeting the management, and learning how to perform drag for a paying audience. It is through the bar or the established drag queens that he will get his first break. Somehow he must impress the manager sufficiently to get hired. If he can make friends with someone who already works in the show, this person may suggest that he be given a trial, the trial generally consisting of an audition during some slow night of the week. In some drag bars an entire evening may be given over to these auditions, which are often called "talent nights." In others, the regular show will feature guest spots, and these are more difficult because the neophyte must perform in direct comparison with the established professionals. Informants who spoke about their professional beginning generally stated that the manager had approached them, rather than the other way around:

When I first started . . . it started like, I used to go to this bar all the time. And business . . . they were in a slump. And so, we used to dance around there a lot, and the manager came up . . . 'course I knew him well 'cause I was in there a lot, he says, "Terry, how would you like to uh. . . ." He said he was thinking about putting in a show. I said, "Well, what kind of show?" He said, "Well, female impersonators. How would you like to be one?" I said, "Me?" And he said, "Yes." I said, "Well, I've never done it before," and at the time I wasn't working, and so I said, "Well, how much you going to pay me?" So he told me how much he was going to pay me. So I said, "You know I don't have anything to wear." He said, "I'll buy that."

In the first stages of a drag career, the commitment is often gradual or sporadic. The informal drag queen becomes a week-end or part-time drag queen:

[The informant is explaining how he accumulated his drag wardrobe.] When I started, uh, here in Chicago, I had a couple of dresses that I used to use for

parties back home, or I would entertain a lot. That's kind of how I got my start, got used to people watching me and so forth. [This is difficult for informant to get out. His voice is strained and embarrassed, but then plunges on, more confidently. He watches my reactions closely.] And I had these dresses, and I worked at the Back Cover on weekends, which is called the Microphone now. And I used to earn a little extra pennies, plus I was working my other job [clerical work]. And when I found that I liked doing it, and I had a possible chance of maybe doing this more often, I invested some money in some wardrobe and had it made up.

The story related by another informant contains a number of typical elements including a strong interest in show business and performing, prior socialization in the homosexual community, and a street phase:

EN:    You say you've only been in drag about three and a half years. How'd you get started in it?

I [informant is white]:    Well, that's a long story. Actually, what happened was, I was in L.A. and I was staying with this colored queen who wanted to work in drag. So we used to go around and try to get jobs, but you can't work in drag in L.A.

EN:    Yeah, so I hear.

I:    So I worked in some straight clubs in records, and I did things like Spike Jones and Sammy Davis, Jr., and things like that, at colored clubs in L.A. And then once in a while we would get brave, and put on drag and all this, you know, and do some wild drag numbers, but we never would announce it, so we'd just do like the one night, and that was it. And everybody knew who we were, so they would just go along with it. And have a ball. I had bought this wig, I still have it in fact, for I think thirty dollars or something like that, and it was a very natural looking wig, and I loved it. We used to go out in drag and everything. . . .

EN:    On the street?

I:    On the street, yes. Because that was in the colored areas, and they never bother you. You could walk around nude, and they probably wouldn't say anything. But I came to San Francisco, and I decided, well, I might as well work in drag, just to see what it was like.

EN:    Had you been in theatre before, performing somehow?

I:    Little bit of theatre, but never professional.

EN:    What did you do before you –.

I:    I worked in offices, and I used to work in nightclubs on weekends. Emcee in rock and roll shows with people like _____. On Halloween night, I emceed in drag.

EN:    But still, as far as drag went, it was still pretty much amateur?

I:    Oh, yeah. Until I got to San Francisco, and then it was even more so, even though I was getting paid for it.

EN: Well, how did you break into the business? There you are in San Francisco, and you decide, well, I'd like to try it out. . .

I: I just went to a club, the 220 Club that had a record show, and I sat in the audience for four days and watched the show. I thought, "I can do better than that," and on the fifth day, I went in and I did.

# Types of Acts

The later orientations of female impersonators emerge out of a common experience, that of the "glamour period." Almost without exception, the female impersonators whom I interviewed reported having gone through a stage of being "married to the mirror" for about the first six months to a year of their professional careers. I also saw many young female impersonators actually in their glamour phase. An impersonator who now does only slapstick comedy reported on his second job:

I:    I'd only worked there two weeks. Five dollars a night, two nights a week. And I thought I was *gorgeous*. Like I have pictures of it, when I was in that era, and I looked horrible.

EN:    Were you doing glamour?

I:    Uh-huh.

EN:    Why did you think you were gorgeous?

I:    Well, you always do, you know (spoken in an "everybody knows that tone"). I didn't think I was gorgeous when I was doing slapstick, but like between shows you wear your wig and gown. I can imagine what I must have looked like (yawns).

The narcissistic extremes of the glamour period are usually the marks of the inexperienced, not fully professionalized female impersonator. I observed earlier that entering the homosexual community represents socialization of private deviance and its integration into shared forms. Entering the community of female impersonators represents a second and much more specialized social-

ization. Those female impersonators who cannot divorce themselves from the domination of the mirror are therefore unsocialized in the eyes of the more experienced and/or more sophisticated performers.

Giving up the narcissism of the glamour period means accepting the judgment of established female impersonators about your capabilities. It means giving up glamour drag completely if more experienced professionals think you are unsuited for it, or becoming theatrical, that is, professional, about glamour if you continue to do it. One female impersonator who now does both comedy and glamour, when talking about the inability of some performers to break the illusion of beauty, said:

I:    And this is also true of the guy who wants to become a female impersonator. And most of them start out being very glamorous, *thinking* they're very glamorous, and looking like . . . hell. And this is the way I started (laughs) . . . I'm very serious. I looked like hell and thought I was very attractive. And then it took a few people who were interested in *me*, to show me what to do, and I always thought they were over made-up or gaudy, and then when I realized how much better I looked with other things, with the make-up and stuff; of course, if you were going on the street you wouldn't wear that kind of make-up, but theatrically speaking. . . .

EN:    But this is a stage?

I:    That's right and you should look like . . . they used to drive this in my mind . . . although I've always been theatrically thinking.

The socialization process has practical consequences. Unless the beginning professional learns to break his initial narcissism, he cannot hope to rise from the lowest paying, lowest prestige jobs at best, and at worst he will find himself out of work permanently. For despite the continuous appeal of glamour to *all* female impersonators, the naive glamour queen is the unskilled laborer of the profession. There are never enough jobs for the crowds of pretty and not-so-pretty young boys who will work for five dollars a night just to get on the stage in drag, and competition is fierce, according to a young black female impersonator who had had a good deal of experience in glamour and was very popular with performers and audiences in Chicago:

EN:    I just wondered because I noticed . . . well, you can't notice this at the Shed, but at the Marlboro, it seems like the young ones don't rely on comedy at all. And the older ones do.

I:    I know. They have . . . the older ones have learned that, uh . . . the older ones that you see do comedy; they do glamour, too.

EN:    Yeah, sure they do, but they also do some comedy.

I:    They have learned that if, say if the Marlboro was to close tonight, those who are versatile and can do both will get a job quicker than the one who can

do glamour. Because every female impersonator who tries to come out, always I'd say, seven out of ten of them always try to come out in glamour.

EN:   To begin with?

I:   To begin with. And if you go to a club that's already working, like downstairs . . . they don't need any more glamour queens down there. Do you think so?

EN:   No.

I:   I don't. O.K. but if one's coming in, she can come in looking glamorous and maybe think, "Well, I look prettier than so-and-so, maybe they'll kick her out and put me in." But this don't always work. It's getting so now, there's so many female impersonators *trying* to get into the business. . . .

EN:   (interrupting) You think there's an upswing?

I:   Yeah. Because they're trying so hard to get into the business that the more you can do, the better off you are holding a job.

EN:   You think the competition's going to get stiffer?

I:   Well, it is already.

EN:   And so people are going to have to do more?

I:   They're going to have to . . . get better . . . at *what* they're doing. Because it used to be that if you just looked pretty up there, they'd hire you. Now they want you to have a *little* talent to go with the looks. Because what's duller than seeing a pretty face, or a pretty body, doing *nothin'*?

The opposition and combination of these two qualities, beauty and talent, form a framework that runs right through the profession and organizes the pay scale, job hierarchy, and social relations of all female impersonators. As female impersonators see it, "beauty" is the closest approximation, in form and movement, to the mass media images of glamorous women. Tastes vary, of course. Some female impersonators think that Lauren Bacall is a beautiful woman, while others prefer Elizabeth Taylor or Marilyn Monroe. The point is that the first referent of the concept of beauty is always some woman who has been publicly recognized as "glamorous." The second referent will be some female impersonator who is widely recognized within the profession as "beautiful." In Chicago, one performer in particular was widely admired and cited as the "most beautiful queen in town," and some performers are so recognized on a national scale.

## SPECIALIZATION

After the break-in glamour period, performers tend to specialize in certain recognized types of acts. There are four basic types of female impersonation: dancing, singing, glamour, and comedy. The execution of these styles is modified depending on whether the show or act is live or record pantomine. Almost all

drag acts are done to some kind of musical accompaniment, and all, except the dance acts, feature "feminine" vocalization, either sung or spoken. In the record act, the musical accompaniment and the vocal are provided by a phonograph record. The dancer will simply dance to it. The "vocals," however, will mouth the words on the record exactly in the way that television performers do "lip synch," that is, matching the mouth movements to the words on the record. Obviously, the record act is much cheaper to produce because it does not use musicians, and the performers are paid less since it is disparagingly said in the profession that "anybody can mouth a record." In any case, the record act involves visual impersonation alone.

The live act, in contrast, uses live musicians, and the performer uses his own voice. Thus the live act has a much larger range and a greater flexibility than the record act. In general, the live performer will be better paid and have higher prestige within the drag world than the record performer.

DANCERS

All dance acts mimic some style of female dancing. Some of the larger shows feature specialized dancers, such as "ballerinas," flamenco dancers, or acrobatic dancers. Such skills demand some prior training. That kind of dance act is undoubtedly thought to add a little "class" to the show, just as did a ballet routine added to the vaudeville shows. A second kind of dancer, the "chorus girl," or "pony," does not have a solo spot, but simply makes up the bare-legged chorus line in the larger shows, such as those in New York and San Francisco, for the production numbers. This type of dancing is simply an excuse for getting a good-looking boy on the stage. But because of the lack of emphasis on elaborate clothing, the "chorus girl" is generally not categorized as a glamour queen.

By far the most common kind of dance act found in drag shows is the "exotic dance," more inelegantly called the "strip." Drag strip differs from its female counterpart only in the difficulty of creating the illusion of femininity with so little body covering. Drag strippers shave off all body hair, and they particularly avoid heavy labor in order to minimize muscular development, especially in the arms. The stripper always wears a "gaff" to conceal (strap back) his genitals.[1]

[1]Performers think that straight audiences in particular watch the pelvic area closely. Failure to conceal the tell-tale bulge of the penis is said to be the worst amateurish mistake. Judging by backstage conversations, professional anxiety about this type of carelessness or accident is intense. Although some performers feel secure about presenting a flat front simply by wearing a tight girdle, most seem to prefer the security of a gaff. This is simply a strip of rubber worn between the legs and held taut by thin rubber bands over the hips, which holds the genitals tightly down and back between the legs. Strippers who must appear in very brief, tight g-strings are especially vocal in their anxiety that the gaff might slip or break. There are numerous stories about such incidents, although I never actually saw it happen.

Desirée (Nick Cristina)

The trick in stripping is to look and move as much like a "real" stripper as possible and create the same erotic effects on the audience, to sustain the illusion of "reality" down to the bra and g-string, and then, as a climax, to "pull" (slip off) the bra, revealing a perfectly flat chest. Since gay audiences know for a certainty that the drag queen has a flat chest, strip is more often seen in the straight shows. The gay strips I have seen have concentrated simply and purely on creating the visual illusion. Judging by audience reaction there is very little erotic (as opposed to technical) interest aroused in most members of the gay audience by a strip, and strippers in a gay club do not "pull the bra" at the end.

### Singers and glamours

These are overlapping categories, since those who sing serious songs must always look glamorous to a certain extent, and glamour queens generally choose the "vocalist" form to display their beauty and skill. The ideal is to be a highly skilled singer who also looks glamorous and beautiful, but most performers are much stronger in one area than the other. The prestige of one category is balanced by the other. Performers recognize that singing skill (the ability to sing like a woman with a certain flair and audience appeal) is much more rare than beauty, that is, singing is seen as a talent and is prized as such, whereas beauty is thought to be innate, although it can be greatly magnified by professional make-up and costume. The emphasis on skills and sophistication among singers gives them very high prestige among the stage performers. However, the performer who is acknowledged as a "beautiful glamour queen" but only a so-so singer will win (sometimes grudging) admiration even from the stage impersonators, and will be idolized by the street impersonators. The homosexual subculture values visual beauty, and beating women at the glamour game is a feat valued by all female impersonators and by many homosexuals in general.

Of course, there is a basic distinction between true vocalists and record vocalists in that true vocalists use their own voices and must accommodate themselves to live musicians, while the record vocalists simply mouth words and music that are already "set." The record vocalist exercises creativity only in the choice of songs he will perform and in his visual appearance during the act. Even within this limitation, record performers can create quite individual styles. One well known record performer in Chicago always performed to torchy, emotional songs. He had an extremely mannered style of presentation, involving much hand-wringing, tortured facial expressions, and arresting body angles. Much of his audience responded favorably to this Judy Garland-like approach. (One performer commented to me that "Vivien" made a successful appeal to the tremendous sentimentality in many homosexuals.) His was a "gutsy," give-em-all-you-got style. Supporting his "delivery" was his make-up style, which made his face severe and hard, and his dress, which ran always to slinky, tight, low-cut gowns and spiked heels.

Another performer at the bar had created an entirely different image. He was middle aged and he chose records in the "red hot mama" genre. He was particularly partial to the records of Mae West and Sophie Tucker, but would occasionally do other singers if the songs were in the same spirit. His gowns, while also often tight and low-cut, looked entirely different on his chubby middle-aged frame, and he preferred them in black and white with much beading and many feathers and fans. His cool, knowingly seductive manner, punctuated by winks and kisses to particular fans, created a distinctive relationship with the audience. While "Vivien Vixen's" heart-wringing productions were always received in reverent silence by "her" admirers, "Wanda's" performances called forth cries of affection, amused laughter, and spontaneous applause.

Desirée (Nick Cristina)

Live singers also work with "impressions," in the manner of "Wanda's" impression of Mae West or Sophie Tucker. The live impression is a deliberate impersonation of the vocal style as well as the visual appearance of a known female performer. T. C. Jones, the best known female impersonator in America, and Lynne Carter, who ranks right behind him, both do such impressions almost exclusively. The art in these impressions depends on a sharply defined tension between maintaining the impersonation as exactly as possible and breaking it completely so as to force the audience to realize that the copy is being done by a man. A common method of doing this is to interject some aside in the deepest possible bass voice. A skilled performer can create the illusion, break it, and pick it up again several times during one song, and the effect can be extremely dramatic and often comic.

The effective impression demands a sharp sense of timing and, needless to say, a highly developed mimic skill. I saw Lynne Carter do impressions of Hildegarde, Hermione Gingold, Phyllis Diller, Mae West, Bette Davis, Marlene Dietrich, and Pearl Bailey, all in one one-hour set, and I know from other people who have seen him perform that he can do and has done many more. Each impression was effective and clearly recognizable, and he used no basic costume change and very minimal props. Less skillful performers can do only four or five successful impressions, but like Jones and Carter, they tend to mimic female performers who (1) are widely known, (2) have a highly individualistic and mannered style, and (3) are well liked by the gay community.

The advantage of the impression is that it gives the female impersonator something to "do." In other words, it provides a form for the performer to work within and against. If the impersonation is reasonably good, the performer not only has immediately created a recognizable female form, but can draw on audience appreciation of the star.[2]

Nevertheless, female impersonators often dispense with impressions in favor of pure singing. This has the advantage of greater artistic freedom; the performer can do his own interpretation of a song. In this case, however, much of the point of the impersonation is lost and emphasis shifts over to performing skill per se. Impressions tend to be fairly successful, since the less skilled performers will not even attempt them. Song stylists range from terrible to very good. Success in singing naturally depends to a very large extent on the quality of the voice. Since most men have very poorly controlled falsettos, most female impersonators sing in a low tenor to high contralto range. The singer tries to push his voice into its upper register and to lighten the tone quality. However, a few female impersonators have controlled falsettos and can produce extremely convincing

---

[2]An impression can backfire, however. While sitting among the audience at a club in Kansas City, I heard members of the (straight) audience express disgust and outrage that their favorite star (often Judy Garland) was being impersonated by a "queer." Some people evidently felt certain impersonations to be "sacrilegious."

sopranos. I once heard a singer with a large traveling show who had very good vocal quality over a range from high soprano to baritone.

The glamour aspect of serious (as opposed to comic) singing either can be the necessary adjunct of the voice or can overshadow the voice as the performer's strong point. Glamour drag and serious drag are synonymous terms to female impersonators. No serious attempt is made to present any female image other than that of a "star" or a female nightclub performer (singer or dancer). Any deviation from that image is treated as incompetence, bad taste, or comic effect. Therefore, glamour means, ideally, a slender body with the appearance of large breasts and wide hips, a youthful face with "good" bone structure, skin that seems soft but is heavily and dramatically made-up, jewelry (especially earrings), a long-haired wig (preferably blond and in a sophisticated style, although many wigs still run to the bee-hive, over-teased look), a gown (preferably low-cut and floor length), and, *invariably*, high-heeled shoes.

Although the truly "beautiful" glamour queen must be young – aging is a terrible problem for the female impersonator, both personally and professionally – a number of female impersonators, including the top names in the profession, are in their 'thirties and forties, and even beyond. In order to continue with any serious impersonations, they must adopt an "older" glamour style and attempt to compensate in sophistication and experience for what they lack in youthfulness. Many older female impersonators look like movie "madams" or hard-bitten bitches of some sort. If they dress skillfully and keep in decent physical condition, older impersonators are still acknowledged within the profession to "look good." However, older performers cannot do strictly serious drag. That is, although they may still wear glamorous drag and seriously impersonate an older but sophisticated woman, they must temper the impersonation more and more with humor. The more experienced female impersonators say this is smart and that even the young and beautiful impersonators should not be too "pussy," that is, too consistently and intensely feminine. While this is probably true, the point is that a young performer can get away with this type of deadly serious impersonation, whereas an older one will be ridiculed by other performers and, perhaps, the audience.

Other deviations from the glamour ideal include "tacky drag" and "transy drag." The word "tacky" means cheap, shoddy, or of poor quality. It connotes a poor quality imitation of a high quality item. Hence the term "tacky" will not be applied to an underdressed performer, but to a glamour performer who looks tawdry, dirty, or low class. "Tacky" is a pejorative term. No single word was more consistently used by the older, more show-business oriented performers to describe the appearance of lower-status street oriented performers and the street fairies themselves. "Tacky" is thus indirectly a class descriptive term as it is used by female impersonators. The street fairies are definitely lower-class oriented, if not of lower-class background, and their ideals of feminine glamour are colored

Desirée (Nick Cristina)

by successful hookers (prostitutes) and strippers. In addition, they usually do not have enough money to buy high quality gowns, make-up, or accessories.

"Transy drag" denotes not so much cheapness as deviance. Here again I refer to the fact that the effect of the female impersonator subculture is to socialize individual deviance so that it is brought under group control and legitimized. Those who have not joined the social group or merged their individual deviance with the cultural forms are considered the *real* deviants. Female impersonators do not refer to themselves as transvestites. Sometimes in interviews one would reluctantly say, "Well, I guess I'm some sort of transvestite," but then he would quickly add, "but I only do it for a living," or, "this is my job." To female impersonators, the real transvestites are the lone wolf isolates whose individual and private experiments with female attire are described as "freakish." To them, the transvestite is one who dresses as a woman for some "perverted" sexual purpose outside the context of performance (either informal, as in the gay bar, or formal, i.e., professional). In practice, "transy drag" is either some item of feminine apparel which is not related to the necessities of performance, or feminine clothing which is worn in everyday circumstances:

A street-oriented boy was changing costume backstage. This revealed that he had on a pair of women's underpants. However, these were not the usual simple nylon briefs worn by the others, but were pink and frilly. The other performers immediately began to tease him about his "pussy" underpants. He laughed it off, saying, "You old queens are just jealous of my transy panties." However, I noticed that he did not wear them again.

Another street-oriented boy, who was very much disliked by the other performers, and who had only been working for a few weeks, had outfitted himself largely with skirts and blouses. The emcee began to criticize this, saying his appearance was too transy. Soon the boy was in a state of some anxiety about it, and before he would go on stage he would nervously ask anyone who was standing around, "Does this look too transy?" to which they would always reply, "Yes." When I asked one of the older performers what this meant, he said it meant the boy's drag looked "too much like a real woman. It's not showy enough. No woman would go on stage looking like that."

Transy drag is wrong because it violates the glamour standard, which is synonymous with professionalism, that is, the right context and motivation for impersonation (performance, making legitimate money) as opposed to the wrong context and motivation (private life, private compulsion to *be* rather than to *imitate* a woman).[3] In addition, transy drag violates the implicit aesthetic in the glamour standard, for transy drag makes one look like an ordinary woman, and ordinary women are not beautiful.

[3] Female impersonators seemed always anxious to tell me in no uncertain terms that they were not transvestites; this label was a source of a good deal of fear, although they had no hesitation about revealing their homosexuality. A very introspective impersonator described the channeling process involving performance:

Comics

To female impersonators, the only legitimate contrast to glamour drag (besides dancing, which is an auxiliary of glamour) is comic drag. Opinions differ as to whether comedy has a legitimate place in a glamour act. Some impersonators say that an act should be one or the other, and that they should not be mixed. However, almost all the most successful performers have evolved a style based on the contrast of glamour and comedy within a single act. The successful performers are not only more versatile in that they can sing, be glamorous, and be comic, but they have created an individual style based on merging all three skills.

There are two principal types of comic acts: slapstick comedy and stand-up comedy. Slapstick comedy utilizes gross comic effects, usually visual. The slapstick comedian attempts to make himself *look* as ridiculous as possible. The standard props are the old "ratty" dress, the false nose, and the "fright wig." The fright wig is the ugly wig as opposed to the beautiful wig. The hair on a fright wig is typically coarse, of uneven lengths, and flying off in as many directions as possible. However, any deliberately messy and slovenly arrangement puts a wig in this category. (The hair style worn by Elizabeth Taylor in "Who's Afraid of Virginia Woolf" was termed a fright wig by a friend of mine in the theatre world.)

Most slapstick performers are record artists. Their usual approach is to mouth a record by some comedienne such as Phyllis Diller, Kaye Ballard, or Rusty Warren. At the same time, the performer's physical appearance and his body motions form a support and, sometimes, a commentary on the words in the "set" routine. In particular, the body movements are used to indicate a "dirtier" dimension to the words. A typical ploy, for instance, is to draw attention to the genital area when the subject of love is mentioned, or to imitate the rhythmic

"You can't get away completely from hustling in drag because female impersonation is so involved with the transvestite thing that we all fear." Basically there is always that "I am a woman" or "I am my mother" thing. He said, "The first time I got in drag I must have jerked off five times with the feeling, 'at last I have become mother.' " He says that if one had all the relevant information he would be able to tell in any given case, especially with beginning drag queens, which female relative they were patterning themselves after. I said, "Then what's the difference between a transvestite and a drag queen?" He said, "First of all, the true transvestite wants to sleep with women, and does not consider himself a homosexual. Also, the drag queen always wants to perform to an audience, whereas the transy, if he wants to perform, only does so for the person or persons he sleeps with. The typical transy mode is to wear feminine attire *underneath* men's clothes. The drag queen hardly ever does this. The transy is sexually excited by the *feel* of feminine attire – also has something to do with being confined. They buy bras, for instance, that cut into them, and rigid corsets." He said he tried this once – feminine underwear under men's clothes – and experienced nothing but discomfort. He has also tried to wear female attire around the house, but doesn't any more because he felt foolish. "Who am I performing to?" he asked himself. A number of impersonators confided to me that at first wearing drag had been "exciting" but that eventually it had become both routinized and rechanneled into performance.

Stacy Lane in comedy drag

motions of intercourse. Often props of an explicitly "dirty" and sexual nature are used. The slapstick comics often bring bottles of KY (lubricant used by some homosexuals in anal intercourse) and other sexual accoutrements onto the stage for homosexual audiences, and bottles of vaseline and condoms onto the stage for heterosexual audiences. For both audiences they rely on grossly phallic objects such as long sticks, immense stuffed snakes, or long, thin balloons. I was told that one performer used to throw a catsup-covered Kotex pad into the audience until he was reprimanded by the manager.

A variant on the comic-record approach is to pick an ostensibly serious record and lampoon it. This produces more striking contrasts and, in my opinion, more comic effects. One performer in Kansas City has an entire repertoire of such routines. One of his best routines is done to a tear-jerking song called "I'm So Hurt," recorded by Timi Yuro. The song is simply the plaint of a girl who has been deserted by a lover:

> I'm so hurt, to think that you, you lied to me.
> So hurt, way down deep inside of me. . . .

The impersonator's performance is the visual interpretation of the song, a dramatization of the story. He appears in a fright wig, a checkered house dress with a number of rips in it, and slippers. Over one arm he carries a large, beat-up purse. His waddling gait and protruding stomach inform the audience that he is pregnant. Immediately the counterpoint to the song has been established: the girl is a pitiful slattern who has been "knocked-up" and left. The desertion now takes on a more serious and realistic form that is, at the same time, ludicrous. The performer is representing the ugly realities we all know to be lurking behind our sentimental and euphemistic songs. The climax of the routine comes on the final words:

> But even though you hurt me, like nobody else could ever do,
> I would never, ever hurt you (violin crescendo).[4]

At the end of the first line, the audience hears a loud POP. (This is done by sticking a pin in the "pregnant" stomach which, in reality, is a large balloon.) The "girl's" face freezes in stylized horror as "she" looks between "her" legs. "She" looks down at her feet, then stoops to pick up the "baby," a foot-long Norwegian troll with wild hair and a blank expression. "She" holds the "baby" at arm's length for a second, gazing at its face with dismay, then sadly and with resignation, "she" gathers it in her arms and shoves it up against one sagging "breast." This routine, relying entirely on the originality of the idea and the mimic genius of the performer, aided by sight gags, was always a huge success with the heterosexual audience for whom it had been created.

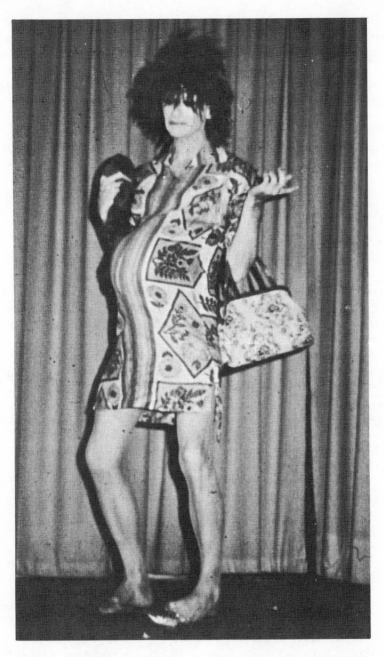

Stacy Lane in comedy drag

While slapstick comics use physical dexterity and visual contrasts to create their effects, stand-up comedians rely on verbal agility. Much as the homosexual subculture values dramatic visual effects, it values incisive verbal wit even more. Because the good stand-up comics possess this specialized gift of gab and have honed it to its finest edge, they are the elite of the profession. The stand-up comic is the specialized, professionally performing version of the best-defined role figure in homosexual life, the campy queen.

The ubiquity of the camp role and style in most homosexual social groups, regardless of the status position of the group, is one of the most striking features of homosexual culture. As camp style represents all that is most unique in the homosexual subculture, *the* camp is the cultural and social focus of the majority of male homosexual groups. The fundamental split between glamour and humor among female impersonators has its foundation not in the female nightclub acts, but in the homosexual subculture itself.

At any given homosexual party, there will be two competing, yet often complementary people around whom interest and activity swirl: the "most beautiful," most sexually desirable man there, and the "campiest," most dramatic, most verbally entertaining queen. The complementary nature of the two roles is made clearest when, as often happens, the queen is holding the attention of his audience by actually commenting (by no means always favorably) on the "beauty" and on the strategies employed by those who are trying to win the "beauty's" favors for the night. The good party and the good drag show both ideally will feature beautiful young men and campy queens. In neither is it likely that the two virtues will be combined in the same person. The camp, both on and off stage, tends to be a person who is, by group criteria, less sexually attractive, whether by virtue of advancing age or fewer physical charms or, frequently, both. Whatever the camp's "objective" physical appearance, his most successful joke is on himself. Almost every joke the camp makes elaborates in the same way on the stories of Snow White or Cinderella; the camp is always the evil stepmother, the jealous ugly sisters, or the wicked queen. His face is eternally frozen in the mirror, as in the female impersonator's comic routine of the "watch queen." The mirror always mocks:

"Mirror, mirror on the wall, who's the fairyest of them all?" and the mirror said (sarcastically), "*you* are, girl." It made her feel so good. But usually the mirror brutally replies, "*Snow White*, you ugly bitch!"

In contrast to the slapstick comics, stand-up comics nearly always dress in the glamour mode, just as the campy queen nearly always pretends to think "she" is beautiful. Of course, the glamour mode is a requisite for impressions of famous female stars, but most stand-up comics, with a few exceptions, wear glamour even if they do not do impressions. This is not a question of hard and fast rules,

but of stylistic preference. And the fact is that for most female impersonators, glamour carries the most compelling dramatic power. From this standpoint, it does not make much difference whether the routine presents glamour to the audience for admiration or for derision.

The glamour image is central to drag performances. At first I thought that this emphasis was exaggerated. I wondered why drag queens' portrayals of women were so limited. Now it seems to me that as in any art form, the non-essential details have been pared away and the core archetype simply accentuated. When all is said and done, does it matter whether Miss America plays the kazoo or teaches retarded children to tie their shoelaces? The glamour mode presents women at their "best," that is, at their most desirable and exciting to men. Glamour is stylized pornography, and the style is. fundamentally in the clothing. The flip side of glamour is prostitution. This relationship is laid bare (literally) in the strip, which begins as a clothing show and ends as a skin show. Both the glamour queen and the prostitute are frankly desirable to men and in this they contrast with the housewife-mother; therefore, they are also déclassé. This scheme of polarities in women's roles is shown below:

| | DÉCLASSÉ | RESPECTABLE |
|---|---|---|
| **SYMBOLIC OPPOSITIONS IN WOMEN'S ROLE** | Bad / Sexy / Exciting | Good / Nice / Dull |
| Strip show | Glamour ↕ Prostitute | Housewife-mother |

But of course women are supposed to be females. The interesting thing about drag queens is that they do not consider themselves to be females and neither do audiences. So if one is *really* a male, it is even more of a feat to look like a glamorous and exciting woman:

I was having a very late breakfast with an impersonator at a restaurant. In the conversation below, the climax of a very heated exchange between us, he is responding to my implicit disapproval — which, unfortunately, I had not been able to hide — of his behavior at a party we had both attended the night before. He said, "I have the *will* to survive. And you know something? I'm beginning to *like* being a *drag queen*." (He spat these words out at me.) "Because they can't touch a drag queen. Even things that will get to a square act can't touch a drag

queen. Because when I'm up there [on stage] life isn't controlling me – I'm controlling it. And the audience can't get to me. The only time they do is when I start to lose my temper, and then I pull myself together. 'Look, Mary,' I say to myself, 'don't let this get you.' And then I'm with it again. And when I'm up there, looking better than anything out there, that is, my age at least, I feel like somebody out there is liking me. And that's how I can go on." He returned to chomping viciously on his eggs. I tried to pull myself together and be professional. "You say the audience likes you and that's how you can go on. How is that different from a straight act?" I asked. "Well," he replied, calmer but still sullen, "a straight act thinks, 'maybe they'll like what I *say*.' "

"So you think they'll like *you* – how you *look*?"
"Yes."

# Two Shows

## PERFORMANCES

The places where impersonators perform are classified as gay or straight (tourist) clubs.[1] There are two basic differences between the two. First, the price of admission and the prices of drinks are almost always considerably higher in straight clubs. Second, the atmosphere of the gay club is sociable and informal, while the straight club is generally anonymous and formal. These two characteristics are closely related; bars are central social institutions in the gay community. However exploitative prices may be in a gay bar, they cannot be more than people of modest means can afford on a regular basis. Many gay bars develop a stable clientele, and the same people can be seen at a particular bar weekend after weekend; in some cases, night after night. Straight clubs, on the other hand, cater to crowds of strangers out for a special event.

Whether a place is gay or straight is a matter of policy that the owners decide. Information about bars circulates through the homosexual community by word of mouth. A homosexual who has had any experience with bars can tell at a glance in most cases whether a bar is gay or straight. Gaudy neon lights, flamboyant advertising of performers, doormen, and heterosexual couples entering and leaving proclaim the straight nightclub at a distance. Gay people know that they may easily be turned away from a straight place if their dress and behavior are too flamboyant or aggressive. The audience in most straight places is composed of couples and groups of couples, so that groups of men are conspicuous.

[1] The crucial thing is not how many people of each type happen to be in the audience, but how the club is defined. In straight clubs, straight rules of behavior must be observed by gay people in the audience. This is enforced by the management.

Gay audiences, on the other hand, are composed mostly of men, and sometimes of smaller groups of women. The few "couples" will be male and female homosexuals in a group or straight people. Adventurous straight people do come to gay bars to see female impersonators, and they are always tolerated by the management, but sometimes meet with open hostility from the rest of the audience, especially if they are making an open issue of their straightness by holding hands or kissing. They are definitely outsiders and they are made to feel it. The performers often strengthen their solidarity with gay audiences by openly denigrating straights in the audience from the stage, thus publicly expressing the general, but sometimes unspoken, hostility.

It may be of some interest that the gay-straight distinction seems to be strongest in the bars that are heavily middle class, and breaks down at the two ends of the social spectrum. The toughest, "lowest" bars seem to be catch-alls for a variety of hardened sinners and those to whom sin is attractive. For instance, in one very "low" bar in Chicago that had a drag show, the audience was composed of a hard core of very tough lesbians, prostitutes of both sexes, flamboyant male homosexuals, and a number of unidentified middle-aged men, some in business suits, some in rather bohemian garb. A similar bar, also near the Loop, had no sexual identity, although it had once been a gay bar. This audience was definitely low class in tone and was described to me by one performer as a "jam" audience, that is, an audience in which everybody jams in together. A similar low bar in Kansas City had a hard core of street fairies and a few whores, but also substantial numbers of straight couples, more "substantial" male and female homosexuals, and some working men.

At the opposite end of the social scale, one chic nightclub that I visited in New York had an audience that was almost evenly divided, numerically and symbolically, into straight couples, who sat at tables in the front and center of the club, and homosexual men dressed in conservative suits, who sat at the back or stood at the bar. The tone of the club and the content of the show were predominantly straight, but this orientation was not as clearcut as at most middle-level tourist clubs and gay bars.

Impersonators also distinguish between audiences by locale. In general, the New York audience is more sophisticated than the Kansas City audience, which is in turn more sophisticated than the Cedar Falls, Iowa, audience. The word "class" is often used to denote locale: the sophisticated New York audience is a "class" or high-class audience. However, performers also make class distinctions per se. The gay audience in Bar X in Chicago is more high class than the audience in Bar Z in the same town, although they are located in the same block and are both definitely higher class than the audience in Bar Y in a different part of town. This means that in Bar X they wear business suits and horn-rimmed glasses; in Bar Z they wear sports clothes, and some men have greasy, slicked-back hair; in Bar Y, whores and pimps are allowed in, and people show

up in working uniforms, such as Pepsi-Cola jackets and truck drivers' caps. In the straight bars, too, class differences of the audience must be inferred from dress, and this is more difficult, as all members of the audience tend to be wearing suits and evening dresses. As nearly as I could tell, all the tourist bars that I visited were predominantly in the middle-class range.

Most performers would rather play in tourist clubs than in gay ones, since the former have higher prestige and pay more for less work. The work is easier in the sense that performances for straight audiences can be routinized and unchanged for a year or so because of the constant audience turnover, while in the gay club the stable audience demands changing performances. However, working in gay clubs is sometimes seen as preferable because of the familiarity between performers and audiences. In fact, the impersonator's basic problem with the gay audience is to maintain some social distance (impersonators must continually struggle to get distance from and command over gay audiences), while the problem with the straight audience is to overcome or minimize that distance.

Because drag bars, from the homosexual point of view, are simply bars that have drag queens performing, and since gay bars are the centers of sexual and social activities, the performer has to battle for the attention of a restless audience for whom the show may be a purely secondary concern. Second, as the impersonators put it, "You are performing to your own people, and they think they own you." This means there are certain demands made by the gay audience on an impersonator and a constant strain toward a familiarity that may be contemptuous. Third, the gay audience is extremely competitive with and critical of the performers. Since the drag and camp roles are integral to the subculture (see Chapter Five), the audience has an easy basis for comparison; in order to win the respect of a gay audience, the performer must be a better drag queen than any informal drag queens in the audience, and he must be campier than any informal camps. These considerations are interwoven in the following interview excerpts:

I:    With me, I'm more relaxed working with a gay audience than I am working with a straight audience, and yet, I really don't like to work to gay audiences.

EN:    Why is that?

I:    I don't know. It's as though I'm being, not scorned — scrutinized — what would you call it, very minutely, by all those tiny little red and green eyes looking at me and flashing at me like . . . Whereas a straight audience says, there's a heavyset broad there, she sings and talks and is kind of funny and they let it go at that, whereas . . . but yet, I *like* to work to gay audiences. I enjoy, because my manner is much easier. But if I had the preference of working to a straight audience or a gay audience, I think I would prefer the straight audience.

EN:    They don't scrutinize you as closely?

I:   Well, they don't do that come-on scene, that holier-than-thou scene that so many queens are famous for; they sit and pick you apart . . . they will dislike you perhaps for something . . . let's say your couterier [sic.], your dress, your costume isn't quite what *they* think it should be. And rather than be impressed with what you are saying and how you are trying to amuse them or entertain them, they will be more interested in saying, hmmm, the dress, the color or the style, the fit, or whatever, you know? . . . I think there are certain standards or certain things that gay audiences *expect* you to say . . . campy little bitchy statements that they probably have heard a million times before you said it, but still, they expect it to be said sometime during the course of your engagement or one of the times they come to see you . . . although as I say, with a gay audience it's . . . I work easier, much easier . . . it's like rolling with the punches when you work with a gay audience. They build you, you can build to a point *with* them. But the moment they want to fight you and the moment they are not receptive, they make it very clear that they dislike you, or that they are not receptive to what you are saying. But with a straight audience, whether they like what you're saying or doing, they will sit through it.

EN:   They're [straights] not as demanding?

I:   A straight audience? No, no.

Both the advantages and the disadvantages of working to a gay audience spring from the framework of common understandings that performer and audience share, as three different performers told me:

I:   Well, of course, being a gay person, and working for a gay audience, there's a certain rapport between a performer who is gay and a gay audience. I mean to start with. And working for an absolutely straight audience, a tourist audience, I feel that . . . when . . . first you must establish with a tourist group what you are, like letting them know that you're queer. Get this out of the way right away and it's never thought of again. But with a gay audience, you see, these things are more or less taken for granted; you automatically have a rapport. However, working with a gay audience, sometimes I find can be very difficult. Because you get into a certain area of . . . oh, bitchiness and you know, campery and name calling, for the simple reason that they know what you are, and you know what they are. But with a straight audience, if you're working to them and you make a particular comment, or you do a particular line and there's some reaction from the audience, like a heckler would shout out an answer; well, then I feel that you have the advantage that you can put 'em down so easily, and quiet them, shut them up, or whatever.

EN:   Would it be harder to put them down if it was a gay audience?

I:   Yes, because unfortunately my experience with the lady hecklers are that they are very persistent. Once they start, they usually have diarrhea of the mouth, and it's like the world's worst thing . . . you know they always try to top you. . . .

I:   I'd much rather work for a gay audience than I would for the straight people.

EN:   You would? Talk about that a little. Why?

I:   I think, well, in the first place, you can get more familiar and uh . . . find out more from the gay kids. Where with the straight audience, you don't go up and talk to them and ask them questions unless they ask you to come join them at their table or so forth. I think the gay audience is more broadminded; they accept things much better than a straight audience. Straight people come to look at us as . . . out of curiosity, probably, and . . . well, I don't know; to see how the other half lives, I guess; I don't know. Like a side-show to them.

I:   Homosexuals are all egotists. Sometimes you'll see this place jammed on a Saturday night, maybe 200 people. But it's not a group, it's just 200 queers. Each one has his problem that he's been thinking about morning, afternoon, and night, and he even dreams about it (laughs).

EN:   Yes, I see. It makes it hard to involve them.

I:   You have to get their attention, work hard. Otherwise they'll start talking and carrying on. I tell three or four different jokes at first, to see what kind of a crowd it is, how I can reach them. . . . Then, too, gay people are critical. Each one is sitting there thinking, "I'm prettier than she is; I've got a better dress and wig I'll wear to the next Halloween drag ball," and so on. Or, "If I'm not prettier, I've got a little twenty year-old boy at home who is." They're critical about the show, too. Each one thinking, "I know the lyrics better than she does, I can sing better," and so on. . . . Now also, you have to please the gay kids. They own the gay bars.

EN:   How do you mean?

I:   The other night we had to ask a young man to leave. As he went out, he said what all the others were thinking: "I've dropped thousands of dollars in here and you can't kick me out." They own the bars.

The problem here is that the impersonator can only succeed with gay people by playing on the common understandings and the group identity. At the same time, the impersonator has to be able to show superiority and excellence in appearance and/or verbal wit to overcome the competitiveness of the audience and maintain respect. The audience knows drag and it knows camp; it expects to see a good show. In fact, the homosexual audience in relation to the drag queen has all the characteristics of a "committed" audience.[2] The demands of the gay audience, to exemplify glamour in drag, to come out on top in verbal exchanges, to articulate and express group sentiments, are extremely draining on performers. At best, however, a powerful catharsis is effected. The atmosphere in a gay

[2]Charles Keil, *Urban Blues* (Chicago: University of Chicago Press, 1966). Keil invented this useful concept for the Black audience for blues singers. It contrasts with middle-class "appreciative" but essentially nonparticipatory, detached audiences.

bar during a good drag performance is electric and consuming. The verbal appeal of the campy drag queen is relatively easy to analyze, but the visual aspect, while equally important, is more elusive. I would guess that the gay audience identifies with the successful sex-role transformation that the beautiful drag queen exemplifies. In comic drag, the performer always tries to focus the attention of the audience on performance rather than on appearance:

I:    Um ... in a gay bar, with a gay audience, you come out, and [you let them] know right away, quick-like, that you are *not* a thing of beauty and a joy forever, as quick as you possibly can. But you don't do it for the same reason that you do with a square audience. With a gay audience, you come out and let them know immediately how you feel about it, so they won't be sitting there thinking, "She thinks she's a thing of beauty and a joy forever." Because then you'll *never* get them away from looking at you until they can find something wrong with you. . . . You can say the first thing that comes to your mind, because the audience already knows. . . . I say something like, "Don't I look like a knocked-up rainbow," or a pregnant pigeon, and so . . . so that the audience is with you.

The way is then cleared for the impersonator to become a professional camp. Many impersonators say that the homosexual audience is envious of them because the queens would all like to be wearing the drag themselves. This is probably true in some cases, but the role of the female impersonator as a public homosexual accounts for all the popularity, with room to spare. The impersonator, like the camp, is flaunting his homosexuality on a stage, without any apology. Not all gay people want to wear drag, but drag symbolizes gayness. The drag queen symbolizes an open declaration, even celebration, of homosexuality. The drag queen says for his gay audience, who cannot say it, "I'm gay, I don't care who knows it; the straight world be damned." "Live" impersonators whom I saw working in gay bars almost invariably "put down" any obvious heterosexuals who happened in, to the great satisfaction of the gay audience.

Despite the satisfactions in performing for "your own people," most impersonators would rather work to straight audiences. The reasons usually cited are the greater pay and prestige in "tourist traps," coupled with the fact that the work is not as hard. However, the impersonator performing to a straight audience is the dishonored, or the representative of the dishonored standing before the honorable. The aim of performing to heterosexuals is to use all the resources of the stage situation plus one's own talents to gain mastery of the audience. This means that the impersonator must get the audience to *accept,* rather than tolerate or reject, the feminine image, despite the fact that the audience knows the performer is a man:

EN: Now I'd like to go back to something you said toward the beginning. You said something about the first requirement of performing was putting the audience at ease and making friends of them. Could you talk some more about that.

I: Well, I told you.

EN: Are you implying that [straight] audiences can be hostile to drag?

I: Oh, God, yes! There's always the hostility of the straight audience toward a man in women's clothes. The women are always envious. Let's face it; they don't like looking up on the stage and seeing some boy maybe looking better than they do.

EN: What about the men?

I: They're worse. It . . . emasculates them. I don't know . . . a man in women's clothes does something to the manly ego. (Hesitates) People are always frightened of things they don't understand. You and I and the gay kids are used to it; it's a part of our lives, but it's different for the straight people. And then, so many of the kids take themselves so seriously. A straight audience won't stand for that. You know, they're married to the mirror, and they walk out only thinking of how beautiful they are. You have to do drag always with tongue in cheek. My act is all comedy; there's nothing serious in it. I poke fun at myself, to let the audience know I'm not serious. . . . You have to be a psychologist on stage; you have to be skillful, to know how to break down the audience step by step. This, incidentally, is what separates the men from the boys in the drag business, and the pros from the amateurs. If you can't do that, you're not doing anything.

EN: Is it possible that the audience is also hostile because they think you must be queer?

I: Yes, in this country I think so. . . . Right at the beginning I'll do something like look at myself in the mirror and say, "You've got a lot of nerve, fella." Or I say, "Would you ever guess that underneath these furs and curls, there beats the heart of a clean-cut American . . . boy?" . . . Most of the boys in the profession spend all their time on wigs and dresses, and it stops *right there*! Most of them don't want to work. You must work, and you must *break* this mask of femininity. If you don't, people say, "Ahhh, that *fruit!*

In other words, the impersonator publicly admits his dishonor in exchange for the audience's suspension of disbelief. The framework is that of a normal audience and a perverted performer; the performer knows the audience finds his condition bizarre and/or funny, and he laughs with them at himself. The straight audience is then relaxed and ready to be entertained.

There is no doubt at all that straight people, on the whole, find the fully costumed drag queen an object of both fright and contempt. On the other hand, drag queens are hostile to straights and will put down the individual who goes too far:

The performer was attempting to talk to a lady in the audience whom I could not see, and referred to her date as "that fat man you're with." The man shot back, "We'd get along a lot better if you'd address me as 'sir'." This obviously angered Tris, who retorted, "You paid a dollar to come in here and watch *me*; you'd better believe I wouldn't pay a dime to watch you roast in hell."

The man wouldn't give up, but repeated his demand, whereupon Tris replied, with elaborate sarcasm in his voice, "Sir. . . ? I'm more 'sir' than you'll ever be, and twice the broad you'll ever pick up." This drew a laugh from the audience and silenced the man.

The social distance between drag queens and straight audiences is also clearly expressed in physical spacing, and this contrasts strongly with spacing behavior of gay audiences.

In Chicago, one very popular performer came down off the stage as part of his act and held out his hands to the gay audience sitting along the bar. The people in the audience virtually climbed all over each other to touch him. In Kansas City, I saw the same performer come down into the straight audience, and the people at the tables as he walked among them visibly shrank back. At one point he accidentally touched a seated woman, and she actually screamed out, "Get it away from me." At this point another woman jumped up yelling, "I'll touch it," and pulled on his wig. Since the wigs are usually glued on fairly firmly, it did not come off. The second woman then screamed louder than the first, "It's its own hair!" and jumped back. There was a moment of panic in the audience. The performer immediately pulled the wig off himself, showing his short hair, and climbed back on the stage, finishing his act in this deliberately incongruous way. As he said to me later, "I had to break the illusion immediately and show them that I was definitely a man."

Usually, however, the confusion, fear, and hostility of the audience remain unspoken, but dissolve very perceptibly if the drag queen can get some interaction going. If the audience is entertained, if it "gets over that freaky thing" and forgets about the drag and the fact that the performer is queer, then the performer has won. He has drawn them into his frame of reference, and they accept his role playing for the duration.

No matter what happens in the course of performance, the relationship between the drag queen and the straight audience is never that of equals and never free of tension. The drag queen is there to entertain his superiors. As with other oppressed people, drag queens find whatever ways they can to express their anger at their predicament. I once heard a New York impersonator tell a straight audience:

Well, I tell you what, I think I'll do a strip. Would you like to see me do a strip? Let's hear it out there if you would. (There is a pause . . . applause only

moderate . . . and he continues.) You know the more you applaud, the more a stripteaser will take off. In my case if you applaud a lot, I'll take off my skin and dance around in my bones for you. Of course that would be messy. If you don't applaud, you can take off *your* clothes and laugh at each *other*. That'll be gay.

The best way for the reader to grasp the points I am trying to make is to go see some drag shows. In the meantime, I have recorded two shows that speak for themselves. These shows contrast rather strongly. I picked them not because they are average or representative, but because they are special. Both Skip Arnold and Lynne Carter are mature, well known performers who have had the experience to master the usual drag skills and also develop their own characteristic styles. Both performers are adept with both straight and gay audiences.

It happens that Skip's performance here is before a gay audience in Chicago, and Lynne's for a straight one in New York City. Lynne's performance is a set routine with little or no flexibility. He is a "class" performer and his is a "class act." His material is carefully written and worked over. The nightclub in which Lynne was performing was not the most expensive nightclub in New York, but not a dump either. The fact that Lynne can "headline" in a straight nightclub indicates the high status of his act. Most female impersonators are completely segregated and do not appear at all with straight acts. Lynne's performance is impersonal and the atmosphere is controlled.

In contrast, the Chicago club is a perfectly ordinary middle-class men's gay bar. This set of performances is especially unusual, as it constituted a subcultural *event*. Skip Arnold, who had made himself extremely popular with the gay community in Chicago during his eight months' engagement, was leaving the next day for Kansas City. The three shows that I recorded were his farewell to Chicago. Not every evening brought forth such emotion, but no evening at the New York nightclub could have been remotely similar. Skip's performance, in contrast to Lynne's, is loose and spontaneous. The audience feels free to participate, a virtue that finally turned into a problem.

The two shows are very similar in their basic definitions of what a drag queen is and what a drag show consists of. Both have the structure of one performer plus musicians and an anonymous, paying audience. In this they are somewhat atypical, since many drag shows feature groups of performers. They are also atypical in being framed by nondrag performers. In both shows, the performer is a male dressed as a "glamorous" woman, and the reader can tell from my descriptions that there is very strong agreement between Skip and Lynne about how a glamorous woman looks. Both are experienced performers, and this and other similarities are due to long socialization in the professional norms of performance, discussed in Chapter Three.

The performances are alike in their numerous references to the maleness of the performer. This is typical of the more professional, higher status drag acts. The anomaly of a man in woman's clothing is implicitly and explicitly explained by such performers as due to and reflective of their homosexuality. The anomaly is further defined by both as funny (rather than magical, sacred, ritualistic, or other possibilities represented in other cultures). Jokes and funny stories are prominent in both performances. A great deal of the humor in both acts revolves around the stigma of homosexuality, which both accept as a given, and is self- and group-deprecating.

The principal topic of both performances is sexuality. Both performers are basically clowns, and they exploit the license of clowns to "talk dirty" about sex, which our culture does not allow in most public situations. There is an added dimension to this "dirty talk" because it is, in general, much more permissible for men to talk about sex and be "dirty" than women. That stricture is maintained by drag queens, but because they appear as women the jokes seem more risqué. Both performers deprecate women insofar as the women they portray discuss tabooed and unseemly subjects, are preoccupied with sex, and are altogether morally shady.

The differences between Skip's performances and Lynne's are due to the fact that Skip is performing in a gay bar to a gay audience, while Lynne is performing in a nightclub. Of course some of the differences of style are partly individual and idiosyncratic – Lynne's preference for impressions, for instance. But the differences relating to the different audiences are striking. Skip actually tells many more gay put-down jokes than Lynne. Paradoxically, this is due to the fact that Skip's audience is gay and is laughing at itself, while Lynne's audience is enjoying the luxury of laughing at others. Likewise, Skip's performances include much more gay special knowledge humor, in-group terminology, and *affirmation* of gay values.

Lynne's performance is more impersonal, abstract, and structured than Skip's. Again, this is partly a matter of personal style, but mainly is due to the different audience and circumstances. Lynne's performance is a set routine. I have seen him do the same impressions several other times. It has no particular location in time or space. Skip's whole performance is permeated with references to a particular time in Chicago and to a very personalized audience. Drag queens performing to straight audiences typically know almost no one in the crowd, while drag queens in gay bars might know a high percentage of the audience, especially after a long stay. Skip's performance is very specifically localized as it centers around a particular event, his farewell to Chicago. I must stress again that these shows are not typical of drag shows or even of Skip – expecially the 12:00 p.m. show. I have used them because they reveal underlying characteristics of the gay community that ordinarily might not be visible; especially solidarity, familiarity, and competition between audience and performer, both on and off

stage. Particularly significant is the appearance of the other impersonators from the Marlboro during the 12:00 p.m. show, their easy transition from audience to stage, their presentation of flowers to Skip, the open competition between Skip and Ronnie, and the knowledgeable involvement of the audience in it, and finally the collective sharing of the cake and champagne provided by the management. My point is that this drag show became a closed (as opposed to public) community (not anonymous) event (not performance) that would never be possible in a straight bar.

These shows are presented as field data. I have kept my own comments (as opposed to description) at a minimum, and have simply tried to explain what may be esoteric or to emphasize important points. I taped Skip's performance, so it is verbatim. However, I have since edited out what seemed repetitious or irrelevant. Most of my later editing and explanations are in brackets. I took notes during Lynne's show and wrote it up later, so I apologize to him for any inaccuracies.

### SKIP ARNOLD'S FAREWELL

The Shed is a gay bar located on North Clark Street (just above Diversy) in Chicago, Illinois. During the autumn of 1965 there were three other gay bars for men within a two block radius of the Shed, two of them owned (managed?) by the same Italian family that owned the Shed. All of them had drag shows at or about this time. Another very popular "cruising" bar, the Highchair, was in the block but never had drag. The other shows were all record shows, however. The most popular of the other shows was at the Marlboro, right down the block from the Shed. While Skip was the only drag queen at the Shed, the Marlboro featured a show of six different performers. These queens from the Marlboro came to the second show here to say goodbye to Skip. There was a great deal of overlap in the Marlboro and Shed audiences. The former had shows at 10:30, 12:30, and 2:30. Each show lasted about an hour. After each show at the Marlboro, anywhere from 25 to 50 percent of the audience would leave and troop down the street to the Shed to catch the show there. In this way, commuting back and forth, one could see what amounted to a continuous drag show from 10:00 (the first show at the Shed) until 3:30 a.m. (end of the last show at the Marlboro).

In spite of the large overlap in the two audiences, there were some general differences in their character. One impersonator told me that the Shed audience tended to be "more intelligent." It was certainly somewhat more heterogeneous. The Marlboro audience tended to be exclusively male, exclusively homosexual, younger, and more casually dressed than the Shed audience. The backbone of the Shed audience was a slightly older (thirties instead of twenties), more formally dressed (some sport jackets and ties, some suits), more settled core of homosexual men. But it was a rare show that did not also have in the audience

one or two straight couples, a few eccentrics (generally older women of no discernable affiliation), and a noticeable smattering of homosexual women, sometimes in the company of homosexual men. These differences were entirely due to the different character of the two shows.

The physical layout of the two clubs was almost identical. From the street, the Shed was unobtrusive. It had no awning or marquee. A large, dark plate-glass window fronted on the street; if you pressed your nose right up to it you could see some of what was going on within, when the inner curtains were not drawn, A single, small neon sign across this window read simply "The Shed." There was nothing to indicate the nature of the bar or that there was a show within. Of course, men of various ages were always coming in and out, and when the door opened you could hear noise and music. One entered the front door, turned right, and entered at the right rear of the bar. The physical set-up is indicated on page 71.

This particular night was especially significant, because Skip Arnold was leaving after a long run at the Shed to go back to Kansas City. This was his last night. Of course there was no advertisement of the fact, but it had spread around through word of mouth, so that the shows were a bit unusual and the audiences were much larger than on a usual Wednesday night. In fact the 12:00 p.m. show played to a capacity crowd, and the 10:00 p.m. and 2:00 a.m. shows were not much less.

I had checked with Skip before the evening about taping the show and he had agreed. When I arrived at about nine o'clock, there was already an atmosphere of excitement and a larger-than-usual crowd of fifty people, almost all men, who had apparently arrived early to be sure of getting a seat. As I was setting up my tape recorder, Skip, still in street clothes, made the circuit of the bar, talking to various friends and acquaintances. At about 9:30 he went backstage to get in drag and make-up. Just before ten, the band came on stage. There were three pieces: a pianist, a bass player, and a drummer.

### First Show

Band plays introduction, which consist of bass player running up and down the scale while the drummer rolls. This signals the audience that Skip is going to enter. He enters, stage right, briskly, goes to downstage center immediately, seats himself on his stool, which has a back and is covered in blue plush satin, and takes hold of the microphone:

**Skip**:    Good evening, ladies and gentlemen: My name is Skip Arnold.

As soon as he enters, applause starts from the audience and continues through the first words of the first song. In appearance on stage, Skip looks like a

Clark Street

Note:

   Ⓜ – Manager checking i.d.

   x – Bar stools

   Stage height – about 4 feet

hard-bitten but rather attractive woman of middle age. He is six feet two inches, and nearly four inches taller with heels and wig, but he does not seem that big on stage. It is only when he comes off the stage and is seen with others that one realizes how gigantic he really is. I had heard many people in and out of the Shed discuss how shocked they were when they first stood next to Skip and realized his size. (His 200 pounds include a very overweight middle section, but Skip dresses well to minimize this.)

For the first performance he wears a rather plain, sheath-like dress, cut low with spaghetti straps. It is an arnel red and black floral print with a free-flowing panel in the back, knee length. He appears to have an extremely ample bosom, and what looks like the beginning of deep cleavage shows at the top of the dress across his chest. His ensemble includes high heels, opera hose, long, dangling rhinestone earrings, and a bluish, shoulder-length wig in a bouffant style. He wears no gloves. His bare arms are quite hairy but not grossly so, as are his legs if you bother to look (he tucks his legs under him on the stool). His nails are long, pointed, but have no nail polish. He wears a large gold ring of ambiguous sexual affiliation. His make-up is heavy, like TV or nightclub make-up for a female entertainer: false eyelashes, penciled eyebrows, "doe-eyes" with much eye-shadow and eyeliner, heavy red lipstick, rouge, and a penciled-on mole on one cheek. A close look at his jaw reveals the shadow of a beard, but this is by no means intrusive. His entrance is commanding, confident, energetic. His gestures are large, expansive, but convincingly feminine, in a stagey way. He uses his arms and hands continually, both while talking and putting over a song, cocking his head from side to side, commanding the audience with a direct gaze. (Actually he is very nearsighted and sees individuals in the audience with difficulty. This problem is increased by the single spotlight on him, and the relative darkness — the bar is kept quite dark during show time — of the audience area. However, he has keen hearing, so that he can identify people easily by their voices and hear sounds and conversations at the far end of the bar.) His usual speaking and singing on stage are in the ranges of a low contralto voice. This is not falsetto, but the very top of his normal baritone vocal range. The impression of femininity is conveyed more by the intonation, stress, and pronunciation than by the pitch itself. This intonation is parodying sweetness, rather mincing. It is a convincing imitation of affected female speech style. Of course he varies the tone and stress for special effects, especially to break the female illusion. The accent is definitely southern mid-west.

The piano plays a four bar introduction to the first song. During this introduction, Skip seats himself on the stool, puts his hand to his mouth and loudly clears his throat, emitting a low and distinctly male vocal sound: the arrangement of the song has a bluesy tinge. Skip (*in female voice*) sings "You Are My Sunshine."

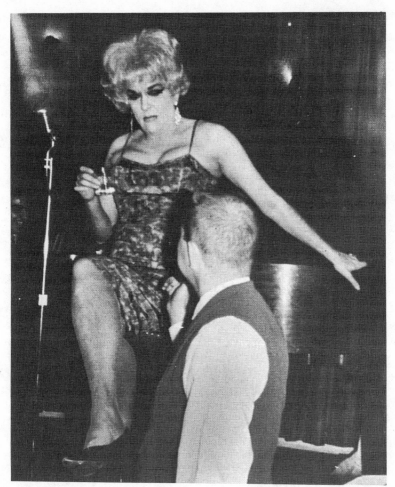

Skip Arnold

The band breaks immediately into the introduction to another song. Skip raises his arms to the audience to signify the ending. The applause is vigorous. During the first song the audience was quiet but excited, lots of movement, and occasionally someone yelled out a word of encouragement: "Yeah" or "Go" or some such thing. The song was done in a definitely up-beat style, signifying the swinging beginning of something. Skip starts immediately into the next song:

S:   (*sings*) "Singin' in The Rain."
(*Repeats two times, each time a little more up-tempo, a little louder, and modulated up a key. Song finishes to applause and shouts.*)

S:   Thank you very much. Thank you. Well, here it is Wednesday night, first show. Oh God, I've had a day and a half today. I've been packing all day, and um, I never knew I owned so much crap before in my life (*this last word is drawn out with emphasized mid-west drawl*). You'd be surprised the things I've been goin', you know, through . . . the dresser drawers, and things I didn't even know I owned anymore. Like a pair of skivvies that has *valentines* all over them. (*laughs*). And I *know* they're not *mine*. And I can't remember who left 'em there. But he must have left in a hurry, in the condition they're in. (*Some people laugh; someone yells "oh" and his intonation implies, "how delightfully raunchy."*)

S:   (*Looks toward the person who exclaimed*) You understand that one, you dirty bitch! (*laughs from the crowd*). And oh, there's other things, like, you know, one earring. I've been saving those in case Yul Brunner ever makes a come-back . . . and some shaving soap and a brush; Williams shaving soap and a brush. And it must have been there when I got there, because uh . . . I don't use that kind of stuff to shave with (*his voice has gradually been getting lower, more frankly conversational*), I get one of those aerosol cans, you know . . . (*One person in the audience, male, giggles.*)

S:   (*As an aside*) Thank you, dear. (*This gets some good laughs from others in the audience*) Have you ever gotten up in the middle of the night and didn't turn the light on 'cause you didn't want to embarrass anybody, and all you had was some aerosol shaving cream? (*He laughs a loud, suggestive laugh.*) Oh, my God, if you turn them over, looks like they're frothing at the mouth . . . (*Breaks off the last word as if the whole sentence were completely off-hand*). (*Enthusiastic laughs from audience.*) [The reference here is to male homosexual life – the aerosol shaving cream is proposed as a substitute lubricant for anal intercourse.] But anyway . . . (*Pauses for a few more laughs, then looks down at bartender closest to stage*). Little darlin' would you pour mother a little something to drink in a glass. (*To the audience*) I never know the bartenders. We have changed bartenders here so often, it looks like the Greyhound Bus station down here. [Another gay reference. Greyhound Bus stations are infamous pick-up and hustling spots. Skip alludes to the quick turnover in hustling sex.] Anyway, we're gonna sing a song for ya. Doesn't that excite ya? I'm so excited I'm all overcome, and (*voice and speaking manner reverting to drag*) (*general laughter*) . . . Oh, my God, we haven't done this in a thousand years. (*Band starts introduction. Skip again clears his throat in a loud masculine way and speaks over the music*): You notice how my chest is all swollen up tonight? Somebody bit me last night. . . . Here, and here. (*Points to one breast, then the other*). (*Laughter.*) [Two dirty stories and a song are omitted here.]

S:   (*He speaks again, with renewed speed and enthusiasm, conversational male tone.*) He loves to drink, he loves to drink. He's got this drinkin' buddy of his, Tony. Everybody knows George and Tony. And they were out havin'

a . . . Chesterfield you know, suckin' up a beer? Well it was before the show. And all of a sudden, this man walked in, wearin' one of them . . . (*Bartender interrupts, bringing up a message on a little piece of paper. Skip takes it, and speaks to the bartender.*) I thank you very much. (*Reads the note, then speaks to the crowd.*) We just got a message from Govern . . . oh, my God, somebody writes a little hand, it must be Craig. . . . I'll hold on and do it again (*refers to the note*), and this man walked in . . . he's wearin' one of these suits, I know you've seen them. They're all striped, chartreuse, pink, and lavender? He said, "Hey George, I'll make you a five-buck bet that one's gonna order a pink lady." The man said (*in a loud masculine voice*), "I'll have a straight shot with water back." He said, "O.K., lost the first five bucks, still bet she's gonna order a pink lady." The man said, "I know what the hell you're talkin' about. You're talkin' about my suit." He said, "It ain't my fault. I sent my wife out to buy it. I told her, I said, 'Honey, would you go out to Cox's and buy a seersucker suit?' and she went to Sears." [Cox's is a department store in Kansas City. Skip told me he was warming up his Kansas City jokes for his next job. The joke is fairly obvious anyhow. Here homosexuals laugh at the joke that they are called cocksuckers, wear special lavender suits, and order "ladies' " cocktail drinks.]

(*Very loud, prolonged laughter at this. Skip looks over audience which breaks into renewed laughter each time another person gets the joke, and says, in lecturing tone*): Well now, you didn't come in here to hear me sing "Come to Jesus," let's face this. (*More laughter*). And you know, living right next door to him and me is this little old lady. She's a hundred and eight years old, God love her. Lord knows, she's too old for anybody else. She stands up here on Walgreen's corner, I don't know whether you know it or not, but that's a damn good corner for a workin' woman. I made two bits up there this afternoon. Skinned the hell out of my knees, though . . . that curb service'll kill ya. [It's a good street corner for a prostitute. The image here is that he kneels on the sidewalk "blowing" (performing fellatio) on passing men for quarters.] She was standing up there, and all of a sudden, the wind blew her dress up, and she grabbed hold of her hat. And this boy said, "Pull your dress down, you ain't got no pants on!" She said (*old person's voice*), "What you're lookin' at's a hundred and eight years old; this hat's *new*!" (*Loud general laughter*) [He tells another story and sings a song.]

S:   Thank you, thank you darlings, thank you. Well, let's see what we got . . . (*Takes a note out of bodice*). Oh "read it later." It says "read later," and we will. I keep . . . I had something in my throat all the way through that (*laughter.*) A farewell present from a good friend. [Reference to fellatio.] (*To the pianist*): Would you like to play me some fairy music, darlin'?

(*Pianist starts "Fairy Tales Can Come True."*) [Skip had a whole collection of these "fairy tales," which were his reworkings of traditional fairy tales to give them a homosexual dimension.]

S:    I'd like to tell you a fairy tale from the book of fairy tales, as told by an old fairy. An old blue-haired fairy (*pats wig*) (*Laughs.*) I really look good tonight, though. I think I look gorgeous . . . with these bangs and this blue hair. I look like a knocked-up pouter pigeon . . . or robin redbreast. Oh well (*clears throat in low voice*) maybe it's what you're smokin' out there, my God . . . Mexico. We'll just sit here and hold our breath and we'll all go together. With our luck, it'd be the same paddy wagon. Well (*his voice now in a completely male tone*) there's some food for thought; you think about that a while. I . . . I've never been to a city like this before. You know it's so exciting to come to town and find out that *everybody* has a set of jokes they tell you. And so . . . you know . . . you try to make friends and influence people, and you laugh, and I was telling some friends that I was over to see the other night that the same jokes that are going around, that they now call Polish jokes, were once Jewish jokes, Puerto Rican jokes, Negro jokes; any, you know, minority jokes. I can't wait until next year, when the Mattachine turns all those same things into queer jokes, you know? Oh, if you think we're not gonna march *then*, you're out of your mind. (*Very general laughter.*) We've suffered the slings and arrows . . . which ain't bad, if you're S and M. [At this time, November 1965, the Mattachine Society was well known in the gay world as virtually the only "civil rights" organization for homosexuals. Most gay people wanted to "be equal," but could scarcely imagine what that would mean. Not many took Mattachine seriously, although it aroused a lot of interest. Skip was intrigued with Mattachine, and here started in a positive vein and began to express his rage at being a "minority." Then he turned it into a joke *against* the gay people who like suffering – the sado-masochists.]

S:    (*Skip signals to piano player, who starts up "Fairy Tales Can Come True" again.*) Once upon a time, in a far off kingdom, there were three pigs. (*During this opening line, he arranges himself again on the stool, looks at his bare arms.*) I feel hair growing. And it's long, too, my God (*chuckles to himself*) uuww (*laughs to himself again*). A . . . now the first pig was a square pig. He was so square he thought *I* was real . . . well so did I, for a long time . . . until I got trapped in a revolving door at the Greyhound Bus Station. (*Audience laughter.*)

And the second pig was a musician pig, so he was hep; and the third pig was a . . . she was, well (*exaggerated faggot intonation and slight lisp on "she"*) you know, everybody called her "Sissy Pork," you know. (*Laughs.*) God, talk about a nellie pig. (*Laughs.*) And they all thought they'd build themselves some houses. Now the first pig, the square pig, he built his out of bricks and mortar. And the hep pig, the musician pig, he built his out of scotch tape, and red lights – oh it was a crazy pad, jug of wine, and a loaf of bread, and (*makes sound of intake breath*) "Oh mother, you laid a roach on me" (*this said in deep Louis Armstrong voice*).

Sissy Pork (*high voice*) she built hers out of crepe paper, and sequins (*laughs*), and she had a mirrored bedroom, much-used lace curtains (*much laughter*) . . . Why is it the girls always understand that and the boys never do? In other words, she done it up brown. Now we're back to the boys again. [Refers to anal intercourse: "the boys" – men who take the insertor role – do not understand.]

Well, anyway, just like advertised, here come the wolf down the highway. He just simply by-passed the square's place altogether, went right over to the hep pig's pad, knocked on the door. The pig said (*deep Armstrong voice*), "Like who calls?" The wolf said, "How do you get to Carnegie Hall?" The pig said, "Practice, dad, practice." He said, "Don't stand on that bag of bagels man. Come on in and listen to a little bit of Brubeck." The wolf said, "I'm gonna eat you." He said, "Cool it dad, I don't go that route." [Wolf says "I'm going to eat you," as in traditional stories, pig interprets this to mean "I'm going to blow you," that is, "I'm gay." This is implicit in pig's reply: "I don't go that route" – "I'm not gay."] "Tell you what though (*voice indicates that musician pig is speaking*), you make it about a half a mile down the road, you come across my little gay brother, and he digs a party the most." And with that (*voice higher*) he turned the stereo so loud, it shook the wolf.

He took off down the highway, a half mile . . . and there she was, a-waitin', Sissy Pork (*last two words with "faggot" pronunciation*). She had a marcel in her   cork-screw tail, spoon-heeled shoes . . . he said, "I'm the big bad wolf." She said (*he imitates the pig's coy stance while replying*), "Why aren't you huffin' and puffin', baby?" (*laughs.*) He said, "I'm gonna eat you." She said, "Wouldn't you know it . . . (*disgusted look*). (*Audience cracks up.*) Well, God damn it, don't stand in the door, I've got neighbors!" She took him back there to the mirrored bedroom, she started to close the door, she poked her head out . . . she said, "That's the way it goes, girls. Yesterday's wolf is today's sister." [By saying "I'm going to eat you," the wolf says "I want to be the passive one (sister) in sex in spite of my masculine appearance. Masculinity is admired and desired by many gay men, but the saying is that "today's butch is tomorrow's sister," that is, there is an inevitable progression toward greater effeminacy.] (*Piano strikes up "Fairy Tales" again.*)

S:    (*singing over applause*)
So fairy tales can come true,
It can happen to you,
Just stay young at heart.

S:    Thank you, thank you very much. Thank you darlin's. (*Long applause*) Oh, knock it off!

Voice from audience: Kansas City. (*A song request*)

S:    All right. Right now, we would like to introduce to you a young man who does such a fabulous job of singing, in fact he's thrilled audiences for quite

some time. I would like to say, he has a hell of a cold, but right now here he is to sing for you, the way you like to hear those songs sung. Ladies and gentlemen, Mr. Shed himself. (*By now Skip is standing. The introduction was made as a female emcee might do it. Now he holds his arm out to stage right, directing audience's gaze to Sandy's entrance.*) Mr. Sandy Byrd! Let's bring him out here right now! (*Sandy makes his entrance. Skip hands him the mike and encourages audience applause with a gesture. Piano strikes up introduction. Skip exits stage right and disappears. Sandy begins his song. He is a young Negro man, about five feet eight inches tall, slender, with a pleasant face and medium dark skin. He is neatly dressed in a perfectly ordinary suit, with a slightly flashy silver tie. He wears a pinky ring. His voice is a pleasant baritone; his style is somewhat like that of Johnny Mathis. The style is straight nightclub, not Negro or particularly gay, although his expression is slightly "pretty." Sandy used to work in glamour drag at a nearby gay bar, and this is probably known to a good portion of the audience.*)

S:    (*Skip re-enters, stage right, in a black, ruffled, off-the-shoulder tulle dress, with a full, floor-length skirt.*) "Sandy Byrd, ladies and gentlemen, Sandy Byrd." (*Skip exits again.*)

Trio plays for about ten minutes. During this interval people in the audience move around, talk, go to the bathroom; there is a rash of fresh drink-buying, and some leave, either to go home or to another bar. During this band spot, Sandy comes from backstage, orders a drink, and strikes up conversation. Near the end of the spot, Skip appears among the audience, in slacks, sports shirt, men's shoes, without wig or earrings, but with the full facial make-up. Many people at the bar try to get his attention, introduce people to him, and so forth. He moves around with his drink, talking to as many as possible. Most of them have met him before. Those who haven't, or haven't seen the show before, gaze curiously but not rudely at his make-up. There is no sense of discomfort. On the contrary, most of the crowd, which by now has partially broken up into small conversation groups, acts as if they are on familiar social terms with him. About eleven-thirty, he breaks away from whomever he is talking with, and goes backstage to get in drag for the 12:00 p.m. show. About this time too, many new people come into the bar. By show time the place is packed.

**12:00 p.m. Show:**

The band starts the introductory drum roll and bass run. Skip enters stage right, now wearing a long blond wig and a floor-length black gown. The shouts from the packed audience are even more enthusiastic than on his entrance for the first show.

S:    Good evening ladies and gentlemen. My name is Skip Arnold. (*Long applause*). Thank you. (*Sandy sings several songs, then Skip re-enters.*) (*Band plays introduction. Skip seats himself on blue stool.*)

S:    (*Sings "Bill Bailey, Won't You Please Come Home."*)

(*In the middle of the song, his voice starts to break and he actually stifles sobs. He calls out, with the air of someone who is pulling himself together*): Could I have a *drink*? (*He sounds a little put out with himself. This is the beginning of the emotional outpouring in the second show surrounding the "farewell."*) (*The piano repeats the phrase without a break, giving him a chance to recover, and he finishes. The audience applauds this spirit of "the show must go on." Total applause at the end of this number, 40 seconds. Skip punctuates it with "Thank you's."*)

[Both these songs and others of their ilk are often sung in drag shows. These songs are sentimental yet "gutsy" and are often about romantic suffering and unrequited love. They make an interesting contrast with male homosexual sexual promiscuity and cynicism.]

S:    Well, here we are on the second show. Lord God, how many times have I said that? You know I was backstage thinking . . . about this club. You know when I first came here, eight months ago, you know, it was strange, walking into a place where all of a sudden you sit up here and you find that — and I'm blind as a bat, you know — and (*laughs*) I can't see half the people who came in. I can remember the nights when I used to get — you know Saturday night has always been a mystery to me in this place; in fact I wish I were going to be here to see what *happens* on a Saturday night, because during this entire time, I have [There are usually four sets on Saturday instead of the daily three.] never been sober enough to see a fourth show. None of us have, as I recall. The band used to get just pissed out of their minds, you know, but they had to help *me* off. And Bob (*the band leader*) would say, "What are you doing?" And I would say, "I don't know, God knows." Well I have been here — in a short time, as you'll recall, a wonderful guy (*his voice breaks*) a very dear friend, who's working tonight, and I like him so very much — Robin White was here, remember? Robin came back stage, and she said to me uh . . . (*fumbles for words*) . . . we have to say "she," you know — *What the hell!* — so she came back and [Robin White is male, a drag queen who had performed at the Shed at one time. Drag queens almost invariably refer to each other as "she" among themselves, and often as "she" in gay company. The use of "she" reflects intimacy and social comfort. It is not professional — distant, formal — to refer to a man as "she" on stage.] she said, "Do you think you're gonna make the fourth show?" and I said, "I've never missed a fourth show yet," so she said, "Well, maybe I'd better go out first." So she came out and she announced it, and I hadn't even spoken to Bob, and so when I came out I said "Well what are we doing?" and he said something and I sang one song and he played another, do you remember? Oh, it was beautiful. And no one in the audience knew the difference.

Well, I have met so many wonderful people when I've been here, I'd like to say thank you to some of them, right now, who are here, because they have a

show of their own. [All of the people mentioned are the drag queens from the show at the Marlboro down the street.] I would like to say thank you, first of all, to a wonderful guy who has been a very dear friend of mine, and has sort of been down here on his night off, bolstering me along by showing me the beautiful men he can have with him, and this didn't do too much for my morale, but I would like for you to help me say thank you to Lillie. (*Lillie is standing where visiting drag queens somehow usually stand, on the stage left side of the bar, at the far end from the stage. He is in his "face" but no other drag. A little space clears around him, and the audience applauds, drum rolls, cries of hooray.*) There is another little guy who has put up with that blue wig of mine more than anybody else in the world, and he has been very dear, both factions of his family (*reference to Jeri's "husband"*), but I think only one part of them is here, would you help me say thank you to Jeri Noble. [Jeri was a young and very "pretty" drag queen who also knew how to set and care for wigs. Jeri and his butch "husband" who was a bartender at the Marlboro, were a handsome and well known couple in the area.] (*More applause, drum roll. Jeri is standing also with "face" but no other drag near Lillie.*) Oh, and there's so many thousands of others. There's like — Ronnie. Is Ronnie here? [Ronnie was a clever and talented young Negro drag queen. He was the "boss" of the show at the Marlboro and was active in all drag events in Chicago. Skip and Ronnie were rumored to be rivals and competitors, and all gossipers promoted these rumors. You can see here how the audience and Ronnie himself force or encourage Skip to "dish" Ronnie, to enter a hostile verbal interchange. The problem below is that Skip was thought to have called Ronnie "old".]

Lillie:    Ronnie's here, honey!

Skip:    God love her. Ronnie, you old. . . . I would like to tell you something about Ronnie. That I've never had a chance — you know we have this little friendly thing going between us . . . you know, screech and scream, but you know in all honesty, I must tell you that I knew Ronnie years ago, when I wasn't even young, but *she* was, and uh . . . (*catty laughs from some in audience. Skip tries to correct this*) she, which hasn't been really that many years ago (*more catty laughs*) . . . but anyway, I was in San Francisco, and this child, actually, as I recall, if I'm not too mistaken, you weren't actually of age?

Ronnie:    No I wasn't.

Skip:    Was *not* of age. There you are, God love ya. . . . Came up and auditioned. . . .

Ronnie:    (*There's a hostile edge on his voice*) Are you saying you can't see me over here? ["Are you saying I'm Black?"] (*Cries and laughs of delight from audience. They anticipate some sharp words.*)

Skip:    Well now that you've *smiled*, I can. [Comeback: "Yes, I can only see your teeth."] (*Even louder cries of joy from audience, and applause.*) [Skip has

a reputation to uphold as the drag queen with the readiest putdown. To hold up in a "dishing" contest is much admired.]

Skip:    (*Having won the joust, he continues.*) Ronnie came and auditioned at the 220, and I didn't see Ronnie until a few years later in Kansas City, and Ronnie came and worked and just set the town on fire. [This is a blatant lie; Ronnie hated Kansas City and was not well received.] And then came up here and worked; and *actually*, Ronnie is the mother of drag in this town. This boy has worked so hard, and has brought you so many, many wonderful personalities, plus his own great personality; will you help me say thanks to. . . .

Bob (*The band leader*):    I would just like at this time to say something. This is a very true story that a lot of you people don't know. Skip and I have often laughed about it since. But when we first started here, I started here with a bass man, and the second week the bass man never showed up and he sent me a flute player, if you guys were here you remember that. So I got a hold of Max, and the three of us played and we added the drummer, and then Skip came. Well I, in all sincerity and truthfully, fought . . . Skip's coming the most. I bucked it and said, "Oh, you don't want a show here, you got enough shows. Let's just keep it music and a quiet bar," and they said "No." So Skip arrived, I met him, on a Monday night, I believe, cause you (*looking at Skip*) opened on a Tuesday, the seventeenth.

Skip:    That's right.

Bob:    Right. And, I was introduced to him, and I didn't think too much, so he said, "Let's have rehearsal." This is the honest to God truth; he walked into the club on Tuesday evening; we rehearsed twenty minutes, and from twenty minutes rehearsal, I knew this man was one of the greatest pros I ever worked with, and not only that. . . . (*Skip twitches one hip, and the expression on his face clues the double entendre on "prostitute." Laughs from audience. Bob continues*): And we started the show and we did 'em right on up, and we've come out here many many nights and just pulled things right out of the bag that no one knew without any rehearsal and done it. And at this time, we'd like to present Skip with a going-away present from the management of the club. (*Applause. Bob hands Skip a small box, which he opens.*)

Skip:    Oh, isn't that *gorgeous*! Look, it's a watch. I was never on time. Oh, it's beautiful. Thank you Anthony (*club manager*) and thank you everybody. (*His voice indicates he really is touched.*) Oh, God love you, that's marvelous!

Bob:    Because we want him to come back. He said he would come back. (*Sandy comes on stage and takes the microphone.*)

Sandy:    And on behalf of all the customers and friends of Skip Arnold since he's been in Chicago, it has been a great privilege and pleasure for me to work with Skip, because Skip sort of started me in this business. I used to wear skirts and high-heeled shoes, and he used to paint my face when I first started. It was a

great privilege for me to work with him here, and I do hope that he'll come back. And as one of his famous jokes says, if he wants to read what the card says, pull it out. (*Hands Skip a bunch of roses.*) And now the kids from the Marlboro would like to parade . . . uh . . . present Skip with some gifts too. All right, Jeri Noble . . . (*Jeri Noble enters stage right, with make-up on but in men's clothes, holding a bunch of flowers. He is a glamour performer at the Marlboro, a young, very handsome man with a ready smile and good manners.*)

Jeri:    (*Taking the microphone*) I just wanted to say that doing Skip's wig was a challenge. (*Loud laughter from audience and Skip.*) (*All these voices are interesting, as none of these performers except Ronnie works live. They are all high and light, the self-conscious voice of a drag queen.*) (*Jeri jumps off stage left and merges into audience.*)

Sandy:    That grand old lady, Lillie . . . (*Lillie enters stage right, presents Skip with more flowers to audience applause and "strip" drum cadence.*)

Lillie:    From one old lady to another, I want to say, love you, Skip Arnold. (*He too jumps off stage to applause.*)

Sandy:    And now Wanda . . . (*He enters also holding flowers, in "face" but no drag. He is a tall young man, a very light Negro with delicate features.*)

Skip:    Wanda!

Wanda:    All I have to say is that I wish Skip Arnold all the w . . . best in the world for him. I've known him for a little time, but he's been a beautiful person to know, really. (*Applause. He hands Skip flowers, then he jumps off.*)

Sandy:    And last but not least, that one and only, Ronnie Winter! (*He enters holding the biggest bunch of flowers of all. He too has "face" but no drag – a sign that he, like the rest, is between shows.*)

Ronnie:    Thank you, and we hope we will see you again soon. And I hope that I get as old as you and as *famous*. (*Laughs from audience; Ronnie has gotten back for the earlier put-down. Applause. He jumps off too. They all unobtrusively leave about five minutes later, since they have to do a show down the block.*)

Bob:    And now on behalf of the band . . . this guy's a pleasure to play for, because he's so easy, because you never worry about him. And now at this time I'd like to present him with a little personal gift, something to remember me by, I hope. . . .

Skip:    (*Sounding dangerously close to tears*) Remember you by? (*Skip looks down at himself. You can hardly see his body, he is so burdened with the flowers presented by Sandy and the Marlboro performers.*) I look like a well-kept grave. (*Applause, whoops, laughter from the audience.*) (*Bob hands him a small box, which he opens.*) Oh, my God! Isn't that gorgeous! (*Holds up a large gold ring set with I think a tiger's-eye stone.*) Oh Bob, it's beautiful. (*He

*slips it on.*) Oh, and who said I couldn't get engaged in Chicago. (*Laughs, applause, shouts of hooray. Very loud applause lasting for 30 seconds until Bob brings things to order*):

Bob:    And now, Skip has a song he'd like to sing at this time, and after the song we'll break out the champagne and cake and all have a good time for awhile. (*Sandy offers to take the flowers*).

Skip:    (*To Sandy*) Yeah, would you? (*Piano strikes up introduction.*)

Skip:    (*Singing*)

If you ever hear a knock on the door, open it, it might be me.
If you ever hear a voice calling out, say hello, cause it might be me.
Just like they said in a play, called "Tea and Sympathy."
When you talk about me — and I know you'll talk about me —
Please be kind.
Because that for all we know, we may never meet again
But before you go, make this moment sweet again.
We won't say goodnight, until the last minute.
I'll hold out my hand, and my heart will be in it.
For all we know, this may only be a dream
We come and go like a ripple on a stream
So love me tonight, tomorrow was made for some . . .[3]

S:    (*Speaking*) On your way home, as I've told you so many times, please drive carefully (*Sobs*). Go with God, God bless each and every one of you, Good night everybody (*Sobs, almost runs off stage*).

The bartenders start to pass out bottles of champagne and a big cake which appears on the end of the bar gets cut up and distributed to the audience. People in the bar start animated conversations over the music. No one seems to be leaving. The bar by this time is exceedingly hot and smoky. After a time Skip re-appears in "face" but men's clothes, has cake, roams around talking to little groups in the crowd, clearly very moved and sentimental. People crowd around to say goodbye, ask questions, just to talk. Eventually the crowd thins out somewhat, and Skip goes back to the dressing room to prepare for the final show.

**2:00 a.m. Show**

(*Band plays usual introduction. Skip enters to applause, again wearing the blue wig.*)

Skip:    Good evening ladies and gentlemen, my name's Skip Arnold. (*Skip sings several songs. The last is "You're Nobody 'Til Somebody Loves You."*) (*The crowd has been getting progressively more rowdy and vocal on each show.*)

S:    (*Sings*)

[3] From *For All We Know*; words by Sam M. Lewis, music by J. Fred Coots; TRO–(c) copyright 1934 and renewed by Cromwell Music, Inc., New York; used by permission.

Let's go home . . . So find yourself somebody, yes find somebody,
Yes, find yourself some *body*, and make love. . . . 4
(*Applause, screams, shouts. Skip laughs.*)

Voice from the crowd: (*Shouts up something, a string of words that I couldn't catch, but probably a song request*).

S:   We're gonna do *everything* for you tonight.

Voice from crowd: OK sweety (*the voice has an edge of sarcasm.*) [This marks the evening's turning point. Until now, the crowd generally had been entirely behind the positive expressions and the solidarity of the farewell event. But, as I had seen many times before, the deep-rooted bitterness, self-deprecation, and competitiveness in the gay culture kept asserting itself.]

S:   (*Laughs*) "OK sweety!" (*His tone is a bit indignant.*) Eight months, I've read off everybody in town, you call me "Sweety." (*To the band*): Would you play me a little bit of "Chicago"? (*Singing*)
Chicago, Chicago, it's a crazy kind of town,
Chicago, Chicago, I haven't been around . . .(*Speaking*) I've met some squares,
but I've never been around.
(*singing*) Bet your bottom dollar . . . (*speaking*) I love that,
(*singing*) You'll lose your blues in Chicago, Chicago
It's a town that Billy Sunday could not shut down.
(*speaking*) Let's see, that goes for the Inferno . . . (*Reference to a drag bar that was shut down*).
(*singing*) On State Street, it's a great street
And I just want to say
Unless they change laws, they'll never keep it from being gay.
I had the time, the time of my life,
I found a guy who had another guy for his wife.
Well where else, but in Chicago, Chicago, your home town. 5

(*Speaking*) But you know, when I first came to Chicago, one of the finest things that I found about it was that you people know how to vote. Where else in the world can you have a sodomy place with no sodomy law? And how many of you queens have got a French poodle? (*A few laughs.*) (*Sounds regretful.*) I wish you'd understood that. [Skip refers here to the fact that Illinois had recently repealed its anti-sodomy laws and made homosexual behavior between consenting adults legal — the only state still where this was so in 1965. "Unless they change laws they'll never keep it from being gay," reflects Skip's ambivalence about this change. I'm not sure I understand what he was getting at about French poodles.]

---

4 Copyright 1944 by Southern Music Publishing Co., Inc.; copyright renewed Southern Music Publishing Co., Inc.; used by permission.

5 *Chicago;* words and music by Fred Fisher. Copyright 1922; US copyright renewed 1949; reprinted by permission of the publisher, Fred Fisher Music Co., Inc.

Voice from audience:   (*Something inaudible*)

Skip:   Oh speak up, for God's sake.

Voice:   (*Still inaudible*)

Skip:   We mustn't talk while mother's on! I get into a terrible snit and I tear my hair out! But anyway . . . you know, Chicago has been a marvelous town to me, I've enjoyed every moment while I've been here. I have so many things to remember . . . Like the Belmont Rocks. (*Laughs from audience*).

Voice:   And the Lincoln Baths.

Skip:   *And* the Lincoln Baths. (*Clapping from audience.*)

Voice:   And Milwaukee!

Skip:   And Milwaukee.

[Belmont Rocks – that part of the Lake Michigan beach where gay people go. Lincoln Baths – steam baths which are a notorious pick-up, sexual-encounter spot. Milwaukee – a few weeks previously, Skip had gone to Milwaukee to appear in a gay bar as a "guest artist." He was very well received, and some men had come down to Chicago especially for the "farewell." It was one of these men who especially riled Skip.]

(*Confused voices from audience, shouting up various names of gay places.*)

Voice:   The Clark Theatre.

Skip:   The Clark Theatre? (*Knowing laughs from audience.*) Now wait a minute. I remember Belmont Rocks and Lincoln Baths and Milwaukee, but I've *missed* the Clark Theatre. Are they having a matinee tomorrow afternoon?

Voice:   Twenty-four-hour service.

Skip:   Oh, my! Service? That don't make it bad, baby. Oh . . . I should have suspected that theatres, you know, in Chicago were like that, because I can remember the first time I went to this one across the street over here, what's the name of this thing? .

Voices:   (*Confused, one emerges*) Highchair. (*Another gay bar in the neighborhood.*)

Skip:   Highchair. It's a marvelous thing. There they are: tiled bathrooms – and you queens have bored your way through solid marble. And the machines! You know, we always say at home, in Kansas City, that everything's up to date in Kansas City. But you people are more up to date here than we ever thought of being. Why I went in there one time and I made a mistake and went into the women's room . . . it really wasn't a mistake, I swear I thought I belonged, you know, and do you know that I ate seven tampaxes before I found out they weren't tamales? (*Shouts and mock cries of horror from audience.*) That's chewin' cotton the hard way honey. But, you do, you have these marvelous machines, you know, like . . . well there I was over there at the Highchair. It's the first time they were showing – it wasn't "Cat Ballou," cause I remember a name like that – but I think it was something with Peter O'Toole. . . . What?

Voice:   I'm drunk as a skunk.

Skip:   So'm I. When was your first clue? (*Crosses his legs, one over the other*) . . . while we're here, we might as well show we've got — a male piano.

Voice:   A male penis.

Skip:   What?

Voice:   *Penis.*

Another voice:   *Penis.*

Skip:   We'll send you back to Milwaukee without any credit card. But you know, I went over there to the Highchair, and you know, I'm so tall, I can see over the top of the men's room, I look over . . . (*Audience laughs.*) and . . . it's better than trying to bend over and look through them little holes, I'll tell you that. (*Audience laughs.*) All of a sudden, I was alone in the place — you know I can clear a bar in thirty seconds, let alone a t-room — I walk in, and this little old man came in and there was a machine, about that tall and that wide, and it said "the bachelors friend," and so he unzipped himself, threw himself inside and threw a quarter in, and screamed — my God, you never heard such screamin' in your life. So I jumped out of the booth where I was, and I *jerked* him out of it, poor son of a bitch, he had a button sewn on the end of it. (*The audience, or members of it, have by this time grown rowdy, yelling out in the middle of jokes and spoiling their timing, and so on. This is not by way of ignoring the performance, but due to drunkenness and the desire to participate. Skip says to one boy*): But I love you child, I really do. (*Sarcastic.*) Thank you. But. . . . (*Laughs.*)

I'm going to take this memory back with me to Kansas City, I really am. All of you *fabulous* people who are here (*sarcastic edge*) . . . that all during the time I found out one thing for sure: you faggots don't have a home. (*Audience laughs.*) You have no place to go, and so you've fallen in here, and we want you to feel that this is your home. We want you to come in here just as often as you possibly can and not be caught. (*Audience laughs.*) And we've just fixed the men's room for you . . .

Voice:   What did you do to it?

Skip:   We carpeted the floor . . . that's so in case when you do it you don't have to flush it real loud and wash your hands so people know what you're doin' in there.

Voice:   The Greyhound . . . (*Shouts and laughs from audience.*)

Skip:   That's where you were conceived and born, you ugly faggot. (*Laughs and claps for this put-down. Drum roll.*) (*To band*) Oh well, here we go. . . .

Voice:   Hit it!

Skip:   Oh, I'd like to . . . right in the mouth.

(*Sings*) Chicago, Chicago, it's a toddling town (*band starts*).

Hey Chicago, Chicago, I'll show you around.

Voice shouts:    What about Milwaukee?

Skip:    (*Signals to band to stop*) What does one sing about Milwaukee? (*Sarcastic*) No, wait a minute! I got one. (*Piano starts playing*) No, there's one that's even better than that. It's, "There's Fairies in the Bottom of My Garden." (*Heavy with sarcasm.*) (*Piano goes right into "Hello Dolly," which is one of Skip's well known numbers, especially liked because he usually comes down the ramp between the bar and shakes hands with those at the bar. Much cheering and applause as he starts this number.*)

Skip:    (*Imitating the voice of Carol Channing*). Hello, Mr. President. This is Carol, Mr. President, Carol Channing, Mr. President; and I'd like to sing a song for you, Mr. President. (*Sings "Hello Lyndon" to tune of "Hello Dolly."*)

(*Speaking, still Carol Channing*) You know it's been so marvelous to have been here with you, and seen all the fabulous things and changes that have happened to Chicago. I can remember, long time ago, when we used to sing about Mrs. O'Leary's cow. Since you've had the law changed, now everybody's sleeping with it. (*Shouts of mock horror from audience.*)

You know, things are different in Washington. You don't dare join the YMCA unless you can prove that you're either YM or CA. (*Audience laughs.*) Of course we had a terrible example, with my very good friend, Jenkins, God love him! Lord knows, he tried everybody else. (*Applause.*) But tonight I would like to ask everybody to please drop over to the Century Bookshop, and buy his new book called "How I Blew my Job in Washington." (*General laughter.*)

But I was so excited with the news today. We are doing so much better in Viet Nam. But I would like to turn the meeting over now to a friend of mine, who's known as the Carol Channing of the Republican Party, Everett Dirksen. (*Applause.*) (*In bass voice of Dirksen*) I would like to point out that Lady Bird is feeling better since they tore her nest out of that tree. I personally would be very happy for her. Of course you know after living with her for a long time, LBJ claimed he had gall stones ... it was a ruptured egg-bag. (*Cries, shouts, applause.*) I came to your town to make an address, and buy some new clothes. My wife said I looked like a bag of drags ... uh, rags. (*Laughs from audience.*) (*Back to Carol Channing.*) But now would you like to sing my song with me? (*Piano starts "Hello Dolly" again.*) Everybody sing! (*The audience, quite loudly and so that one can easily make out the words, sings "Hello Dolly." Skip comes off the stage, goes down one side of the bar to the end and up the other from the inside, shaking hands that are held out to him. Almost everyone who can get a hand through does so. After he has made the circuit, he mounts the stage to applause, and sings.*) Dolly will never go away, Dolly will never go away again. ... (*Shouts, whistles, applause, cries of "more," that join to a unified chorus of "more." The piano starts – someone sings up from the audience – "Come back where you belong," shouts of "yay," applause.*)

END OF SHOW.

Between the second and third shows I had gone backstage for the first time. This was right behind the stage, and certainly did not deserve the name of a dressing room. It had a broken window fronting right out on an alley and was freezing cold. It had hardly any room to move around in, improvised dressing table on some beer boxes, crates of liquor everywhere, drags (dresses) scattered here, there, and everywhere . . . in short, woefully inadequate, undignified, and a mess.

After the show I happened to be standing next to one of the "boys" from Milwaukee who had been making so many comments and acting so drunk. When Skip came up, the boy started in a drunken way to tell Skip how much he loved the show. Skip tore into him with fury. The boy was frightened and hurt, and started to apologize profusely. But Skip "read" him up one side and down the other, refusing any apology, refusing the drink the boy offered, telling him he was a pig and a silly fruit, and that he didn't need people like that in the bar, and so on. Very shortly the boy left in a hurt huff, almost in tears. I told Skip that I thought he had been very hard on him, and Skip replied that maybe it had taught him a lesson about how to behave.

### LYNNE CARTER AT THE 8TH ST. CLUB

On a Saturday night early in 1967, I went with a couple I know to see Lynne Carter's act at the 8th St. Club in New York City. The other woman wore a

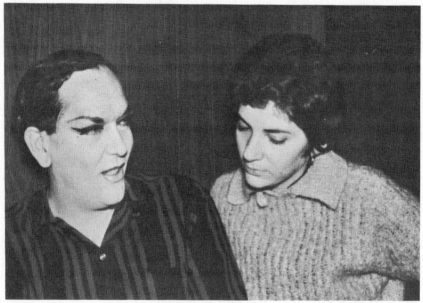

Skip Arnold with the author between shows

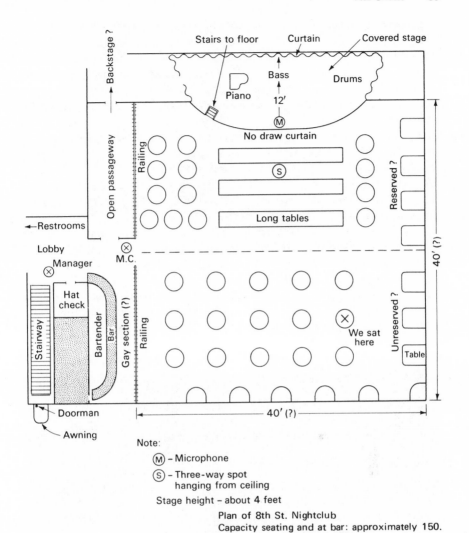

Note:
(M) – Microphone
(S) – Three-way spot
        hanging from ceiling
Stage height – about 4 feet

Plan of 8th St. Nightclub
Capacity seating and at bar: approximately 150.

simple dress and high heels, and I wore a suit and high heels. (At the Shed I wore slacks, a sweater, and tennis shoes.) We were somewhat underdressed compared to most of the women there. We arrived at the 8th St. Club at about 9:40 p.m. The club is on the south side of 8th St. It has a blue awning with the words "8th St." along its side in big white lettering. To the left of the entrance are three eight-by-ten glossies in a glass case. The top one on that night was of Lynne Carter in drag as Phyllis Diller, with no mention at all of his being a female impersonator. Under his picture were pictures of a female singer and a male

singer, who were appearing in the same act. In short, the 8th St. Club neither hides nor blares forth; it is simply there. Neither underground (Shed) nor freak (Bijou Lounge), this is a "class" place.

A rather surly uniformed doorman let us in, and we went down a long flight of carpeted steps. A short, dark, middle-aged man in a suit asked us coldly if we had reservations. When we told him that we did not, he scowled as if this were bad form. As we were standing there, the man yelled up the stairs, "Not in this club you won't." I peered up the stairs and saw a youngish blond man dressed in a zippered jacket and chinos. He seemed slightly unsteady on his feet. I think he was saying that he wanted to use the bathroom, but I couldn't hear him well. The manager was extremely rude. "You have to be in better condition than that to get in here," he yelled, leaving it unclear exactly what condition he was objecting to. The young man turned and left.

We were shown to a table in the back of the club, which I assume was left for those without reservations. At this point the club, whose top capacity I judged to be perhaps one hundred and fifty, had about thirty customers. About ten of these (all men) were at the bar, and the rest were couples in the front half of the main seating area. There were four or five waiters of varying ages, all dressed in red jackets and black pants. Ours was an elderly man who I thought might be homosexual. The floor was carpeted. The decor was simple and unobtrusive, but clean and trying to suggest elegance. All the tables had white tablecloths. The minimum was five dollars per person. The Scotch we were drinking was weak and not of good quality.

By the time Lynne Carter came onstage, the nightclub was packed. The great majority of those at the tables were couples, and I judged them mostly to be straight, and not just homosexuals covering. They were all well dressed, ranging in age from young to middle aged, and middle class in appearance. All were white, except for one Black man accompanying a white woman at a table and one Black man at the bar.

The situation at the bar deserves special mention. As I have indicated on the plan, the area where customers could stand by the bar was separated from the main floor by a waist-high railing. By the time the female singer came on, every stool at the bar had been long filled, and the crush in every available inch of standing room between the stools and the railing was terrific. This crowd was entirely male, ranging in age from middle twenties to early fifties, all similarly dressed in conservative, dark business suits and restrained ties. There was no loudness, no obvious camping that could be discerned from the tables, no calling back and forth, no extreme body movement; in short, a highly conservative crowd, sensitive to its respectable surroundings. And yet, to the knowing eye, the group at the bar was homosexual, and quietly on the make.

Nevertheless, the bar contributed more than its share to audience enthusiasm. There were no squeals and giggles, no cries of "Oh Mary," but there was a great

deal of ready response in the form of applause and laughter. Like so many homo-sexual audiences that I have seen, they clearly enjoyed live entertainment and were ready to support not only the parts they specifically liked, but the endeavor in general.

## The Show

At 10:05 the lively show music piped into the club is turned off. The house lights are dimmed to a very low level. Three Black musicians enter from stage right — a pianist, bassist, and drummer — and they play jazz for ten minutes.

Then a middle-aged man in a suit with a ruffled shirt front mounts the stage by stairway (stage right), announces that he is the emcee, welcomes the audience to the 8th St. Club, and introduces the male singer "in his first engagement at the 8th St." The emcee is noticeably effeminate. The singer is a man in his late twenties, short, stocky, Italian-looking. He wears a black suit with red lining and a patterned vest. His singing style is some variation on Frank Sinatra, and he has a tendency to sing off key.

The emcee back on stage, introduces "an old favorite here at the 8th St. Club, that very talented, Miss T_____ ," who enters stage right and immediately begins singing. She is about thirty, quite fat, with upswept reddish hair. She is wearing a low-cut black velvet gown, and around her ample shoulders is a long chartreuse silk shawl. She, too, has her own pianist, a middle-aged, stony-faced man with a bald head. She sings, in intense soprano. She exits to loud applause. The men at the bar immediately start shouting "more." One voice from the bar cries out, "Do Shirley Temple." Miss T_____ enters and proceeds to do an imitation of Shirley Temple. By the time she exits, the audience is well warmed up.

It is 11:20 when the three Black musicians re-enter. The emcee goes onstage again and announces: "And now the 8th St. very proudly presents the star of our show, the man who made the 8th St. what it is, the very talented Lynne Carter!" [6]

Carter enters briskly from stage right, with the band already playing the introduction to "There Is Nothing Like a Dame." The spot is fairly bright, and it is not particularly flattering. Carter does not make a good-looking woman. His features are sharp — comic, rather than beautiful. But one thing is immediately striking. In contrast to the great majority of female impersonators, the total appearance is subdued rather than overplayed. His make-up is stagey, but not abstracted to a mask of femininity. [7] He wears a dressy three-piece suit of an attractive apple-green color. The jacket and skirt are of some kind of shimmery material, so that one gets a very subdued sequin effect. When, midway through (or just after) the first number, he removed the jacket, the top underneath turn-

[6] I had hoped to quote extensively from Lynne Carter's show, but was unable to obtain permission to do so.

[7] "Femininity" is itself a mask, of course. But many impersonators wear masks of masks.

ed out to be a sleeveless, moderately low-cut vest. A very small suggestion of cleavage shows. The whole is close-fitting, but not really tight. The skirt is knee length. The high heels are matching apple green. His nails have red polish. He wears at least one feminine diamond ring, a small diamond bracelet, and around his neck, a single small pendant on a light chain. The wig is blond, of good quality, hanging to shoulder length down the back, held back over the ears by a medium width green ribbon, with straight bangs in front — the simplest wig I ever saw on a female impersonator.

Carter's stage presence is immediately commanding, confident, and fast-paced. I now recall Skip's saying that Carter could hold the stage longer and more successfully than any other female impersonator, a better performer even than T. C. Jones, the hardest worker around.

Carter sings in a voice somewhere between alto and tenor, "There is nothing you could name, that is anything like a dame . . . . . What ain't I got? . . ." In a deep voice, looking down at his chest, "You know damn well." The audience is immediately with him. He finishes the song, then takes off his jacket, revealing rather large shoulders. His outfit makes no special effort to hide the fact that he is muscular. He makes a gesture of flexing his arms and, lowering his voice, announces to the audience that he is what is known as an impressionist, and that he will take them on a trip around the world to famous night spots, and he'll do impressions of various stars. The lights black out. He says they are now at the Fairmont Hotel in San Francisco, and he is the lovely Hildegarde. When the spot comes back on, Carter wears long gloves and holds a large hand mirror. When the tableau starts, his arms are raised. He sniffs his armpits. He holds the mirror to his face and inspects himself ostentatiously. He jumps back with a little exclamation, "Oh, I scared myself! I thought it was an old man with a bloody mouth." He looks at himself again. "It *is* an old man with a bloody mouth." [8]

He flashes the mirror around the audience, but at the tables, not at the bar. He sings, "Hello, Young Lovers, Wherever You Are." He engages in some patter about good fairies and evil fairies and about Christine Keeler, whom he calls the "Cabinet-maker." He shines the mirror into the audience again; the light rests on a young woman. "You're a girl, aren't you?" His voice implies that this is a rarity in his audiences and at the same time that he isn't quite sure she's a girl. "Well, don't feel bad, honey, no one's perfect."

He sings, "Love Is Better, the Other Way Around." Then he announces that he is going to do an impression of Hermione Gingold, as she might address a

---

[8] Drag queens are given to vivid macabre images. Cf. "I'll dance around in my bones for you . . ."

graduating class. The stage is blacked out. The piano has been moved to center stage, and on top of it a pile of brightly colored cloths and feathers are visible. When the spot comes on, Carter is revealed wearing a loose gown of muted pink and orange: a large ruffled bonnet, a long, flowing robe with full sleeves and ruffles at the neck, a string of large beads, and heavy rings. The facial and vocal impersonation of Gingold is excellent. He sings a pseudomoralistic song about the evils of dope, called "Please, Stay off the Grass," then reaches behind him on the piano and grasps a synthetic bunch of flowers and asks the audience to identify them. When the pianist, a large Black man whom Carter calls Thelma, answers "Poppies," Carter says "Poppers?" referring to a heart-stimulating drug used to enhance orgasm.

He ends the Gingold impersonation and announces that next he will do Phyllis Diller. The lights black out; in a few seconds he is revealed in the green outfit again, but with a Diller hat and a fantastic array of colorful feathers pinned to the front of the dress; he carries a cigarette holder. Once again the expression change is complete: his bearing and facial expressions overwhelmingly suggest Phyllis Diller, and his imitation of Diller's inflection and loud voice are wonderfully accurate.

Calling attention to the feathers, he explains that he shot the bird this morning. The bird was bending down looking for crumbs, exposing its backside, when the cab Carter was in hit it. That, he said, would teach the bird to get in that position. [9]

Carter's patter during the Diller impression is gay. The principal theme is how he got into the female-impersonation business: "One morning I was sitting with my husband eating toast and margarine, and suddenly there was this big crown on my head. My husband said, 'Why, Mary, you look like a queen.' [This is a reference to a TV commercial for margarine.] So naturally I ran right out and bought myself some dresses."

Then Carter announces that he will do a song about the Statue of Liberty, as Mae West might have written it. The lights black out, and after a short pause Carter is revealed dressed as the Statue of Liberty and at the same time doing an incredibly accurate imitation of the distinctive bodily movements, voice, and expression of Mae West. He wears a floor-length flowing green robe of gauzy material and a spiked crown of green, holds in his left hand a large piece of green cardboard in the shape of a book braced against his hip, and in his right hand an upraised tin torch. This apparition is greeted with screams of delight from the audience.

Carter sings "Miss Liberty's Gonna Be Liberal from Now On." His song laments the terrible boredom of standing in the water not having any kicks, with side remarks about how hard it is anyway for a big girl to have any fun. (Some of this

[9] Straight audiences are only somewhat less fond of anal humor than gay ones.

is actually sung, and some talked, just as many of Mae West's songs really are done.) First there is a long introduction about Miss Liberty's sad lot in life, the public neglect, and, of course, the depredations of the pigeons. He describes a typical day: first the garbage scows passing by; then the Staten Island ferries (much double entendre on this word) passing; a visit from the ladies of the Bronx Bagel Corps; then the school children sticking their chewing gum up her insides, and leaving their candied-apples everywhere. Around dusk an exciting thing happens to Miss Liberty. Here Beethoven's Fifth Symphony starts to play, drum rolls. Miss Liberty sees a man approaching in a Viking boat, but it turns out to be only Erik smoking his cigar. (This is another reference to a commercial.) He ends with a statement about the statue being so desperate she's considering making it with the Green Giant, and after a rousing chorus of "Miss Liberty's gonna be liberal from now on," Carter exits.

It is about midnight; he had already been on for forty minutes, an unusually long spot for a female impersonator. Now he re-enters and announces that he will do an impression of his favorite actress, Bette Davis, as she might have appeared in Lincoln Center.[10] He uses no props or costume change for this one, but again the physical imitation is impressive. He makes a great show of walking back and forth along the stage front with an exaggerated Davis sway. The mouth is pulled down, the voice hard and brittle. He sings, "Bill Bailey, Won't You Please Come Home," as Davis might have done if she were a singer.

There is another blackout, and this time when the spot comes on, he is sitting on top of the piano with crossed legs elaborately, showing a pink feather boa around his shoulders. It could be no one but Marlene Dietrich. He sings, "Having It Done Again," a reference, as he shows, to face lifting, and a parody of her famous song, "Falling in Love Again." After the first chorus, he shifts his legs so they are crossed the other way. This allows a quick glimpse up his dress.

Yes, boys, he says, "I've still got it . . . trouble is, it's so old nobody wants it. (Then he does a sketch review of her movies and "See What the Boys in the Backroom Will Have," which has the good gay association of the next line: "and tell them I'm having the same.") "One day someone came to me and said she had had a man six feet tall. But I wasn't interested. Who wants a man with six feet . . . well, I suppose he might be a conversation piece at a cocktail party." The review of the movies continues, and ends again with a chorus of "Having It Done Again." At the end of this impersonation, the spotlight starts blinking at him, which is usually a signal that the act has gone overtime, to get off the stage as soon as gracefully possible. However, Carter is well into it now, and announces he will

---

[10] No actress is more often impersonated by drag queens than Bette Davis. There is a profound identification with her style and many of her roles, especially that of the aging actress Marlo Cook in "All About Eve." Here she plays a sophisticated, frankly sexual woman who competes with a pretty, scheming young thing. Marlo is bitchy and childish but has a "heart of gold."

finish with one more impression, that of Pearl Bailey, who, he says, started him in show business, and so is particularly close to his heart." The spot blacks out but comes on almost instantly. He has no props at all, and of course his physical appearance is not Pearl Bailey, but the walk and the voice are perfect. He sings "I Could Have Danced All Night." After a couple of choruses, he stops and pulls off one shoe. "Oh, these shoes hurt mah feet," and a few other remarks. Then he sings "I'm Tired," interrupts this by patter about how he went to see a psychiatrist to find out why he was so tired. He says that psychiatrists see you *deep* down, where you are rotten to the core.

He says that he went to Paris and saw it all, the Champs Elysées, and "the plain easy lay." Then, somehow, a transition to New York, and how, speaking of easy lays, he was down on 53rd Street and Third Avenue the other night. This gets a laugh especially from the bar—Fifty-third Street and Third Avenue is in the center of a part of the East Side that is heavily gay. There is a lot of "cruising" there. ("Cruising" means looking at others of the same sex as potential sexual objects. Cruising can be done anywhere, with varying degrees of openness, but some areas are agreed-upon cruising places, "meat racks" where cruising is open and usually leads directly to sexual activity between men.)

Still in the character of Pearl Bailey, Carter goes through a routine involving small change, mainly about how in his early days in show business he used to be able to sweep change off the table into his bosom without anyone noticing. In order to demonstrate the technique, he gets off the stage and stands by one of the front row tables. Getting down, he makes a show of having to go down by the stairs: "not as young as I used to be." As he is finishing sweeping up the change, a woman at the next table laughs or draws back or something. He leans over her, but facing the rest of the audience "I bet you never been this close to one before. Wait till you find out that I'm your milkman," and hops easily back on stage with one bound. There are several levels here, playing on blackness and homosexuality. He sings, "Saving My Love For You." He introduces the band in the usual enthusiastic way and sings, "If My Friends Could See Me Now," and exits.

He re-enters, now out of the character of Pearl Bailey. He warms up with a falsetto high note, which reveals that his falsetto is poor. Then he sings, "The Boy from Fire Island," to the tune of the "Girl from Ipanema." When he passes, each boy he passes goes (suddenly turning sideways so we can see the limp faggot pose) "get *her!*" (and the second time turning sideways again, in exasperated faggot speech) "Are you ready for that queen?" It is 12:25 a.m. He has worked for a little over an hour, a very long set.

My companions and I are exhausted. My friends were extremely enthusiastic about Carter's performance. The girl, however, did not understand all of it. [11]

[11] As a general rule, middle-class men know a great many more "dirty" words and allusions than middle-class women, especially if the men have been in the Armed Forces. It took me a long time and many questions to acquire the knowledge of "our" culture's sexual terminology that men take for granted.

One further thing to mention. Carter did no "mixing" (with the audience) at all, at least not while we were there. During the male singer's spot, I could see Carter in drag, standing talking to one of the waiters in the passageway that leads backstage, but he was behind the waiter and unobtrusive. His appearance caused no comment, and he was there for only five minutes or so, looking over the crowd.

# Role Models

Female impersonators, particularly the stage impersonators (see Chapter One), identify strongly with professional performers. Their special, but not exclusive, idols are female entertainers. Street impersonators usually try to model themselves on movie stars rather than on stage actresses and nightclub performers. Stage impersonators are quite conversant with the language of the theatres and nightclubs, while the street impersonators are not. In Kansas City, the stage impersonators frequently talked with avid interest about stage and nightclub "personalities." The street impersonators could not join in these discussions for lack of knowledge.

Stage impersonators very often told me that they considered themselves to be nightclub performers or to be in the nightclub business, "just like other [straight] performers."

When impersonators criticized each other's on- or off-stage conduct as "unprofessional," this was a direct appeal to norms of show business. Certain show business phrases such as "break a leg" (for good luck) were used routinely, and I was admonished not to whistle backstage. The following response of a stage impersonator shows this emphasis in response to my question, "What's the difference between professionals and street fairies?" This impersonator was a "headliner" (had top billing) at a club in New York:

Well (laughs), simply saying ... well, I can leave that up to you. You have seen the show. You see the difference between *me* and some of these other people (his voice makes it sound as if this point is utterly self-evident) who are working in this left field of show business, and I'm quite sure that you see a

*distinct* difference. I am more conscious of being a performer, and I think generally speaking, most, or a lot, of other people who are appearing in the same show are just doing it, not as a lark — we won't say that it's a lark — but they're doing it because it's something they can drop in and out of. They have fun, they laugh, have drinks, and play around, and just have a good time. But to *me*, now, playing around and having a good time is [sic.] important to me also; but primarily my interest from the time I arrive at the club till the end of the evening — I am there as a performer, as an entertainer, and this to me is the most important thing. And I dare say that if needs be, I probably could do it, and be just as good an entertainer . . . I don't know if I would be any more successful if I were working in men's clothes than I am working as a woman. But comparing myself to some of the people that I would consider real professional entertainers — people who are genuinely interested in the show as a show, and not just as I say, a street fairy, who wants to put on a dress and a pair of high heels to be seen and show off in public.

The stage impersonators are interested in "billings" and publicity, in lighting and make-up and stage effects, in "timing" and "stage presence." The quality by which they measure performers and performances is "talent." Their models in these matters are established performers, both in their performances and in their off-stage lives, insofar as the impersonators are familiar with the latter. The practice of doing "impressions" is, of course, a very direct expression of this role modeling.

From this perspective, female impersonators are simply nightclub performers who happen to use impersonation as a medium. It will be recalled (Chapter One) that many stage impersonators are drab in appearance (and sometimes in manner) off stage. These men often say that drag is simply a medium or mask that allows them to perform. The mask is borrowed from female performers, the ethos of performance from show business norms in general.

The stated aspiration of almost all stage impersonators is to "go legit," that is, to play in movies, television, and on stage or in respectable nightclubs, either in drag *or* (some say) in men's clothes. Failing this, they would like to see the whole profession "upgraded," made more legitimate and professional (and to this end they would like to see all street impersonators barred from working, for they claim that the street performers downgrade the profession). T. C. Jones is universally accorded highest status among impersonators because he has appeared on Broadway (New Faces of 1956) and on television (Alfred Hitchcock) and plays only high-status nightclubs.

### THE DRAG QUEEN

Professionally, impersonators place themselves as a group at the bottom of the show business world. But socially, their self-image can be represented

(without the moral implications; see Chapter Six) in its simplest form as three concentric circles. The impersonators, or drag queens, are the inner circle. Surrounding them are the queens, ordinary gay men. The straights are the outer circle. In this way, impersonators are "a society within a society within a society," as one impersonator told me.

A few impersonators deny publicly that they are gay. These impersonators are married, and some have children. Of course, being married and having children constitute no barrier to participation in the homosexual subculture. But

Skip Arnold at home

whatever may be the actual case with these few, the impersonators I knew universally described such public statements as "cover." One impersonator's statement was particularly revealing. He said that "in practice" perhaps some impersonators were straight, but "in theory" they could not be. "How can a man perform in female attire and not have something wrong with him?" he asked.

The role of the female impersonator is directly related to both the drag queen and camp roles in the homosexual subculture. In gay life, the two roles are strongly associated. In homosexual terminology, a drag queen is a homosexual male who often, or habitually, dresses in female attire. (A drag butch is a lesbian who often, or habitually, dresses in male attire.) Drag and camp are the most representative and widely used symbols of homosexuality in the English speaking world. This is true even though many homosexuals would never wear drag or go to a drag party and even though most homosexuals who do wear drag do so only in special contexts, such as private parties and Halloween balls.[1] At the middle-class level, it is common to give "costume" parties at which those who want to wear drag can do so, and the others can wear a costume appropriate to their gender.

The principle opposition around which the gay world revolves is masculine-feminine. There are a number of ways of presenting this opposition through one's own person, where it becomes also an opposition of "inside" = "outside" or "underneath" = "outside." Ultimately, all drag symbolism opposes the "inner" or "real" self (subjective self) to the "outer" self (social self). For the great majority of homosexuals, the social self is often a calculated respectability and the subjective or real self is stigmatized. The "inner" = "outer" opposition is almost parallel to "back" = "front." In fact, the social self is usually described as "front" and social relationships (especially with women) designed to support the veracity of the "front" are called "cover." The "front" = "back" opposition also has a direct tie-in with the body: "front" = "face"; "back" = "ass."

There are two different levels on which the oppositions can be played out. One is *within* the sartorial system[2] itself, that is, wearing feminine clothing "underneath" and masculine clothing "outside." (This method seems to be used more

---

[1] In two Broadway plays (since made into movies) dealing with English homosexuals, "The Killing of Sister George" (lesbians) and "Staircase" (male homosexuals), drag played a prominent role. In "George," an entire scene shows George and her lover dressed in tuxedos and top hats on their way to a drag party. In "Staircase," the entire plot turns on the fact that one of the characters has been arrested for "going in drag" to the local pub. Throughout the second act, this character wears a black shawl over his shoulders. This item of clothing is symbolic of full drag. This same character is a camp and, in my opinion, George was a very rare bird, a lesbian camp. Both plays, at any rate, abounded in camp humor. "The Boys in the Band," another recent play and movie, doesn't feature drag as prominently but has two camp roles and much camp humor.

[2] This concept was developed and suggested to me by Julian Pitt-Rivers.

by heterosexual transvestites.) It symbolizes that the visible, social, masculine clothing is a costume, which in turn symbolizes that the entire sex-role behavior is a role – an act. Conversely, stage impersonators sometimes wear jockey shorts underneath full stage drag, symbolizing that the feminine clothing is a costume.

A second "internal" method is to mix sex-role referents *within* the visible sartorial system. This generally involves some "outside" item from the feminine sartorial system such as earrings, lipstick, high-heeled shoes, a necklace, etc., worn *with* masculine clothing. This kind of opposition is used very frequently in informal camping by homosexuals. The feminine item stands out so glaringly by incongruity that it "undermines" the masculine system and proclaims that the inner identification is feminine.[3] When this method is used on stage, it is called "working with (feminine) pieces." The performer generally works in a tuxedo or business suit and a woman's large hat and earrings.

The second level poses an opposition between a one sex-role sartorial system and the "self," whose identity has to be indicated in some other way. Thus when impersonators are performing, the oppositional play is between "appearance," which is female, and "reality," or "essence," which is male. One way to do this is to show that the appearance is an illusion; for instance, a standard impersonation maneuver is to pull out one "breast" and show it to the audience. A more drastic step is taking off the wig. Strippers actually routinize the progression from "outside" to "inside" visually, by starting in a full stripping costume and ending by taking off the bra and showing the audience the flat chest. Another method is to demonstrate "maleness" verbally or vocally by suddenly dropping the vocal level or by some direct reference. One impersonator routinely tells the audience: "Have a ball. I have two." (But genitals must *never* be seen.) Another tells unruly members of the audience that he will "put on my men's clothes and beat you up."

Impersonators play on the opposition to varying extents, but most experienced stage impersonators have a characteristic method of doing it. Generally speaking, the desire and ability to break the illusion of femininity is the mark of an experienced impersonator who has freed himself from other impersonators as the immediate reference group and is working fully to the audience. Even so, some stage impersonators admitted that it is difficult to break the unity of the feminine sartorial system. For instance, they said that it is difficult, subjectively, to speak in a deep tone of voice while on stage and especially while wearing a wig. The "breasts" especially seem to symbolize the entire feminine sartorial system and role. This is shown not only by the very common device of removing them in order to break the illusion, but in the

---

[3] Even one feminine item ruins the integrity of the masculine system; the male loses his caste honor. The superordinate role in a hierarchy is more fragile than the subordinate. Manhood must be achieved, and once achieved, guarded and protected.

command, "tits up!" meaning, "get into the role," or "get into feminine character."

The tension between the masculine-feminine and inside-outside oppositions pervade the homosexual subculture at all class and status levels. In a sense the different class and status levels consist of different ways of balancing these oppositions. Low-status homosexuals (both male and female) characteristically insist on very strong dichotomization between masculine-feminine so that people must play out one principle or the other exclusively. Low-status queens are expected to be very nellie, always, and low-status butch men are so "masculine" that they very often consider themselves straight.[4] (Although as mentioned in Chapter Four, the queens say in private that "today's butch is tomorrow's sister.") Nevertheless, in the most nellie queen the opposition is still implicitly there, since to participate in the male homosexual subculture as a peer, one must be male inside (physiologically).

Recently, this principle has begun to be challenged by hormone use and by the sex-changing operation. The use of these techniques as a final resolution of the masculine-feminine opposition is hotly discussed in the homosexual subculture. A very significant proportion of the impersonators, and especially the street impersonators, have used or are using hormone shots or plastic inserts to create artificial breasts and change the shape of their bodies. This development is strongly deplored by the stage impersonators who say that the whole point of female impersonation depends on maleness. They further say that these "hormone queens" are placing themselves out of the homosexual subculture, since, by definition, a homosexual man wants to sleep with other *men* (i.e., no gay man would want to sleep with these "hormone queens").

In carrying the transformation even farther, to "become a woman" is approved by the stage impersonators, with the provision that the "sex changes" should get out of gay life altogether and go straight. The "sex changes" do not always comply, however. One quite successful impersonator in Chicago had the operation but continued to perform in a straight club with other impersonators. Some impersonators in Chicago told me that this person was now considered "out of gay life" by the homosexuals and could not perform in a gay club. I also heard a persistent rumor that "she" now liked to sleep with lesbians!

It should be readily apparent why drag is such an effective symbol of both the outside-inside and masculine-feminine oppositions. There are relatively few ascribed roles in American culture and sex role is one of them; sex role radiates a complex and ubiquitous system of typing achieved roles. Obvious examples are in the kinship system (wife, mother, etc.) but sex typing also extends far out

---

[4] The middle-class idea tends to be that any man who has had sexual relations with men is queer. The lower classes strip down to "essentials," and the man who is "dominant" can be normal (masculine). Lower-class men give themselves a bit more leeway before they consider themselves to be gay.

into the occupational-role system (airline stewardess, waitress, policeman, etc.). The effect of the drag system is to wrench the sex roles loose from that which supposedly determines them, that is, genital sex. Gay people know that sex-typed behavior can be achieved, contrary to what is popularly believed. They know that the possession of one type of genital equipment by no means guarantees the "naturally appropriate" behavior.

Thus drag in the homosexual subculture symbolizes two somewhat conflicting statements concerning the sex-role system. The first statement symbolized by drag is that the sex-role system really is natural: therefore homosexuals are unnatural (typical responses: "I am physically abnormal"; "I can't help it, I was born with the wrong hormone balance"; "I am really a woman who was born with the wrong equipment"; "I am psychologically sick").

The second symbolic statement of drag questions the "naturalness" of the sex-role system *in toto*; if sex-role behavior can be achieved by the "wrong" sex, it logically follows that it is in reality also achieved, not inherited, by the "right" sex. Anthropologists say that sex-role behavior is learned. The gay world, via drag, says that sex-role behavior is an appearance; it is "outside." It can be manipulated at will.

Drag symbolizes both these assertions in a very complex way. At the simplest level, drag signifies that the person wearing it is a homosexual, that he is a male who is behaving in a specifically inappropriate way, that he is a male who places himself as a woman in relation to other men. In this sense it signifies stigma. At the most complex, it is a double inversion that says "appearance is an illusion." Drag says, "my 'outside' appearance is feminine, but my essence 'inside' [the body] is masculine." At the same time it symbolizes the opposite inversion: "my appearance 'outside' [my body, my gender] is masculine but my essence 'inside' [myself] is feminine."

In the context of the homosexual subculture, all professional female impersonators are "drag queens." Drag is always worn for performance in any case; the female impersonator has simply professionalized this subcultural role. Among themselves and in conversation with other homosexuals, female impersonators usually call themselves and are called drag queens. In the same way, their performances are referred to by themselves and others as drag shows.

But when the varied meanings of drag are taken into consideration, it should be obvious why the drag queen is an ambivalent figure in the gay world. The drag queen symbolizes all that homosexuals say they fear the most in themselves, all that they say they feel guilty about; he symbolizes, in fact, *the* stigma. In this way, the term "drag queen" is comparable to "nigger." And like that word, it may be all right in an ingroup context but not in an outgroup one. Those who do not want to think of themselves or be identified as drag queens under any circumstances attempt to disassociate themselves from "drag" completely. These homosexuals deplore drag shows and profess total lack of

interest in them. Their attitude toward drag queens is one of condemnation combined with the expression of vast social distance between themselves and the drag queen.

Other homosexuals enjoy being queens among themselves, but do not want to be stigmatized by the heterosexual culture. These homosexuals admire drag and drag queens in homosexual contexts, but deplore female impersonators and street fairies for "giving us a bad name" or "projecting the wrong image" to the heterosexual culture. The drag queen is definitely a marked man in the subculture.

Homosexuality consists of sex-role deviation made up of two related but distinct parts: "wrong" sexual object choices and "wrong" sex-role presentation of self.[5] The first deviation is shared by all homosexuals, but it can be hidden best. The second deviation logically (in this culture) corresponds with the first, which it symbolizes. But it cannot be hidden, and it actually compounds the stigma.

Thus, insofar as female impersonators are professional drag queens, they are evaluated positively by gay people to the extent that they have perfected a subcultural skill and to the extent that gay people are willing to oppose the heterosexual culture directly (in much the same way that Negroes now call themselves Blacks). On the other hand, they are despised because they symbolize and embody the stigma. At present, the balance is far on the negative side, although this varies by context and by the position of the observer (relative to the stigma). This explains the impersonators' negative identification with the term drag queen when it is used by outsiders. (In the same way, they at first used masculine pronouns of address and reference toward each other in my presence, but reverted to feminine pronouns when I became more or less integrated into the system.)

## THE CAMP

While all female impersonators are drag queens in the gay world, by no means are all of them "camps." Both the drag queen and the camp are expressive performing roles, and both specialize in transformation. But the drag queen is

[5]It becomes clear that the core of the stigma is in "wrong" sexual object choice when it is considered that there is little stigma in simply being effeminate, or even in wearing feminine apparel in some contexts, as long as the male is known to be heterosexual, that is, known to sleep with women or, rather, not to sleep with men. But when I say that sleeping with men is the core of the stigma, or that feminine behavior logically corresponds with this, I do not mean it in any causal sense. In fact, I have an impression that some homosexual men sleep with men *because* it strengthens their identification with the feminine role, rather than the other way around. This makes a lot of sense developmentally, if one assumes, as I do, that children learn sex-role identity before they learn any strictly sexual object choices. In other words, I think that children learn they are boys or girls before they are made to understand that boys *only* love girls and vice versa.

concerned with masculine-feminine transformation, while the camp is concerned with what might be called a philosophy of transformations and incongruity. Certainly the two roles are intimately related, since to be a feminine man is by definition incongruous. But strictly speaking, the drag queen simply expresses the incongruity while the camp actually uses it to achieve a higher synthesis. To the extent that a drag queen does this, he is called "campy." The drag queen role is emotionally charged and connotes low status for most homosexuals because it bears the visible stigmata of homosexuality; camps, however, are found at all status levels in the homosexual subculture and are very often the center of primary group organization.[6]

The camp is the central role figure in the subcultural ideology of camp. The camp ethos or style plays a role analogous to "soul" in the Negro subculture.[7] Like soul, camp is a "strategy for a situation."[8] The special perspective of the female impersonators (see Chapter Six) is a case of a broader homosexual ethos. This is the perspective of moral deviance and, consequently, of a "spoiled identity," in Goffman's terms.[9] Like the Negro problem, the homosexual problem centers on self-hatred and the lack of self-esteem.[10] But if "the soul ideology ministers to the needs for identity,"[11] the camp ideology ministers to the needs for dealing with an identity that is well defined but loaded with contempt. As one impersonator who was also a well known camp told me, "No one is more miserable about homosexuality than the homosexual."

Camp is not a thing. Most broadly it signifies a *relationship between* things, people, and activities or qualities, and homosexuality. In this sense, "camp taste," for instance, is synonymous with homosexual taste. Informants stressed that even between individuals there is very little agreement on what is camp because camp is in the eye of the beholder, that is, different homosexuals like different things, and because of the spontaneity and individuality of camp, camp taste is always changing. This has the advantage, recognized by some informants, that a clear division can always be maintained between homosexual and "straight" taste:

---

[6] The role of the "pretty boy" is also a very positive one, and in some ways the camp is an alternative for those who are not pretty. However, the pretty boy is subject to the depredations of aging, which in the subculture is thought to set in at thirty (at the latest). Because the camp depends on inventiveness and wit rather than on physical beauty, he is ageless.

[7] Keil, *Urban Blues*, pp. 164-90.

[8] This phrase is used by Kenneth Burke in reference to poetry and is used by Keil in a sociological sense.

[9] Irving Goffman, *Stigma* (Englewood Cliffs, N.J.: Prentice-Hall, 1963.)

[10] I would say that the main problem today is heterosexuals, just as the main problem for Blacks is Whites.

[11] Keil, *Urban Blues*, p. 165.

He said Susan Sontag was wrong about camp's being a cult,[12] and the moment it becomes a public cult, you watch the queens stop it. Because if it becomes the squares, it doesn't belong to them any more. And what will be "camp art," no queen will own. It's like taking off the work clothes and putting on the home clothes. When the queen is coming home, she wants to come home to a campy apartment that's hers – it's very queer – because all day long she's been very straight. So when it all of a sudden becomes very straight – to come home to an apartment that any square could have – she's not going to have it any more.[13]

While camp is in the eye of the homosexual beholder, it is assumed that there is an underlying unity of perspective among homosexuals that gives any particular campy thing its special flavor. It is possible to discern strong themes in any particular campy thing or event. The three that seemed most recurrent and characteristic to me were *incongruity, theatricality,* and *humor*. All three are intimately related to the homosexual situation and strategy. Incongruity is the subject matter of camp, theatricality its style, and humor its strategy.

Camp usually depends on the perception or creation of *incongruous juxtapositions.* Either way, the homosexual "creates" the camp, by pointing out the incongruity or by devising it. For instance, one informant said that the campiest thing he had seen recently was a Midwestern football player in high drag at a Halloween ball. He pointed out that the football player was seriously trying to be a lady, and so his intent was not camp, but that the *effect* to the observer was campy. (The informant went on to say that it would have been even campier if the football player had been picked up by the police and had his picture published in the paper the next day.) This is an example of unintentional camp, in that the campy person or thing does not perceive the incongruity.

Created camp also depends on transformations and juxtapositions, but here the effect is intentional. The most concrete examples can be seen in the

---

[12]I don't want to pass over the implication here that female impersonators keep up with Susan Sontag. Generally, they don't. I had given him Susan Sontag's "Notes on 'Camp' " (*Partisan Review* [Fall, 1964]: 515-30) to see what he would say. He was college educated, and perfectly able to get through it. He was enraged (justifiably, I felt) that she had almost edited homosexuals out of camp.

[13]Informants said that many ideas had been taken over by straights through the mass media, but that the moment this happened the idea would no longer be campy. For instance, one man said that a queen he knew had gotten the idea of growing plants in the water tank of the toilet. But the idea is no longer campy because it is being advertised through such mass media as *Family Circle* magazine.

How to defend *any* symbols or values from the absorbing powers of the mass media? Jules Henry, I believe, was one of the first to point to the power of advertising to subvert traditional values by appropriating them for commercial purposes (*Culture Against Man*, New York: Random House, 1963). But subcultural symbols and values lose their integrity in the same way. Although Sontag's New York *avant garde* had already appropriated camp from homosexuals, they did so in the effort to create their own aristocracy or integrity of taste as against the mass culture.

apartments of campy queens, for instance, in the idea of growing plants in the toilet tank. One queen said that *TV Guide* had described a little Mexican horse statue as campy. He said there was nothing campy about this at all, but if you put a nude cut-out of Bette Davis on it, it would be campy. Masculine-feminine juxtapositions are, of course, the most characteristic kind of camp, but any very incongruous contrast can be campy. For instance, juxtapositions of high and low status, youth and old age, profane and sacred functions or symbols, cheap and expensive articles are frequently used for camp purposes. Objects or people are often said to be campy, but the camp inheres not in the person or thing itself but in the tension between that person or thing and the context or association. For instance, I was told by impersonators that a homosexual clothes designer made himself a beautiful Halloween ball gown. After the ball he sold it to a wealthy society lady. It was said that when he wore it, it was very campy, but when she wore it, it was just an expensive gown, unless she had run around her ball saying she was really not herself but her faggot dress designer.

The nexus of this perception by incongruity lies in the basic homosexual experience, that is, squarely on the moral deviation. One informant said, "Camp is all based on homosexual thought. It is all based on the idea of two men or two women in bed. It's incongruous and it's funny." If moral deviation is the locus of the perception of incongruity, it is more specifically role deviation and role manipulation that are at the core of the second property of camp, *theatricality*.

Camp is theatrical in three interlocking ways. First of all, camp is style. Importance tends to shift from what a thing *is* to how it *looks*, from *what* is done to *how* it is done. It has been remarked that homosexuals excel in the decorative arts. The kind of incongruities that are campy are very often created by adornment or stylization of a well-defined thing or symbol. But the emphasis on style goes further than this in that camp is also exaggerated, consciously "stagey," specifically theatrical. This is especially true of *the* camp, who is definitely a performer.

The second aspect of theatricality in camp is its dramatic form. Camp, like drag, always involves a performer or performers and an audience. This is its structure. It is only stretching the point a little to say that even in unintentional camp, this interaction is maintained. In the case of the football player, his behavior was transformed by his audience into a performance. In many cases of unintentional camp, the camp performs to his audience by commenting on the behavior or appearance of "the scene," which is then described as "campy." In intentional camp, the structure of performer and audience is almost always clearly defined. This point will be elaborated below.

Third, camp is suffused with the perception of "being as playing a role" and "life as theatre."[14] It is at this point that drag and camp merge and augment each other. I was led to an appreciation of this while reading Parker Tyler's

[14] Sontag, "Notes on 'Camp,' " p. 529.

appraisal of Greta Garbo.[15] Garbo is generally regarded in the homosexual community as "high camp." Tyler stated that " 'Drag acts,' I believe, are not confined to the declassed sexes. Garbo 'got in drag' whenever she took some heavy glamour part, whenever she melted in or out of a man's arms, whenever she simply let that heavenly-flexed neck . . . bear the weight of her thrown-back head."[16] He concludes, "How resplendent seems the art of acting! It is all *impersonation*, whether the sex underneath is true or not."[17]

We have to take the long way around to get at the real relationship between Garbo and camp. The homosexual is stigmatized, but his stigma can be hidden. In Goffman's terminology, information about his stigma can be managed. Therefore, of crucial importance to homosexuals themselves and to non-homosexuals is whether the stigma is displayed so that one is immediately recognizable or is hidden so that he can pass to the world at large as a respectable citizen. The covert half (conceptually, not necessarily numerically) of the homosexual community is engaged in "impersonating" respectable citizenry, at least some of the time. What is being impersonated?

The stigma essentially lies in being less than a man and in doing something that is unnatural (wrong) for a man to do. Surrounding this essence is a halo effect: violation of culturally standardized canons of taste, behavior, speech, and so on, rigorously associated (prescribed) with the male role (e.g., fanciful or decorative clothing styles, "effeminate" speech and manner, expressed disinterest in women as sexual objects, expressed interest in men as sexual objects, unseemly concern with personal appearance, etc.). The covert homosexual must therefore do two things: first, he must conceal the fact that he sleeps with men. But concealing this *fact* is far less difficult than his second problem, which is controlling the *halo effect* or signals that would announce that he sleeps with men. The covert homosexual must in fact impersonate a *man*, that is, he must *appear* to the "straight" world to be fulfilling (or not violating) all the requisites of the male role as defined by the "straight" world.

The immediate relationship between Tyler's point about Garbo and camp/ drag is this: if Garbo playing women is drag, then homosexuals "passing" are playing men; they are in drag. This is the larger implication of drag/camp. In fact, gay people often use the word "drag" in this broader sense, even to include role playing which most people simply take for granted: role playing in school, at the office, at parties, and so on. In fact, all of life is role and theatre — appearance.

But granted that all acting is impersonation, what moved Tyler to designate Garbo's acting specifically as "drag"? Drag means, first of all, role playing. The

---

[15] Parker Tyler, "The Garbo Image," in *The Films of Greta Garbo,* ed. Michael Conway, Dion McGregor, and Mark Ricci (New York: Citadel Press, no date), pp. 9-31.

[16] Tyler, "The Garbo Image," p. 12.

[17] Ibid. p. 28.

way in which it defines role playing contains its implicit attitude. The word "drag" attaches specifically to the outward, visible appurtenances of a role. In the type case, sex role, drag primarily refers to the wearing apparel and accessories that designate a human being as male or female, when it is worn by the opposite sex. By focusing on the outward appearance of role, drag implies that sex role and, by extension, role in general is something superficial, which can be manipulated, put on and off again at will. The drag concept implies *distance* between the actor and the role or "act." But drag also means "costume." This theatrical referent is the key to the attitude toward role playing embodied in drag as camp. Role playing is *play*; it is an act or show. The necessity to play at life, living role after superficial role, should not be the cause of bitterness or despair. Most of the sex role and other impersonations that male homosexuals do are done with ease, grace, and especially humor. The actor should throw himself into it; he should put on a good show; he should view the whole experience as fun, as a camp.[18]

The double stance toward role, putting on a good show while indicating distance (showing that it is a show) is the heart of drag as camp. Garbo's acting was thought to be "drag" because it was considered markedly androgynous, and because she played (even overplayed) the role of femme fatale with style. No man (in her movies) and very few audiences (judging by her success) could resist her allure. And yet most of the men she seduced were her victims because she was only playing at love – only acting. This is made quite explicit in the film "Mata Hari," in which Garbo the spy seduces men to get information from them.

The third quality of camp is its *humor*. Camp is for fun; the aim of camp is to make an audience laugh. In fact, it is a *system* of humor. Camp humor is a system of laughing at one's incongruous position instead of crying.[19] That is, the humor does not cover up, it transforms. I saw the reverse transformation – from laughter to pathos – often enough, and it is axiomatic among the impersonators that when the camp cannot laugh, he dissolves into a maudlin bundle of self-pity.

One of the most confounding aspects of my interaction with the impersonators was their tendency to laugh at situations that to me were horrifying or tragic. I was amazed, for instance, when one impersonator described to me as "very campy" the scene in "Whatever Happened to Baby Jane" in which Bette Davis served Joan Crawford a rat, or the scene in which Bette Davis makes her "comeback" in the parlor with the piano player.

Of course, not all impersonators and not all homosexuals are campy. *The*

[18]It is clear to me now how camp undercuts rage and therefore rebellion by ridiculing serious and concentrated bitterness.

[19]It would be worthwhile to compare camp humor with the humor systems of other oppressed people (Eastern European Jewish, Negro, etc.).

camp is a homosexual wit and clown; his campy productions and performances are a continuous creative strategy for dealing with the homosexual situation, and, in the process, defining a positive homosexual identity. As one performer summed it up for me, "Homosexuality is a way of life that is against all ways of life, including nature's. And no one is more aware of it than the homosexual. The camp accepts his role as a homosexual and flaunts his homosexuality. He makes the other homosexuals laugh; he makes life a little brighter for them. And he builds a bridge to the straight people by getting them to laugh with him." The same man described the role of the camp more concretely in an interview:

Well, "to camp" actually means "to sit in front of a group of people" . . . not on-stage, but you *can* camp on-stage . . . I think that I do that when I talk to the audience. I think I'm camping with 'em. But a "camp" herself is a queen who sits and starts entertaining a group of people at a bar around her. They all start listening to what she's got to say. And she says campy things. Oh, somebody smarts off at her and she gives 'em a very flip answer. A camp is a flip person who has declared emotional freedom. She is going to say to the world, "I'm queer." Although she may not do this all the time, but most of the time a camp queen will. She'll walk down the street and she'll see you and say, "Hi, Mary, how are you?" right in the busiest part of town . . . she'll actually camp, right there. And she'll swish down the street. And she may be in a business suit; she doesn't have to be dressed outlandishly. Even at work the people figure that she's a camp. They don't know what to *call* her, but they hire her 'cause she's a good kid, keeps the office laughing, doesn't bother anybody, and everyone'll say, "Oh, running around with Georgie's more fun! He's just more fun!" The squares are saying this. And the other ones [homosexuals] are saying, "Oh, you've got to know George, she's a camp." Because the whole time she's light-hearted. Very seldom is camp sad. Camp has got to be flip. A camp queen's got to think faster than other queens. *This* makes her camp. She's got to have an answer to anything that's put to her. . . .[20]

Now *homosexuality* is *not* camp. But you take a camp, and she turns around and she makes homosexuality funny, but not ludicrous; funny but not ridiculous . . . this is a great, great art. This is a fine thing. . . . Now when it suddenly became the word . . . became like . . . it's like the word "Mary." Everybody's "Mary." "Hi, Mary. How are you, Mary." And like "girl." You may be talking to one of the butchest queens in the world, but you still say, "Oh, girl." And sometimes they say, "Well, don't call me 'she' and don't call me 'girl.' I don't feel like a girl. I'm a *man*. I just like to go to bed with you *girls*. I don't want to go to bed with another man." And you say, "Oh, girl, get you. Now she's turned butch." And so you camp about it. It's sort of laughing at yourself instead of crying. And a good camp will make you laugh along with her, to

[20]Speed and spontaneity are of the essence. For example, at a dinner party, someone said, "Oh, we forgot to say grace." One woman folded her hands without missing a beat and intoned, "Thank God everyone at this table is gay."

where you suddenly feel . . . you don't feel like she's made fun of you. She's sort of made light of a bad situation.

The camp queen makes no bones about it; to him the gay world is the "sisterhood." By accepting his homosexuality and flaunting it, the camp undercuts all homosexuals who won't accept the stigmatized identity. Only by fully embracing the stigma itself can one neutralize the sting and make it laughable.[21] Not all references to the stigma are campy, however. Only if it is pointed out as a joke is it camp, although there is no requirement that the jokes be gentle or friendly. A lot of camping is extremely hostile; it is almost always sarcastic. But its intent is humorous as well. Campy queens are very often said to be "bitches" just as camp humor is said to be "bitchy."[22] The campy queen who can "read" (put down) all challengers and cut everyone down to size is admired. Humor is the campy queen's weapon. A camp queen in good form can come out on top (by group consensus) against all the competition.

Female impersonators who use drag in a comic way or are themselves comics are considered camps by gay people. (Serious glamour drag is considered campy by many homosexuals, but it is unintentional camp. Those who see glamour drag as a serious business do not consider it to be campy. Those who think it is ludicrous for drag queens to take themselves seriously see the whole business as a campy incongruity.) Since the camp role is a positive one, many impersonators take pride in being camps, at least on stage.[23] Since the camp role depends to such a large extent on verbal agility, it reinforces the superiority of the live performers over record performers, who, even if they are comic, must depend wholly on visual effects.

[21] It's important to stress again that camp is a pre- or proto-political phenomenon. The anti-camp in this system is the person who wants to dissociate from the stigma to be like the oppressors. The camp says, "I am not like the oppressors." But in so doing he agrees with the oppressors' definition of who he is. The new radicals deny the stigma in a different way, by saying that the oppressors are illegitimate. This step is only foreshadowed in camp. It is also interesting that the lesbian wing of the radical homosexuals have come to women's meetings holding signs saying: "We are the women your parents warned you against."

[22] The "bitch," as I see it, is a woman who *accepts* her inferior status, but refuses to do so gracefully or without fighting back. Women and homosexual men are oppressed by straight men, and it is no accident that both are beginning to move beyond bitchiness toward refusal of inferior status.

[23] Many impersonators told me that they got tired of being camps for their friends, lovers, and acquaintances. They often felt they were asked to gay parties simply to entertain and camp it up, and said they did not feel like camping off stage, or didn't feel competent when out of drag. This broadens out into the social problem of all clowns and entertainers, or, even further, to anyone with a talent. He will often wonder if he is loved for himself.

# "The Fast Fuck and the Quick Buck"

Finally, I want to present some data on conditions that are central to the situation of female impersonators: the conditions of work, the hierarchy of control over shows and jobs, and the effects of the collective consciousness.

## THE CONDITIONS OF WORK

Female impersonator shows, consisting of anywhere from one to twenty or more performers, may be indefinitely attached to a particular bar or nightclub, or they may travel as a unit, appearing in theatres or bars in various cities.

### Backstage

Whenever there is a group (more than one man) drag show, the backstage area tends to be an important social institution for impersonators all over the city, and also for the many impersonators who are just traveling through or looking for work. There is no solidarity, but there is social interaction and a great deal of shared knowledge and consciousness.

There is a great deal of difference between what goes on backstage and what is presented to the audience. Backstage, the performers can "let their hair down," and freely engage in their own talk and behavior. Here, however, my direct data is based on the one club in which I had free access to the backstage. Other than that I had to rely on what I was told by the performers about other backstage conditions.

Many people seem surprised when I say that Kansas City is a center for drag shows, as if drag would only exist in Europe or on the more sophisticated (evil, decadent) east coast. But drag, like violence, is as American as apple pie. Like

112

violence, it is not an accident or mistake, nor is it caused by a few people's weak character. It is an organic part of American culture -- exactly the "flip side" of many precious ideals. Many, if not most (white) female impersonators are from small towns in middle and southern America; they are home grown.

On a main street in Kansas City, although not in the downtown area, is a strip of nightclubs offering "sin" to Kansas Citians on their nights out. Three of the clubs, the drag show and two strip joints, are spacious, well equipped, and heavily frequented by prosperous looking white Americans. On New Year's Eve, the drag show is packed with married couples, and champagne bubbles all evening. The fourth club is a low hustling bar, where street fairies, other gay people, dating couples, and working-class men rub elbows. This club is small but has a stage and sometimes a drag queen. The owners allowed a Halloween drag contest to be held there. The Kansas City strip also has several all-night restaurants.

A Kansas City tourist club presents a drag show every night except Monday, three times a night and four on Saturday. Every night for three months I arrived there at about 8:00 p.m. and stayed until the last show was over, about 2:30. The physical set-up of the club was as follows: In a very barren and rather dirty basement, were the "dressingrooms," one to each performer (six in all). These were tiny cubicles created by the simple expedient of plywood partitions. Each had a wall mirror, a table made of plywood board, and a chair. The tables were heaped with tissues, make-up, magazines, and every imaginable sort of miscellany. Lighting was supplied by one bare light bulb hanging from the ceiling over each cubicle. This basement dressingroom area was freezing cold in winter and blazing hot in summer. Before the first show, all the performers went down to the basement to make up in their own dressingrooms, take off their street clothes, and put on the basic undergarments of their trade (gaff, corset, girdle, brassiere, hip padding, etc.), a process that took anywhere from fifteen minutes to an hour, depending on the individual's particular pattern and how much time he had on a given evening.

Wooden stairs led directly up to the backstage proper, a long, narrow room off stage left. It was miserably uncomfortable, and though the performers complained about it constantly, they never made a concerted effort to get the manager to do anything about it, and in fact, nothing was done during the year that I spent time there.[1] For instance, along the back wall were two windows

---

[1] When I first arrived in Kansas City, there was a specialist lighting man working the lights from a booth out on the floor. My first night in Kansas City, this young man attempted to demonstrate his heterosexuality by making a mild pass at me in the basement. Later, Larry attached himself to me at a table, and said I should hear his views on drag. Queens are tremendously difficult to work with, he said, more so than any other type of performer, and he's been in show business for ten years and his father was in it before him. They are egotistical and keep trying to tell him how to run his lights, whereas he doesn't try to tell them how to do drag. For their part, the female impersonators bitterly resented the

that looked out on a back alley. One of these was broken, and freely admitted icy blasts during the winter. Finally one performer put some cardboard over the break. The cold air was offset by the pipes in the heating system, which ran up through the backstage. Performers would often burn themselves on the naked pipes. The overall effect was of stifling heat interrupted by blasts of freezing air.

Projecting out about four feet from the back wall were horizontal iron bars which were used to hang costumes on. Almost all changing from one dress or costume to another was therefore done in the backstage area, so that the room presented a continual panorama of performers in various stages of dressing and undressing. The costume racks were anything but neat, and the floor beneath presented an unexplored mountainous terrain of shoes, slippers, scarves, jewelry, and numerous costumes that had simply slipped off the hangers. Along the length of the other wall were wooden shelves, and over them a long mirror in which performers could check wigs and make-up. The shelves were always heaped with make-up, jewelry, hand mirrors, dirty tissues, new and old boxes of candy, french fried potatoes, half full and empty glasses with lipstick smeared straws, photographs, and so on. Records were stacked more or less haphazardly on the bottom shelves. On the end closest to the stage were the record player and the lighting and sound controls. At that end, the room ended in four steps that led up to stage left. The performers did not usually enter the stage that way, but went around behind the back curtain and entered at stage rear center. The backstage was hidden from the view of the audience by the back curtain, which curved around across the end of the backstage to stage left front. By standing behind this curtain and pulling it slightly away from the wall, the performers could and did observe the audience without being seen by them.

At the other end of the room was a wall, part of which was given over to another large mirror. One door led to a small toilet (the performers were not allowed to use the toilets used by the clientele and other bar employees). The other doorway led through a small hall area where more dresses were hung; the hall ended with a door (always kept closed) that gave off at right angles on the hallway where the ladies' room was located, and past this were the "outside," the audience floor, and the bar.

This rather chaotic and uncomfortable area, then, was the sanctuary of the cast — six female impersonators. The total space was perhaps nine by twelve feet, but the actual area in which one could move about was much less because of the protruding shelves and costume racks. Nevertheless, the performers made

---

lighting man, claimed he was stupid, uncooperative, and didn't know anything about lights. Their opposition to him was so consistent and so strong that this became the only issue (in my experience) upon which they were able to form a united front to the manager. They demanded that he be fired, and after several more weeks of complaints, this was done. The impersonators took over the lights themselves by means of a small control panel backstage. I gathered this was the usual procedure in all but the very biggest shows.

themselves at home there. Backstage was the scene of constant activity, performers coming and going from the outside floor on one end, and the stage at the other, changing costumes, fussing with wigs and make-up in front of the mirrors, lounging on the folding chairs or the stairs leading up to the stage, changing records, working the lights, pulling curtains, and simply preening themselves. The air was always full of conversation, exclamations, curses, gossip about boy friends and other "queens," talk about movies, movie stars, the show, directions being given, and the usual trivia that constitutes in-group communication.

In spite of the activities and the conversation, however, boredom hung heavy in the backstage atmosphere. The drag queens were there, after all, to do a job, and one that had become quite routine for them. On the other hand, there was a strong feeling of tension and potential crisis always under the surface. This was partly, but by no means entirely, due to the exigencies and anxieties of performing before a live audience on the stage. The greatest source of tension was inherent in the life-situation of most female impersonators. Cut-throat motives of gain and competition were allowed free play and even encouraged in a very loosely structured situation whose only certainties were uncertainties.

### The Gay Bar

The primary goal of the gay bar, as of other businesses, is to make money for its owner. The gay bar provides an informal, semi-public[2] place where homosexuals may meet, socialize, and make sexual contacts. It is a place to congregate away from the hostile pressures of the straight world. The bar is the central institution in homosexual group life. However, since the bars are semi-public gathering places, they are vulnerable to police sanctions. Any gay bar is living on borrowed time, and neither owners nor clientele can count on permanence. Therefore, gay bars operate by and large on a quick-money policy. This is most extreme where police pressure is most intense and less pronounced where owners can count on some degree of stability. The quick-money policy means that owners invest little in plant, keep overhead and operating expenses low, and try to reap quick profits on the relatively high price of drinks.

The price of drinks is high relative to those in bars patronized by heterosexuals but low in comparison to those in nightclubs. Prices in gay bars are set by the relatively heavy demand for the bar and the high risk from the business point of view, coupled with the need to keep them low enough so that

[2] Not all gay bars are open to the general public, or even to the homosexual public. In Kansas City, for instance, "private party" signs are on bar doors. To get in, you must be recognized by the man at the door, be with someone who is, or at least produce a name that is known to him.

gay people can afford them on a regular basis. The gay bar is a social institution for which there is a continuous and urgent need.

However, the consequences of the quick-money policy for the drag queens are severe: The bars tend to be physically small, and their facilities (stage, lighting, dressingroom) tend to be jerry-built and in poor condition. Job tenure is nil. A gay bar may be closed any time. Furthermore, salaries for performers are extremely low. All female impersonators agree that there is no money in gay bars. The highest weekly salary I ever heard of for a single female impersonator in a gay bar was $200 a week, and this is exceptional. The average is closer to $75 a week, with some salaries as low as $40.

Furthermore, being a female impersonator is expensive — much more so in a gay bar than in a straight one. It is necessary to digress a little to explain why. Female impersonators must pay for their own costumes, or "drags" as they are called. The major items in the wardrobe are dresses and wigs, but the cost of all the accessories mounts up, too. Because the gay audience is fundamentally a "repeating" audience — that is, many of the same people will be in the audience night after night — and because the gay audience takes a very keen interest in the appearance of female impersonators, performers in gay clubs constantly must vary not only their act, the actual content, but also their gowns and wigs. Once the initial investment is made, upkeep becomes crucial. Because the gay bars are physically small, members of the audience can get a close look at the costumes and wigs, and they are extremely critical about the fine points of appearance. Only a minority of female impersonators have the time and skill to clean and set their own wigs, which means using the services of a hairdresser. Again, only a minority can make their own gowns; the rest must purchase theirs or know a sympathetic designer.

The second major expense is the bar tab. The bar tab is apparently standard for nightclub entertainers and personnel, but the cost is higher for female impersonators in a gay bar because of the highly sociable character of the interaction between the performers and the audience. There is usually a forty-five-minute intermission between shows, and in a gay bar, the performers are generally expected to come out and mingle with the audience. In this way, many members of the audience will be known to a performer after he has worked at a particular bar for more than two weeks, and where he has been in town working at various bars for any length of time, he will know many bar-going members of the homosexual community at large from his off-stage life as well. The sociability of drinking requires that drinks be exchanged as a sign of friendship, good-will, or gratitude. Admiring members of the homosexual audience often like to buy performers a drink, and etiquette demands that if this happens often enough, the performer must reciprocate. It means that in addition to the bill for his often large alcoholic consumption, the performer is required by rules of sociability to buy drinks for others. This bar tab comes out of his

salary. One highly sociable performer, who is himself a heavy drinker, runs a weekly bar tab of between $25 and $50. This may be exceptionally high, but the bar tab is a considerable expense for most performers.

The gay bar also offers few possibilities for the performer to rise in status. His audience is limited; he has practically no access to influential heterosexuals, and this includes many people in show business. The gay bars do not advertise. The performer working at the gay bar may become well known to the homosexual community but still be unknown to the straight world.

Counterbalancing the low pay and lack of renown in the straight world for many performers is the advantage of working for a homosexual audience. The female impersonator working for a homosexual audience feels that he is among his own people. This means that his performance tends to be much more relaxed and that his off-stage hours spent at the bar will be characterized by sociability rather than by social distance, as in a straight bar.

### The Tourist Club

The primary purpose of the tourist club, like the gay bar, is to make money for its owners. However, the principle of its operation is quite different. The basic function of a gay bar is to provide a public meeting place. The show may get homosexuals to socialize in that bar rather than others, or usually in addition to others. Most gay bars have no show of any kind, but the tourist club depends entirely on its show. Unlike the "chic" clubs to be considered below, the usual tourist place specializes exclusively in female impersonators. This is true of the four largest and best known tourist clubs in the country: the 82 Club in New York City, the My-Oh-My in New Orleans, the Jewel Box Lounge in Kansas City, and Finnochio's in San Francisco.[3] The latter has been presenting a female impersonator show continuously since the 1930s, and, in direct contrast to gay bars, it is known either directly or by reputation to the general public in the San Francisco area.

While the gay bar relies on heavy and continuous patronage from a limited segment of the population, the tourist club draws on a much larger potential public. However, the tourist audience has a high turnover. Performers say that most people in the tourist audience are not repeaters. They come once, perhaps twice, to see something that is, to most of them, frankly exotic. While the bar is a central institution in the life of the homosexual community, the nightclub is a peripheral institution to most Americans.

In the tourist club sociability between audience and performers is not expected or encouraged. The audience is defined as straight no matter how many homosexuals happen to be in it. In fact, behavior by homosexuals in the

[3] Europe has its counterparts, for instance, the well known Madame Artur's in Paris and Danny LaRue's in London.

audience that might draw attention is actively discouraged by the management. Precautions are taken to promote the idea that there is a secure space between the stage and the floor:

The "82," which has become one of the "camp" places to go in town, is comfortable, not at all seedy. In other words, the deviates are all on the stage and the audience's honor is never threatened.[4]

Since tourist clubs cater by definition to heterosexual audiences, they are much freer from police sanctions. Tourist clubs are stable institutions by gay bar standards. The stability, combined with the fact that audiences do not demand face-to-face contact with each other and with the performers, allows the tourist clubs to be at least three times the size of the average gay bar. Not only is the stage larger to accommodate a bigger and more lavish show, but the floor space is larger to pack in more people. The method of accommodating the audience is different as well. The audience in a gay bar is restless and very mobile. Many gay bars have no tables at all and are dominated by their one essential feature, the bar itself. The audience sits at the bar, and the rest stand. Tourist clubs may have a bar, but it is peripheral. The majority of the audience sit at tables, as in any nightclub. They do not need to move around to socialize with each other, and their sitting posture emphasizes that they are spectators, not participants.

Prices in the tourist clubs are extremely high; they are often called "clip joints" by the performers. This is especially true on week ends which, after all, are "date nights" or "nights-out" for the heterosexual populace. One club charges a $5 minimum *per show* on week ends, and this does not include tipping the (drag butch) waiters or the hatcheck girl. The drinks themselves are very high, and so is the food. Another club charges $1.50 cover charge on week ends, and drinks are high. A club in San Francisco has a $2.50 cover charge on week ends.

From the point of view of the performer, working in a tourist club means working in a bigger and more elaborate show. The structure of the show is basically the same as in gay shows, that is, at least three production numbers with "spots" (solo performances) in between. There are more spots than in the gay show, but unlike the gay show, each performer will only do one spot per show. The production numbers are much more elaborate and involve more performers. In terms of physical amenities (dressingroom), stage facilities (lighting, curtains, band), and actual time spent on the stage, the show at the tourist club is probably easier on the performers. However, performers in a tourist club are freaks or clowns up for display to a hostile audience. Although

[4]Michael Zwerin, "After Theatre Jump," *Playbill*, 4, no. 2 (1967), p. 47. *Playbill* is a magazine handed out free to New York theatre-goers.

all performers find this difficult, for some it becomes a challenge, while for others it remains terrifying and discouraging.

Salaries in tourist clubs are generally higher than those in gay clubs, especially for performers with top billing. The performers' bar tab in tourist clubs is lower, for reasons already discussed. Also, even the star performers can get by with many fewer changes of costume in tourist clubs. Because of the high audience turnover, the tourist club need vary its show very little. In the tourist club, the dress and the song that were good enough for last Friday's audience will be good enough for this Friday's audience as well, because hardly any of the same people will be there. Costumes to be worn for production numbers will be paid for by the management, which means that some of the lowest paid performers who do not have solo spots will not have to buy any of their own dresses.

Not only can the star performer make more money in the tourist club, but he has a chance to gain recognition in the straight world. Tourist clubs advertise, and the stage names of featured performers often appear in the advertisements. In theory there is a much greater chance that influential contacts can be made. Many female impersonators hope that they will be "discovered" by show business people who may be in the audience, and hence offered better jobs. They do become known to a much larger segment of the general population. The performers in the tourist club in Kansas City were known to a good many ordinary citizens in that city, and I saw them receiving sympathetic treatment in some of the downtown stores on that account. I understand that the situation is the same for the performers in San Francisco, and that these performers are even invited to straight parties.

### "Chic" Clubs

While the gay bar caters to homosexual audiences, and the tourist club specializes in female impersonator shows for straight audiences, the chic club is simply a nightclub. It caters to what is defined as a heterosexual audience, usually a rather sophisticated one, and over the course of a year it offers a variety of performers, of which a female impersonator is simply one type. In theory, any nightclub might hire a female impersonator. In practice, very few do. Only the most talented, aggressive, and prestigious performers can hope to get jobs in the chic nightclubs, where they face stiff competition for jobs from many other, more conventional nightclub acts. The chic nightclub does not hire a female impersonator show *in toto*, but only one or at the most two performers, who then must hold the stage unaided for anywhere from half an hour to an hour and fifteen minutes. In San Francisco and New York there are two "chic" nightclubs that have hired female impersonators, and I know from my interviews that some of the top performers have worked in others, although

only T. C. Jones, the best known female impersonator, has ever to my knowledge worked in the Mecca of nightclubs, Las Vegas.

Salaries in the chic nightclubs are high, astronomically so in comparison with most salaries received by those in gay and tourist clubs. Physical arrangements are said to be excellent, although the chic clubs are smaller than the tourist clubs. The prestige of working in a chic club is very high among female impersonators, but very few of them are willing and/or able to do so.

<div align="right">Traveling Shows</div>

Traveling shows, like those appearing in gay bars and tourist clubs, tend nowadays to be made up exclusively of female impersonators. They vary in size. The best known, and most durable, is the Jewel Box Revue, which has been operating under that name since the 1930s. It has twenty-six performers, of which, when I saw it in 1966, six were men who danced in male attire, one was a man who sang in male attire, eighteen were female impersonators, and one, the emcee, was a male impersonator (woman in male attire). The Jewel Box Revue travels as a unit, appearing in large theatres in major cities, such as Detroit, Chicago, New York, and Atlanta. It is usually booked into a specific theatre for two-week stands and is often held over.

Job tenure at the Jewel Box Revue is said to be good, but salaries are low, probably on a par with those in most tourist clubs. The Revue always plays to audiences that are defined as straight, but the fact that it appears in theatres radically alters its problems. The theatre audience is not a drinking audience, which means that in general it is more attentive, although less euphoric. The physical layout of a large theatre is ideal from the point of view of maintaining distance between performers and audience, for the performers never leave their recessed proscenium stage, and the audience is bunched together in darkness. Not all traveling shows play in theatres, however, and most are smaller, less elaborate, and less permanent than the Jewel Box Revue. I have never seen any other traveling shows, and it may be that they are not as common as formerly. Also, traveling shows tend to play in smaller cities and towns.

Female impersonators dislike being "on the road" in small-town America. Audiences and entire towns can be "unsophisticated" and aggressively hostile. Most traveling shows consist of between four and ten performers who have banded together temporarily for a specific tour arranged by an agent, although sometimes they simply travel from town to town and dicker with local bar owners in the hopes of finding work. The show can break up at any time and usually does not survive a specific tour of a few weeks or months.

These are the principal types of clubs and shows in which female impersonators perform. Female impersonators depend entirely on the clubs because, with very few exceptions, they have at present no other place or

context in which to perform.[5] The club is the professional home of the female impersonators. Their livelihood depends upon it. It is the scene of their confrontation with audiences. Because female impersonators are largely segregated from other kinds of entertainers, and because they so often perform in groups, it is the principal center of their group life.

## THE HIERARCHY OF CONTROL

Like the majority of Americans, female impersonators have to sell their skills to live.[6] They have no control at all over the conditions of their work, no job security, no collective strength. In spite of the obvious advantages, clubs are very seldom, if ever, either owned or managed by female impersonators themselves, even in those clubs that have long specialized exclusively in their performances. Even the gay bars are infrequently owned or managed by homosexuals.[7] This fact probably accounts for some of the tension between managers and performers, although a considerable amount of strain is probably a result of structural conflicts involving differing goals of management and labor that would remain even if managers were more sympathetic to the impersonators.

It is difficult to find out who actually owns the clubs. Often the performers themselves do not know. This is especially true where the bars are syndicate owned or controlled, as in Chicago. The pattern of bar ownership affects female impersonators, even if the owners or owner have no personal contact with the performers. For instance, if one owner or group of owners controls several bars

[5] The restriction of female impersonators to nightclubs and bars is an historical process that has occurred since the end of vaudeville. The white population apparently does not consider female impersonators or strippers fit to perform where children might be in the audience. (In contrast, there are many children present when the Jewel Box Review plays at the Regal Theatre [Chicago] or the Apollo [New York], both in black ghettos.) This excludes them from most movies and especially from TV. TV has featured almost all other kinds of nightclub performances, in modified form.

[6] Female impersonators can and do sell their sexuality as well: This is called "hustling" or "turning tricks." There appeared to be inverse correlation between amount of salary and amount of hustling. Men out of work altogether may hustle full time. This is more true of the street impersonators. Stage men generally say they would try to get a legitimate job. But they are not out of work as much.

[7] The principal exception seems to be the gay bars in San Francisco and perhaps in smaller cities. One can speculate that this is because of an absence of syndicate involvement there. Bars there are reputed to be owned and managed by small entrepreneurs free of outside control. Several years ago, the owners of gay bars in San Francisco formed an association called the Tavern Guild with the dual aim of presenting a united front to the police and of keeping up standards of the bars themselves, partly by restricting competition. They have apparently been quite successful in these aims. This is an unprecedented situation. I was told, when I was in San Francisco, that many of the members of the Tavern Guild were themselves homosexual.

Many performers say that owners should not be homosexual, and opinion was very divided in the case of managers. This idea is based on the premise that homosexuals are too involved in group life to be able to exert sufficient control on public behavior of other homosexuals. An outsider is needed, they claim.

that hire female impersonators, the performer who is *persona non grata* in one of them is not welcome at any of the others. The hiring and firing of female impersonators can often become involved in personal or business disputes and alliances between owners. Owners, especially syndicate owners, can harass or protect female impersonators significantly. Kenneth Marlowe writes how he was detained in a Calumet City drag nightclub by threats from the syndicate owners.[8] A similar case from my field notes:

A very popular performer in a gay bar had given the managers notice after a highly successful run of several months. The managers nightly approached him about staying. He told me that he was determined to leave, but that he had to be careful to be tactful about it, as he didn't want to wind up beaten up in an alley. He said he was afraid of the syndicate.

Female impersonators can also be protected by owners:

All the performers at a particular nightclub enjoyed an unusual degree of immunity from the police for their off-stage misdeeds. One of the club personnel told me that this was partly due to the fact that one of the owners was a local judge.

Although owners set general policy for clubs, such as whether the club will cater to gay or straight audiences, they only directly control club policy where they are also the managers. Otherwise, this power devolves on the manager as the owner's representative. It is the manager who decides on salary, hiring and firing, and content of the performances; he even monitors the off-stage behavior of the female impersonators.

There tend to be many, sometimes conflicting, demands on the manager. His primary duty, of course, is to make the bar or club a paying proposition. Within broad limits set by the owner, the manager may exercise his personal judgment as to how this is to be done. His judgment quite frequently conflicts with the performers' own wishes and ideas. The most frequent complaint by impersonators is that managers are stupid and do not know what they are doing, or do not take enough interest in the show. Managers do approve or reject acts through hiring power and also exert veto power over performances, although they do not create them. Sometimes the veto power can be used arbitrarily, as when a manager forbids a certain song that he dislikes. But it is usually in the area of "vulgarity" that the manager exercises the veto, although he often leaves it to the "boss" female impersonator of the show to see that his orders are carried out.

[8]Kenneth Marlowe, *Mr. Madame: Confessions of a Male Madame* (Los Angeles: Sherbourne Press, 1964).

If the manager takes on personal direction of the backstage or even off-stage behavior of the performers, he tends to be paternalistic. This is true whether he treats the performers as unruly and troublesome children needing firm control, or as degraded perverts of no status, or as some combination of these characteristics. Some performers in some clubs, especially those that have specialized in female impersonators for some time, evolve reciprocal relationships with the manager of a paternalistic/child type. This has the divisive result that the performers vie with one another for his approval, as symbolized by money, protection, delegated authority, and so on.

I suspect that managers become more directly and personally involved in the management of the female impersonators in the tourist clubs. In the first place, these shows tend to be larger so that there are more opportunities for disputes arising among the cast that someone must control to prevent backstage havoc. Second, in the tourist club the difficulty of conflict between the performers and the audience arises constantly, either on stage during performance, or off stage beween shows, if the performers are allowed or expected to mingle with the audience.

Conflict between audience and performers also arises in gay bars, but here the managers seem to take a "plague on both your houses" attitude. It is important to remember that most managers are straight. Overall, there is a general tendency for the manager to take the part of audience members in conflict with the performers, perhaps because, as one informant explained to me: "X [an owner-manager] always thinks that drag queens are like whores . . . you can always find another one."

All in all, the manager is the man the impersonators most fear, for he has a great deal of control over them, ultimately hiring and firing. The impersonators have no way to fight back; no way to appeal. The owner is a distant figure, but the manager must be pleased, placated, and flattered night after night.

In some clubs, even the bartenders have, or try to exercise, power over the impersonators. Especially in gay bars, a bartender may be delegated to manage at certain times:

From his own account, the bartender is general manager of the bar in the absence of the owner or manager, which can be often, or usually. The owner or manager lays down the basic policy, but the bartender has a lot of leeway in carrying it out. He makes many of the decisions on a day-to-day basis concerning who can come into the bar, and he acts as a bouncer.

To the degree that the bartender is the representative of the management, the female impersonators must be able to get along with him. This sometimes becomes a problem, especially in tourist clubs where the bartender may be heterosexual and basically unsympathetic to the performers. In the tourist club

that I studied in Kansas City, the top ("boss") female impersonator had a long-standing feud going with the bartender:

Godiva (a dark-skinned boy) complained that the bartender had called him a "nigger." Tris (the "boss") was incensed. He told me he went to the bartender between shows and told him that he may not like queers, but he makes his living off them, so he'd better shut up about it. But the bartender was not fired or even reprimanded, and tension between them grew.

The direct link between the management and the show is the "boss" of the show, who is often the emcee as well. The boss not only exercises loose control over the form of the show, but is responsible to the manager and owner for the behavior of the other female impersonators, both on stage and off, while they are in the club. His position thus has many built-in conflicts. He is not a true middleman. On the one hand, his authority is resented by the other female impersonators who make constant attempts to circumvent it by independent appeals to the manager, to members of the audience (in a gay bar), and by little conspiracies among themselves; on the other hand, to the manager he is a convenience who can be dispensed with, and is basically as alien to the manager and as little worthy of respect as the others. Furthermore, his position mainly rests on his performing proficiency, and if this should slip, he will be fired regardless of how good a "boss" he is. His power comes from the manager, not the performers. Therefore, they resent him and he is isolated. The performer who is in charge of the show invariably gets a reputation as a "bitch."

The owners of one big show tried to circumvent this problem by putting a male impersonator (a woman), who was also the performing emcee, in charge of the show. According to her, she was far more successful at the job than a female impersonator could have been. She said that she was partially an outsider, and that this strengthened her authority, especially in presiding over disputes among the cast. She maintained that a female impersonator could never preside successfully over a female impersonator show.

None of the performers worked under contract, so that they could be (and were) fired at a moment's notice. No one knew when the ax might fall. Requirements for job holding were nowhere formalized or even made explicit, although performers knew that seriously antagonizing the manager in any way could mean dismissal. Furthermore, the performers, as a group or singly, had no way of combating competition: "big names" from other towns who might want their jobs, or unknowns who might be willing to work for less. Nor did the performers maintain anything like a solid front in the face of this insecurity, as indicated above. Personal and professional animosities, often not clearly distinguished, were endemic. Performers often complained to me that some other member of the cast was trying to get them fired, and in some cases this

appeared to be true. And from time to time, these animosities broke out in the open, resulting in verbally abusive fights that disrupted the surface, but which none of the other performers made serious efforts to mediate or control. The performers divided into unstable little feuding cliques; personal alliances could change overnight. There was no stable hierarchy of authority – the manager could fire anyone. Competition, distrust, and scheming were commonplace. Cooperation was haphazard. The "boss" had no real power or authority. So long as the fights did not grossly interfere with the show or the audience, the manager was unconcerned.

### THE COLLECTIVE CONSCIOUSNESS

Female impersonators see themselves as sophisticated urbanites. Like all "city slickers," they refer contemptuously to rural areas and small towns as "the sticks," and to rural people as "hicks." Most female impersonators have to perform in small towns at one time or another, and they unanimously refer to this as an unpleasant experience.[9] These exotic flowers may have their roots in "the sticks," but they bloom in the cities. Their urbanism is more profound than simply a desire for "bright lights." Organized nightlife is found in cities, and impersonators need the anonymity of cities to exist. But, more than this, impersonators see themselves as "unnatural," and in our culture, the city can accommodate every unnatural thing. It is the country that represents to us "nature" and, ultimately, what is real. Impersonators said they felt uncomfortable in the country. As one told me, "Scenery is okay as long as it's on picture postcards."

Impersonators are "night people" through necessity and, by inference, through choice. They move in the ambiance of the night. Impersonators would say of themselves: We are city people; we are night people; and we are dishonored people. In certain ways, their consciousness is most like that of prostitutes; they sometimes call themselves "ladies of the night."

Female impersonators as a group perceive the world as a moral arena. Sexuality and its "inevitable" *moral* implications are seen as the wellspring of all human behavior from birth to death, from the simplest individual acts to the most complex and elaborate collective phenomena. Nothing is more characteris-

[9]I was not able to get systematic life histories from female impersonators. But when I did find out where an impersonator came from, he almost invariably came originally from a small town in the South or Midwest. (This was not true of Black impersonators, who seemed to come from urban areas.) Undoubtedly this is partly related to the fact that I worked in Chicago and Kansas City. However, I formed a definite impression that a disproportionate number of drag queens (and homosexual men) were raised in such places. If this is so, it might be related to the more rigid moral system of rural America, especially in the Midwest and South.

tic of female impersonators than the *pars pro toto* mode of addressing each other as "cunt" or of referring to a group of women as "those cunts." Similarly, impersonators refer to a host of attributes and qualities perceived as feminine in things, individuals, groups, and events as "pussy."[10]

The general direction of motivations and conditions in the *moral* arena, however, is not "uplift," but "downfall." The sense of downfall and degradation is so strong that a more accurate statement might be that female impersonators conceive of the world as an *immoral* arena. (Performers frequently refer to an historical past or ideal state of affairs that is more moral.) Yet the world as it is, as opposed to the world as it ought to be, can be clearly perceived only after a hard ordeal of disillusionment. The group conception gives powerful validation and meaning to the personal "fall" that each of these men has experienced by whatever process he has become a drag queen: the "fall" is not for nothing. In the process one comes to see reality for *what it is*, as well as being prepared to cope with it. And this world as it is is driven by rapacious sexuality and competitiveness, which means the immorality of exploitation and degradation:

Backstage between shows: Bonnie (age approximately 73) fomented a discussion by saying to me that people are "awful and terrible" – all they want is "a fast fuck, a good drink, and how much?" When this was repeated aloud to the five other female impersonators there, all of them immediately agreed that this was absolutely true. I was the only hold-out, saying that it wasn't true, that it wasn't all that people really wanted. Tris said I was extremely naïve and had lived a sheltered life surrounded by people who had the same life, whereas if I got out in the big, cruel world, I'd find out that it was true. He said that this last week (in Kansas City) had been an important part of my education. Bonnie said life hadn't rubbed against me hard enough yet, and it would kick me around enough eventually to where I'd change my mind. Then they all gave examples from personal experience illustrating the general principle. These were mostly tales of betrayals by friends for sexual or economic gain. Tris said it was getting worse and worse, and each year "the fucking got quicker and the drinking harder."

Disillusionment, of course, produces cynicism and contempt: cynicism because so many people continually fool themselves about the nature of the world, or try to fool you, while the aware person would see through appearances to the true nature of reality and motivation; contempt because people, through ignorance or for personal gain, pretend to be better than they are. One female

---

[10]Men, however, are not generally referred to as "pricks." In fact, there is a conspicuous lack of specifically male phallic words used in the subculture. The antonym of "pussy" is "butch," which, while signifying maleness in all its attributes, does not directly refer to male genitals.

impersonator in Kansas City referred contemptuously to the straight audiences as "fools, dirty-minded fools."

To the impersonator, the world is a "jungle"; man in the jungle is a "savage"; this is wrong, but it is the actual state of affairs. Anyone who seems to be different is ignorant or unscrupulous. Exploitative sexuality is the root and framework of all human motivation.

Granted the overwhelming importance of sexuality, it follows that female impersonators see the division between male and female as the most fundamental social distinction, and masculinity and femininity as *the* polar modes of existence. All other social distinctions and all other principles of organization are derivative or secondary. (For instance, national and racial distinctions are secondary.)

For impersonators, the most important consequence of the male-female dichotomy is the division of mankind into straight (heterosexual) and gay (homosexual). Straight people are those in whom gender and sexuality match; this is right. Gay people are those in whom gender and sexuality are opposed or out of joint; this is wrong. Male homosexuals are feminine men. Female homosexuals are masculine women as impersonators see it.

Not only do masculinity and femininity constitute the all-inclusive framework for "approved" human behavior, but they are strongly polarized and, from the point of view of the middle-class person, very strongly "idealized." Granting certain differences in individual idealizations of manliness, the general idea of female impersonators is that the only "real" men look like football tackles, act at all times like John Wayne, and are "hung like stud mules." At base, "masculinity" is the principle of aggressive brute force in the world.

The ideal of femininity is symbolized for them in the word "lady." Most female impersonators aspire to act like "ladies," and to call a woman a "lady" is to confer the highest honor. Femininity opposes male strength through manipulativeness and beauty. Women should be "beautiful" at all times. By this is meant Hollywood high style (e.g., Sophia Loren or Elizabeth Taylor). Women should be (or seem to be) totally helpless and incompetent in most activities (in relation to men). However, it is recognized that literally carried out, this would not leave women enough power to get what they want. Therefore, they should always achieve their ends not by a direct show of strength, but by manipulation. In its more positive forms, feminine manipulation might be termed "womanly charms." However, it very often has a hostile, distinctly nasty manifestation: "bitchiness." Thus the real woman is of necessity *both* beautiful and bitchy.

The female impersonators' views of the moral *order* of the world (as opposed to the moral *condition*) is not so well elaborated. There seem to be two scales that they. use most frequently in making moral evaluations. One is a "natural-unnatural" scale. This is mainly applied in terms of sex-role behavior

(1) *Gay-straight division*

|  |  | GENDER | |
|---|---|---|---|
|  |  | Male | Female |
| ROLES | Masculine | Men | Dykes<br>Lesbians |
|  | Feminine | Queens | Women |

Note that the logically possible but "normally" blank contrasts are filled out by gay people.

(2) *Gay roles*

|  |  | GENDER | |
|---|---|---|---|
|  |  | Male | Female |
| ROLES | Butch | Butch queen<br>S – M, rough trades | Drag butch<br>Bull dykes<br>Butch dykes |
|  | Fem | Nellie queens<br>Drag queen | Fems |

Here the same principles are applied within the gay world.
Underlined roles are most deviant.

and sexual behavior *per se*, and is related to the strong "idealization" mentioned earlier. By this scale, for instance, the really masculine man is "natural." Any deviations from this are "unnatural." These terms carry a heavy moral load. Heterosexual relations are natural; any deviation is unnatural (i.e., homosexual, bestial, group, masturbation, etc.).

Tempering this conception, however, is their notion that the world in general is immoral because of brutality, sexuality, and competiveness. Within the general orbit of immorality, relative judgments can be made in terms of "purity-impurity." These words are not used much by the impersonators themselves but are meant to cover a whole array of moral judgments, which are framed in terms of highness and lowness, cleanliness and filth. In general, any activity, person, or

thing that is directly connected with sexuality is low and filthy. The opposite is true of those persons, things, and activities that are (or appear to be) as unrelated as possible to sexuality.

The *place* to which female impersonators have relegated themselves in this scheme should be clear. They are the bitchiest of the nellie queens, those most unnatural of men, and they deal publicly and professionally with sex. Their only compensation is that no one else is "really" any better (since all human beings must be discovered to be sexual beings at some point) and that they are losers in the competitive jungle, the victims in a brutal world. In fact, victimization may confer a certain moral superiority. But the weight of depression in both an individual psychological sense and in a cultural sense (by which I mean that the group consensus supports the individual in his personal depression) is heavy. The following excerpt from my field notes is extreme, but not unrepresentative:

Tiger, age twenty-five, said that as soon as his mother died he wouldn't mind dying either.
**EN:**   Why?
**I:**   I'm sure you know that life is not that interesting to me. I'm sure you can tell I'm a little stoned now. I would be more, but I was too lazy and couldn't afford to go to the drug store more than twice today. But you know that I'll get stoned again, all the time. That's the only way I can get through it. It truly is. The world is a rotten place anyway, and this country is more degenerate than ancient Rome. Years ago, a man wouldn't smoke a cigarette in the same room with a woman, but now any old jerk walking down the street will yell out to a woman, just for the hell of it, "Hey, mother-fucker."
**EN:**   Well, for one thing, I think this is a rough town.
**I:**   Any town is a rough town for queens, honey. In Chicago the queens will kill you just to get your wig.

Female impersonators are quite explicit in their judgment of their profession · as it is, although this is often opposed to a more respectable and valued place that it should have. As things stand now, impersonators universally describe their profession as "ratty." One informant said that it was "morally and legally illegitimate," and another that show business people would laugh at me if I were to ask them what they thought of female impersonators as professionals. In relation to show business, the gay world, and society as a whole, drag queens describe themselves as both "outside" and "down." The "outsideness" is not seen as the bottom end of a continuum, but rather as an isolation beyond the pale, comparable to the position of lepers or untouchables. Impersonators do not often deny society's judgment of them, and they even cooperate by blaming themselves more than the straight world for their lowly estate. They tend to describe the profession and often their own persons with such words as "sick,"

"rotten," "tainted," and "shitty." The following excerpt from an interview with an older impersonator well illustrates the feelings of moral pollution and isolation:

... one time, I had a terrible feeling about it. I gave a party and invited them [other impersonators] up, and we had a bang-up time. Everybody was talking. And I had just gotten through reading *A House Is Not a Home* [the autobiography of a madam]. And just as it was time for them all to go home, I felt like the madam at the Christmas party. It was as though I was sitting there and all the whores were going to go home. Because of the fact that the female impersonator has so divorced themselves [sic] from the rest of the world, they have to cling together, and they have nothing in common with each other. But because of business, and because of the way it is, there they were stuck with each other ... it was like a comedy of errors. It was not a nice feeling. And I said, "I don't want to ever get into this position. I don't want to feel this way. I want to get out." It was cold outside, and I threw all the windows open, trying to air the place out.

It's too sad! The female impersonator is in reality a very sad person. They want to belong, yet they've jumped off the bridge of society ... there is no female impersonation in society. Even the homosexual does not completely subject himself to them all the time [i.e., even the homosexual does not do drag all the time, does not face society's censure every day] ... when they're with each other, and they look at this person after a couple of hours and some drinks, and they look at the person and say, "Now what do I have in common with you?" They feel degraded in amongst themselves. And if you look down your nose at them, then they begin to hate you because of the fact that they think they're just as good as you are, so why should *you* do it? They never make for real close friends. They've been ... too tied up with each other. And other performers don't have to go through this. ...

If you work in a club where you are a female impersonator, and the guy that's emceeing the show isn't, and after the show's over, he says, "Well, I'll see you kids later," and he goes out on the street and goes to another bar; *you* can't go out on the streets[11] ... You're still stuck with each other, still stuck with the audiences that you're going to be performing to. When it comes time to go home that night, unless you've picked up a body that's just going to be there for a very few moments and leave, you've still got that daylight to look forward to. If you have messed up your life so much by, uh ... growing your own hair and making yourself too obvious, so that your job ... so that you're holding your job by being feminine ... and if you're too feminine on the street, then the only thing you can do is go up and down the street camping, or saying, "I don't care," when in reality you really *do* care. And it's not a beautiful life at all. There's nothing really pretty about it ... it's like Outward Bound. You're going to have

[11]Impersonators can't go out in the street in drag or in make-up. The make-up takes time to apply, and once it is on it stays on for the evening.

to ride this ship the rest of . . . eternity. Just back and forth, back and forth. Uh . . . I think this is the saddest I've ever talked to you about it, but it *isn't* a nice way of life, simply because of the fact it isn't an acceptable way of life.

# Field Methods

The research for this book was traditional anthropological field work, with certain qualifications imposed by time, resources, and the special constitution of the "community" under study. There is to date no full ethnography of the homosexual community, much less of the drag world, so that from the beginning I was "flying blind." Moreover, very few ethnographies (except for the early community studies) have been attempted in America, so that my model of field work procedure was largely based on non-urban precedents.

A female impersonator show or "drag show" generally consists of a number of short acts or routines performed sequentially by the same or different performers. The shows often open and close with routines by all the performers together, called production numbers. The number of performers in the cast of a particular show can range from one to twenty-six (this was the largest cast I ever saw, although in theory a cast could be larger), but the majority of drag shows have casts of about five or six. The shows take place in bars, nightclubs, and theatres for paying audiences, and last about an hour each. Performers generally do three shows an evening.

The first drag show I saw was in a small bar on Chicago's Near North Side. I did not understand about half of the performance, and my reaction was one of mingled shock and fascination. The audience clearly found the performance exceedingly funny. Never having seen a man dressed in full female attire before, I was astounded to find performer and audience joined through laughter in the commission and witnessing of a taboo act. At the same time I was struck by the effectiveness of the impersonation, by the highly charged nature of the symbol being presented dramatically, and by the intensely familiar interaction between the performer and the audience. The closest analogue I had seen was a Negro gospel show in Chicago, in which the performers came down off the stage and

132

mingled with the audience in a "laying-on of hands," and members of the audience "got the spirit." On the basis of that observation I hypothesized that I had witnessed a "cultural performance"[1] and decided to attempt to analyze it in much the same way that Keil had analyzed the blues show in relation to Negro audiences.[2]

At this early stage the practical problem was to see more drag shows and to establish contact with a female impersonator to see if the study was feasible. At that time (August–September, 1965) there were five drag shows in Chicago, and I very shortly got around to see four of them. This convinced me that drag shows did indeed follow predictable conventions that indicated ritual or cultural performance. At the same time, I approached a female impersonator between shows in the bar in which he was working. I explained that I was an anthropologist at the University of Chicago and that I would like to interview him. I stated that I was impressed with his performance and with the enthusiasm of the audience and that I wanted to question him about the profession of female impersonation. To my amazement, he replied that he had majored in anthropology in college and that he would willingly talk to me. Thereafter I interviewed this man seven times, at first in the bar and later at his home with a tape recorder. He turned out to be my entree into the drag world and my best informant. He was a highly articulate, intelligent man who from the first was at least as dedicated to the study as I was. He had been performing professionally for about twelve years in several different parts of the country, and he knew the history and structure of the profession.

Between August and November, 1965, I interviewed four other female impersonators in their apartments. These interviews were set up for me by my original informant. In addition, I spent many evenings "hanging around" Chicago drag bars, seeing shows, and getting to know performers and audiences. The problem at this stage was in getting impersonators to talk to me at all. Above all they did not wish to be confronted by an unsympathetic person who would ask insensitive questions or show a condescending attitude. The fact that most of them did not really know what an anthropologist was was helpful in avoiding preconceived hostility. But it is doubtful that they would have consented to talk to me without the enthusiastic endorsement of my original informant, who was a respected figure in the group. Second, in speaking with the potential informant to set up the interview, I made it plain that I had some familiarity with drag (that I was "wise" in Goffman's terminology) and that I was *not* interested in psychological problems.

I continued to find the taped interview a very useful tool throughout the field work. However, it was not possible to interview many impersonators in this way.

[1] Milton Singer, "The Cultural Pattern of Indian Civilization," *Far Eastern Quarterly* 15, (1955): 23-36.

[2] Charles Keil, *Urban Blues* (Chicago: University of Chicago Press, 1966).

Such interviews were only done with the "stage" impersonators (see Chapter Five) who were verbally oriented and articulate and who felt relatively comfortable with the interview situation. In all, I interviewed ten of them: six in Chicago, three in New York City, and one in Kansas City. All were interviewed in two-hour or longer sessions from one to seven times in their own apartments. But my tentative attempts to interview "street" impersonators convinced me immediately that this would not be a useful approach with them. Many of them perceived me as a complete outsider and were appalled at the idea of spending several hours alone with me. In addition, their apartments were too chaotic to permit the requisite privacy and concentration. Even given good will, they were unwilling or unable to respond thoughtfully to sustained verbal interaction. Some more informal approach was called for, and I needed a chance to observe interaction rather than to ask questions about it.

These problems were solved when my original informant left Chicago to take a job in Kansas City. He suggested that I come to Kansas City and that in his capacity as "boss" of the show, he would gain me admittance to the backstage, where I could meet the performers on a more sustained and less formal basis and could actually observe them in their natural habitat. Accordingly, between December, 1965, and December, 1966, I made three trips to Kansas City. The first two times (December, 1965, and August, 1966), I stayed about a month each; the third time I stayed one week. Once the performers had accepted me as a fixture backstage and rapport had been established, I proceeded more or less as a field worker might. I lived in two different cheap hotels where performers lived. I spent time during the day with impersonators, both singly and in groups, and participated in their activities, including parties and outings. Most important, I spent every night in the two bars where the impersonators worked, either backstage, watching the show, or talking to the bar personnel and generally observing the bar life. I considered my own role to include a great deal of participation, which would have been difficult to avoid in any case. I not only listened and questioned, I also answered questions and argued. I helped out with the shows whenever I could, pulling curtains, running messages for the performers, and bringing in drinks and french fries from the restaurant across the street. When the performers half jokingly suggested that I should stand in for an absent stripper, however, I drew the line.[3]

[3]This happened toward the end of my first stay in Kansas City. It took about three weeks to establish a good working rapport with the performers. I considered such incidents as being urged to perform and invitations to spend time with performers during the daytime indicative, but most conclusive was the gradual relaxation of linguistic usage in my presence, especially the unselfconscious use of feminine pronouns and names. (As with so many stigmatized groups, terms that are slanderous and insulting from an outsider are self-identifying from an insider.) Finally, in the last week of the first trip, one of the performers offered me what I considered to be a full "courtesy stigma" [Irving Goffman,

There is no reason, in theory, why a field worker actually could not have stayed in Kansas City (or any city in which rapport has been established) for a full year and in this way approximate conventional field work. The ethnography of such a small and specialized group as female impersonators did not seem to demand such a commitment. However, ethnography of the homosexual community in even one city, or of the various "street" groups, would certainly require such an effort.

In spite of my concern with interviews and with the group life of female impersonators, I continued throughout to concentrate on the central ritual of the "community," the performances. In the course of my active engagement with the field work (about fourteen months), I saw shows in New York, Chicago, Kansas City, and San Francisco. Some shows I saw only once, while I must have seen part or all of over one hundred shows in Kansas City. Simply recording dramatic performances should not be a problem technically. Ideally this should be done with a sound movie camera or video tape. Unfortunately, even the use of a still camera proved extremely distracting to the performers, particularly because of the flash gun that I was forced to use because of the dim light. Every time I used the flash, the performers began to perform to the camera, and, needless to say, neither the management nor the audience was pleased. I did take notes on numerous shows, taped where I could get permission from management and performers, and got a number of still photographs of performers on stage.

The most difficult methodological problem was not with performances per se but with audiences. Urban audiences are bound to present a problem; they are anonymous and transient. Drag audiences are worse, because there is an aura around drag shows that is at best risque, at worst sordid. This is particularly true of the straight audiences. (Drag shows are categorized as intended for straight, heterosexual audiences or for gay, homosexual audiences.) Drag shows are subcultural events for many homosexuals, and the audiences are stable and drawn from a recognizable subculture. In Chicago and Kansas City, I came to know many of the "regulars" at gay drag shows and could reasonably question them about their relationship to female impersonators, both socially and as

---

*Stigma* (Englewood Cliffs, N.J.: Prentice-Hall, 1963:28-31)]. When asked by a visiting impersonator who I was, he replied casually, "Oh, she's my husband."

It seems to me that I had relatively little difficulty establishing rapport. I assume this was due to the influence of my sponsor, but some peculiarities of my status and personality must be taken into account. My status as a bookish female enabled me to present myself as a relatively asexual being, which was helpful. Although my own background is middle class, alienated perspectives are congenial to me. Because of this, I may have erred on the side of "unconventional sentimentality" [Howard Becker, *Introduction in the Other Side: Perspectives on Deviance* (New York: Free Press, 1965)]. However, the respect and liking which I had for many of the performers may have been decisive. Impersonators, like members of other stigmatized groups, are extraordinarily sensitive to contempt.

performers. Straight audiences, on the other hand, are made up of people who have no or only very limited contact with female impersonators in a social sense, and who are entirely anonymous. Nor do members of straight audiences wish to be questioned during or between performances by a roving anthropologist. Not only is their attendance at a drag show risque and probably slightly shameful, but they are generally out strictly "to have a good time." I would have been thrown out of the club immediately by the manager, had any members of the straight audiences complained about me. After all, business is business. In this situation, the best I could do was to observe straight audiences again and again, and to consider them as entities, transient but with certain standard characteristics.